D1673442

OVER 400 PAGES IN COLOR

by **Paul Levitz**

THE LINE OF DC SUPER STARS

The BRONZE AGE of DC COMICS
1970–1984

Art Direction and Design
by Josh Baker

TASCHEN

THERE ARE CHARACTERS AND THERE ARE CHARACTERS.

The characters portrayed in DC Comics are among the best-known fictional characters in the world, and their stories are best told by the wealth of visual imagery swirling through this book—and the others in this series—images that captured the popular imagination.

The real-life characters who created DC Comics are far less well known, and their stories, and the evolution of DC itself, are best told in narrative history, providing a context to the extraordinary events they presided over.

DC has published more than a million pages of comics and produced thousands of hours of television and animation, and dozens of films, serials, and cartoons made for the movie theaters...plus work in every other creative medium commercially viable in the past seven decades. For all the heft of what you're holding, it's only a small taste.

You could fill a shelf with books written about Superman alone, from Alvin Schwartz recalling sitting in a taxicab, meeting the living manifestation of the hero in *An Unlikely Prophet*, to Tom De Haven's scholarly *Our Hero: Superman on Earth*. Or consider that Les Klinger's four-volume annotation of *The Sandman* examines just that one Vertigo series. The depth of commentary and debate shows how these have become myths, tales told and retold, interpreted in search of their deepest meanings. The visuals selected here attempt to show some of the most amazing images, and to place DC's history in the larger context of the culture that shaped the company.

We have also tried to honor some of the thousands of talented, creative people who have contributed to DC and crafted modern myths in many different media to create larger-than-life reflections that help us understand our humanity and our world. Many of them led lives worthy of full biographies, and their work has been the subject of many monographs. They appear here too briefly, to introduce themselves and their most important moments in the pageant of DC's history.

No matter how familiar you are with DC, you will find pictures and moments that you don't know within these pages...and those of the other volumes in this series. Culled from the supersized, Eisner Award–winning tome *75 Years of DC Comics*, each volume focuses on a different era of DC's history: the Golden, Silver, and Bronze Ages of Comics. Each include a new original interview with a legend of the era—Joe Kubert for the Golden Age, Neal Adams for the Silver Age, and so on—as well as significant new illustrations and updated essays by yours truly.

It's our hope that whether you first visited this world through a comic book's pages or a screen, or by putting on a Halloween costume, you'll find a connection to your own history here, and an invitation to explore.

Come, walk among the characters...and begin *before* the beginning...

— PAUL LEVITZ

Bob— This is hot news! Make it fit somewhere!

DC

Interview with Dennis O'Neil Paul Levitz	6
The Humanized Super Hero Paul Levitz	14
The Bronze Age 1970–1984	46
Selected Index	396
Bibliography	398
Credits	399
Acknowledgments	400

Dick

Dick Giordano

Interview with Dennis O'Neil
Paul Levitz

Denny O'Neil entered the comics field in the late 1960s as a freelance writer, mainly for Charlton, then for DC. His stories sparked the most important changes that inaugurated the Bronze Age at DC: His Wonder Woman put aside her Amazon powers and lasso in favor of the martial arts, his Superman no longer worried about Kryptonite, his Batman was the Dark Knight Detective... and, most famously, his tales of Green Lantern and Green Arrow made headlines for the relevance of the social issues they touched on, issue after issue.

O'Neil began editing at DC shortly thereafter, and played a role in encouraging the careers of a generation of young artists with nontraditional DC styles, like Jeff Jones and Howard Chaykin. Moving to Marvel, O'Neil gave the *Daredevil* assignment to Frank Miller as his first series, then made the unprecedented move of allowing Miller to write the series as well, with award-winning results. Returning to DC in 1986, he served as the editorial leader of the Batman titles for the next 15 years, and is widely considered the man who understands that legendary character best.

For many years a teacher at the School of Visual Arts and New York University, O'Neil now works a more relaxed schedule as a writer, including regular columns commenting on the worlds of comics and politics. Paul Levitz made the trip up the Hudson River on July 6, 2012, to sit down with his former colleague and poker buddy at the house he shares with his wife, Marifran.

Let's talk about your arrival at DC. How did you perceive DC from the outside?

Very much as a closed corporation. It never occurred to me to look for work at DC. I did some journalism, wrote a book. But nobody of my generation looked upon DC as a source of income because we thought they'd been using the same people since 1940. When Dick Giordano got hired away from Charlton and decided to bring some of his Charlton people with him, I found myself working for DC and, like almost everything in my alleged career, not intentionally. I came in one week for my visit with Dick, and he said, "How'd you like to be doing the same thing you've been doing for me at Charlton but for DC at three times the money?" I said, "My arm is twisted." A week later I was writing *Bomba the Jungle Boy* for DC.

BOMBA THE JUNGLE BOY No. 5

Above: *Cover art, Jack Sparling, May–June 1968.*

Dennis O'Neil picked up the *Bomba* scripting assignment by default, thanks to fellow writer Steve Skeates having beaten him to Dick Giordano's editorial office to claim the higher-profile *Aquaman*.

BATMAN No. 232

Opposite: *Cover art, Neal Adams, June 1971.*

TV robbed Batman's Rogues Gallery of its menace, so newer, more threatening foes were needed. Writer Denny O'Neil responded by crafting the League of Assassins, whose leader, the immortal Rā's al Ghūl (Arabic for "demon's head") became, in Neal Adams' depiction, the first enduringly popular villain in decades. Rā's is now a fixture of the Bat-mythology, his status acknowledged by his major role in the 2005 box-office smash *Batman Begins*.

FRESH VOICES, NEW DIRECTIONS

Above: *Contact sheet, Dennis O'Neil and Julius Schwartz, photographs by Jack Adler, early 1971.*

Enamored of the detailed characterization O'Neil brought to *Justice League of America* in 1968, editor Julius Schwartz quickly began to depend on the young writer for new approaches to characters like Green Lantern, Superman, and Captain Marvel.

CHEYENNE KID No. 66

Below: *Interior, "Wander"; script, Denny O'Neil; pencils and inks, Jim Aparo. May 1968.*

Wary of jeopardizing his assignments from the better-paying Marvel and DC, Denny O'Neil used the pseudonym "Sergius O'Shaughnessy" on his scripts for Charlton, taking the name from a character in Norman Mailer's 1955 novel *The Deer Park*.

How about you as a reader — where did DC or the other comics of the time fit into your childhood?

 I wasn't much of a reader. Comics were — as I now realize, looking back — a huge part of my childhood, but not in any way that was organized. I didn't collect comics; I traded them. Corny as it sounds, like something out of Norman Rockwell, once a month or so during the summer I'd walk up and down Claxton Avenue with a little red wagon full of comic books, and I'd stop at the houses of the kids I knew who read comics, and at the end of an hour, I had 30 new comics.

 Then the comics just went away. I vaguely recall something in the *Catholic Digest* about how wicked comic books were. And there was the business of changing retail patterns: The places where we used to buy comics didn't exist anymore — the little mom-and-pop retail stores where you got a quart of milk for the family and a comic book disappeared by the time when I was out of high school [or] some of them took the space where they used to display comics and used it for higher-mark-up stuff, paperback books maybe. So I had no reason to think about them.

 When I left college, with — let us now chortle — a minor in creative writing, or if you want to laugh even harder, in philosophy — I wanted to be a writer, not a teacher, and I didn't understand how you would be a writer with the information that I had. I now look back and think that it was an early Catholic rough draft of the No Child Left Behind Act. There was no value on education qua education; it was about passing the test, but that just didn't occur to me, partially because I was just too dense.

 I went into the service, and the last half-year of my time as a seaman was as a journalist: I edited a daily newspaper and wrote a lot of press releases. I even did a radio show. Coming out, that seemed like a possibility. Well, I knew about *Editor & Publisher* and its ads, so I looked I at it at the public library and it said, "Daily reporter wanted, southeast Missouri." My father, who was working 16-hour days for most of his life, got an afternoon off and drove me down the hundred and ten miles, and leaving that place I had a job as a news reporter. That was writing, and reporting is an interesting job if you're an introvert…the old great Warner Bros. movies with the wise-cracking guy with the hat with the press card notwithstanding.

COMICS IN THE PRESS

Right: *Newspaper clipping,* Southeast Missourian, *May 24, 1965.*

Dennis O'Neil's entrée into the comic book industry was a series of articles on the mid-1960s super hero revival that he wrote for Cape Girardeau, Missouri's local newspaper. An invitation from fellow Midwesterner Roy Thomas—one of his interview subjects and the first comics "fan" to turn pro—resulted in O'Neil's first scripting assignments for Marvel Comics months later.

I met Alfred Bester at a party in Greenwich Village. This was, my god, Alfred Bester. I couldn't speak. The guy who wrote *The Stars My Destination* is breathing the same air as I am. But a month or so later when Roy Thomas gave me an assignment to interview [Bester] for a rival magazine, I went to see him and it was a glorious afternoon. Burned up five cassettes. But I could talk to him because it wasn't me; it was the magazine. The assignment was speaking to him.

When you first started doing work for DC, who were the friendly faces? You were a very different person than what they were used to seeing in the halls.

Well, comic book people are like most people: They're not involved in politics very much. Most people are so busy getting the kids to soccer practice and taking care of the mortgage—and none of us understands economics, unless you're Paul Krugman, because it's become so complicated and so dense. If my life had taken a different turn, I wouldn't have gotten as involved in that stuff, but yeah, we were different. At one point, Steve Skeates and I were instructed not to take the direct route from one office to another, but to go around through the mailroom, because we weren't to pass the office of the head of the company dressed the way we were.

Your writing style is one of the most economical in comics. Not just the crisp words that the readers see, but you write the tersest effective art direction in the business.

They responded well or they didn't respond at all. One, after we stopped working on an assignment, boasted that the first thing he'd do after getting one of my scripts was put the dialogue in his computer and ignore everything else. He was kind of bragging about that, and I thought, that's awful in terms of the art form, because I wrote all sorts of silent panels that were there for a reason. Nothing should ever be arbitrary in a script. So I would have written it very differently if I had known.

You worked with the best artists of three eras in comics, both as a writer and an editor. Which artists amazed you the most, in how they brought your stories to life?

My favorite was Jim Aparo, because he was the consummate writer's artist. No matter what impossibly dumb thing you'd ask for, he'd deliver it.

SUPERMAN No. 233

Left: *Interior, "Superman Breaks Loose"; script, Denny O'Neil; pencils, Curt Swan; inks, Murphy Anderson. January 1971.*

After two decades guided by Mort Weisinger, longtime Superman readers could only be happily shocked by the less powerful, more introspective Man of Steel (and TV newsman Kent) served up by the new writer-editor team of O'Neil and Julius Schwartz.

THE SHADOW No. 1

Below: *Cover art, Michael Kaluta, October–November 1973.*

Uncomfortable with the Shadow's use of firearms but unwilling to change the character, writer O'Neil removed all thought balloons, rendering the vigilante an unknowable force of nature.

WONDER WOMAN No. 199

Opposite: *Interior, "Tribunal of Fear"; script, Denny O'Neil; pencils, Don Heck; inks, Dick Giordano. March–April 1972.*

A student of Eastern philosophy and meditation, O'Neil occasionally drew on sources like Richard Hittleman's books on yoga for his scripts.

LIKE A ROLLING STONE

Bottom: *Photograph, Dennis O'Neil by Jack Adler, ca. 1969.*

DC management is said to have complained about long-haired "delivery boys" loitering in the offices until Dick Giordano pointed out that the "boys" were actually writers O'Neil and Steve Skeates.

First thing I worked on with him was "Wander," which I still think would make a terrific TV show. That was a tongue-in-cheek action series, and he hit exactly the right line. Being real new, I thought, "That's what artists do. They do it appropriately."

Most of them know how to do one style, and that's what you get it. It's like casting a movie: If you get the right guy matched to the right role, you're OK; otherwise, it's "good luck."

There were times when the artist did not exactly follow the script, and in one instance I was personally insulted by what came out under my byline. I don't exactly know why the editor let it roll, but that comes with the territory. But I think it's one of the reasons I tend not to want to ever look at published work. There's also the fear that I will have done something egregiously stupid, and that's well within the realm of possibility. When Marifran, who is a serious fan, would be reading a printed comic of mine and would quietly get up and walk over to the computer to bring up the script to understand what's going on, I would say, "OK, that's one I will never look at again."

As an editor, you were regarded as an exceptional teacher. Who were your best teachers?

The language that I use when I teach is not what was the lingua franca when I started. Nobody talked about structure. I remember getting some kind of cheerleading from Stan. There was a rule that there had to be 20 copy units per page. That was obviously somebody's arbitrary rule, and it was one of the first things I discarded when I got more freedom.

The thing I am most grateful for is [writing] *Millie the Model*, because it was a chance to learn Comics Writing 101 with nothing at stake. If anybody was reading those books, we didn't know who they were. It was a way to learn "how many panels on a page" kind of stuff, which are the kind of mistakes my students make, even the very bright ones. The non-*Millie* stuff, my job was to imitate Stan Lee, and I succeeded to the degree that my work was indistinguishable from his, which frosted me at the time. But I am now so grateful for that, because everybody starts out imitating someone and my job was to imitate the guy who was arguably the best comics writer in the world.

GREEN LANTERN No. 76

Opposite: *Cover art, Neal Adams, April 1970.*

This cover scene ushered in the era of "relevance" in comics, with O'Neil's *Green Lantern* turning its attention to topical tales of social unrest. The image became iconic, with its layout paid homage in several later cover illustrations.

GREEN LANTERN No. 89

Right: *Interior, "…And Through Him Save a World"; script, Denny O'Neil; pencils and inks, Neal Adams. April–May 1972.*

Reflecting on the cancellation of *Green Lantern/Green Arrow*, Julius Schwartz declared, "The average reader was not interested in relevancy. Publicity is not worth two cents if you don't buy…"

GREEN LANTERN No. 89

Above: *Cover art, Neal Adams, April–May 1972.*

An environmentalist's protest was meant to evoke messianic parallels, particularly in its crucifixion imagery. The cover "was intended to punch people in the face, very hard," Adams said in a 2010 interview, "and, of course, it did."

GREEN LANTERN No. 89

Right: *Interior, "…And Through Him Save a World"; script, Denny O'Neil; pencils and inks, Neal Adams. April–May 1972.*

Green Lantern's destruction of the prototype jet in response to its manufacturer's callousness was a scene conceived by Adams. While Denny O'Neil wasn't entirely comfortable with the revision, he couldn't argue that it gave the story a powerful conclusion.

Eventually, I tried to think about it. I think I reinvented the three-act structure, but I don't deserve any credit for it; it was just having to write six or seven stories a month. The three-act structure is the logical way to tell a story. [Robert] McKee, [John] Truby, [Blake] Snyder have pretty much different ways of saying the same thing: You set up a problem, you complicate it, and you resolve it.

Be a journalist again for two minutes. The assignment is go over to DC and do a profile of this up-and-coming kid, O'Neil.

A description of me that I'm delighted with is "erudite hippie." I don't know what I would have made of me. I was, in many ways, a psychological train wreck; I don't know how much of that showed. I was professional, and I did have a respect for comics as an art form though I didn't think I was committing that. One of my mantras is: You have to respect it as an art form, but look at it as a job.

You look at Will Eisner or George Herriman or Walt Kelly, and you say by any reasonable criteria these are artists. That shows that the form can rise to the level of art. I would be paralyzed if I thought I had to create art. It was a problem: I had to create these story problems and I had to do it by Thursday.

Years later, you look back and see what's good. At the time that we did *Green Lantern/Green Arrow*, Neal [Adams] and I were aware that we were pushing the envelope—but I don't think either of us would have believed that 30 years later there was going to be a $75 slipcover edition.

THE AMAZING NEW ADVENTURES OF SUPERMAN

DC SUPERMAN

JAN. NO. 233
15¢

NUMBER 1

BEST-SELLING COMICS MAGAZINE!

APPROVED BY THE COMICS CODE AUTHORITY

KRYPTONITE NEVERMORE!

The Humanized Super Hero
Paul Levitz

COMICS GROW UP

Once merely a cheap entertainment for children, ubiquitously distributed and produced largely anonymously, the comic book was getting ready to change as the 1960s drew to a close. From the late '30s to mid-'50s DC had gone through the enormous burst of creativity that was termed the Golden Age of Comics and then, after a painful retrenchment, on to a second wave in the late '50s and '60s led by modernized super heroes, defining a Silver Age. But although credits had quietly begun to appear at DC, and a handful of creators had begun to have aspirations for their work, the public image of comics had been overwhelmed by the POW! BAM! ZAP! of *Batman* on television and the camp movement it embodied in popular culture. Like an exhausted sprinter doubling over after crossing the finish line, the end of the Silver Age left comics breathless. If you had asked the writers and artists of DC what the next era of comics would bring, few would have predicted it…but the Bronze Age that was dawning would at last see the recognition of comics as an unembarrassed American art form.

Maybe we think of this era as Bronze because the metal by that name is forged as the alloy of two metals, copper and tin, neither as strong separately as they are together…and in the Bronze Age of comics, neither the aging, ailing newsstand distribution nor the rising-but-still-small comic-shop network could separately support comics; but together, they allowed the field to limp through. Or perhaps it's Bronze because the key characters of the period echoed what had come before, merely polished to a new tone. Or perhaps the name is fitting simply because as the archaeological Bronze Age saw the discovery of metalworking, but not yet the sharp and powerful iron tools, this similarly named time in comics was full of discovery of creative tools that would come to full fruition afterwards.

During those days, though, it seemed more like the end times for comics. Marvel was emerging as a solid competitor in DC's home territory—the super heroes, with a new tone for the genre that had evolved in the Silver Age work of Stan Lee, Jack Kirby, and Steve Ditko—and was poised to challenge DC's control of the shrinking newsstand business. By the summer of 1968, Marvel was up to 20 titles in a month (to DC's 31), and was gaining circulation steadily at DC's expense.

SUPERMAN No. 233

Opposite: *Cover art, Neal Adams, January 1971.*

Reflecting DC's growing awareness of a fan market that prized Number Ones, this *Superman* reboot tried to create a first (issue) impression with its trade dress, while preserving the series numbering.

"BWEEEOW! WHRAAAM! COMIC BOOKS BECOME RELEVANT"

Above: *Cover, The New York Times Magazine, May 2, 1971. Featured art, cover of* Our Army at War *No. 233; pencils and inks, Joe Kubert; June 1971.*

HOUSE OF MYSTERY No. 217

Right: *Cover art, Bernie Wrightson, September 1973.*

As a young artist, Bernie Wrightson held editor Joe Orlando in high regard, remarking that "he had a way of thinking pictorially that I had never before been exposed to or would have considered. He was there, pointing me very gently in the right direction. He was very much a mentor who really cared about me. I really valued his opinion and I really treasure the experience of having worked with him."

ADVENTURE COMICS No. 436

Far right: *Cover art, Jim Aparo, November–December 1974.*

HOUSE OF MYSTERY No. 202

Below: *Interior, "House of Mystery"; script, unknown; pencils and inks, Michael Kaluta. May 1972.*

This period, when they were the primary cover artists on DC's horror titles, Michael Kaluta and Bernie Wrightson had a friendly rivalry, to see who could outdo whom each month.

WEIRD MYSTERY TALES No. 2

Opposite: *Cover art, Howard Purcell, September–October 1972.*

In the late 1960s, veteran artist Howard Purcell was commissioned to create a horror anthology that would go unrealized. The contents intended for the series—along with material meant for Jack Kirby's *Spirit World* No. 2—later became the basis for the first few *Weird Mystery* issues.

Settled in as editorial director, former star artist Carmine Infantino began to gesture with his cigar, moving beyond changing editorial staffers and talent assignments. 1967 saw *Showcase* shift to one-issue experiments, creative pilots more than actual sales tests, with series launched from there to bring new talent, genres, and projects that would have been unimaginable within the boundaries of how DC had worked only a few years before…even using reprints to test abandoned genres. And *Showcase* was only one of the shifts. Change—not one of DC's strengths in the Silver Age—had arrived.

Spider-Man artist Ditko developed *The Creeper* and the politically conscious *The Hawk and the Dove*; Joe Simon tried to capture the hippie culture in *Brother Power the Geek*; Howie Post returned after more than a decade's absence to explore the prehistoric world with *Anthro*; and on and on. The radical experiments mostly vanished as quickly as they arrived…often canceled after a handful of issues as results from the declining newsstands came in… but characters and ideas introduced there would remain beloved parts of DC's mythos for decades afterward.

Entire genres were wiped out or altered beyond recognition. After two decades as one of the pillars of the DC line, funny animals vanished with the end of *The Fox and the Crow*, and new teen titles blossomed, with updated DC offering *Leave It to Binky* and a new star, *Debbi*. With families having shifted from the cities to suburbia, little children were no longer going past newsstands with their mothers as often, so titles that could appeal to adolescents took their place.

But the biggest contributors were the vaguely science-fiction and monster-mystery titles changed to Joe Orlando's *House of Mystery* style, an "EC Comics lite" based on his elfin "whistling past the graveyard" approach that incorporated kids into scary covers (and often stories) that pressed the boundaries of the Comics Code. Orlando had been an EC artist, acclaimed by fans for his horror and science fiction work, but before settling down as a DC editor, had done mostly humor work for *MAD* magazine and DC projects like *Scooter* and *Inferior Five*. Even if the Code won most of its collisions with Orlando and the editors who followed in his wake, his genre titles were so much the rent payer of the early '70s that even venerable *Adventure Comics* briefly became *Weird Adventure Comics*, joining *Weird Western*, *Weird Mystery*,

WONDER WOMAN No. 191

Far left: *Cover art, Mike Sekowsky and Dick Giordano, November–December 1970.*

The transformation of Wonder Woman from costumed crime fighter to mod heroine coincided with the rise of artist-driven series. Initially a co-plotter and artist on *Wonder Woman*, Mike Sekowsky rose quickly to become editor and writer as well, bringing his talent to bear on established features and new creations alike.

OUR ARMY AT WAR No. 278

Left: *Cover art, Joe Kubert, March 1975.*

When Joe Kubert replaced Bob Kanigher as editor of DC's war books in 1968, he insisted on maintaining their long-time collaboration, retaining Kanigher as the line's primary writer. Overcoming any initial awkwardness, the two men maintained the inverted relationship for nearly two more decades.

Weird Worlds, and even *Weird War*. The stories within were short, often clichéd, but occasionally moving and memorable. So much so that decades later the diversely talented DC alumnus Neil Gaiman would collect a Newberry Award for children's literature for his *The Graveyard Book*, and acknowledge its grounding in the *House of Mystery* tales he loved (married with the influence of Rudyard Kipling's epic, *The Jungle Book*, of course).

The Bat-craze that had swept the country was sweeping away as fast as it had arrived. The staying power of fads in the 1960s was slight, and it was no longer enough to squeeze Batman onto a cover to sell a comic. New answers were needed.

Experimenting with content wasn't enough: It was also a time to change working methods. Infantino sped up the change toward putting power in the hands of the talent by trying a freelance editor structure, building on the part-time deal he'd made to bring legendary artist Joe Kubert behind an editor's desk over the war comics he'd long contributed to, and giving Mike Sekowsky control over *Wonder Woman* as its penciller in 1968. And if artists were to be celebrated, why not see how far that could be taken? *DC Special* was launched, providing another test vehicle (albeit a reprint-driven one) and starting with an issue that made Infantino himself the star, as Stan Lee was doing.

NOTES FROM THE UNDERGROUND

As DC unpacked in its offices in the new 909 Third Avenue building, across the country another experiment critical to the future of American comics took place: In San Francisco's Haight-Ashbury district, Robert Crumb self-published *Zap Comix* No. 1, the breakthrough underground comix. In the anarchic '60s, bypassing the "establishment" publishers to achieve creative freedom was more important to some artists than immediate economic rewards, and Crumb and his fellow creators in the underground movement clearly had stories to tell that would never have been approved under the Comics Code or even in many communities due to local obscenity and libel laws. The undergrounds were unconventional, anti-establishment, often celebrating sexual freedom and drug culture…but they demonstrated that comics could be powerful with a wider range of styles and themes than had ever been allowed in American comics. And although they were largely produced out of passion rather

ZAP COMIX No. 1

Above: *Cover art, Robert Crumb, 1968.*

The counterculture of the 1960s gave birth to "underground comix"—a term coined by EC Comics fan and future DC staffer Bhob Stewart. Small-press and self-published artists like Crumb, Gilbert Shelton, Vaughn Bodé, Rick Griffin, and Robert Williams quickly gained an audience, breaking creative and cultural barriers—and ignoring the Comics Code Authority—along the way.

DC SPECIAL No. 6

Opposite: *Cover art, Neal Adams, January–March 1970.*

TEEN TITANS No. 20

Above: Interior, "Titans Fit the Battle of Jericho"; script and pencils, Neal Adams; inks, Nick Cardy. March–April 1969.

A rejected Len Wein–Marv Wolfman story was revised by Neal Adams, introducing a new hero named Joshua while incorporating as many of artist Nick Cardy's finished pages as possible.

TEEN TITANS No. 19

Opposite: *Cover art, Nick Cardy, January–February 1969.*

Much as young Jim Shooter had brought a more authentic voice to the Legion of Super-Heroes a few years earlier, youthful writers like Marv Wolfman, Len Wein, and Mike Friedrich were poised to revitalize *Teen Titans* under new editor Dick Giordano.

TEEN TITANS No. 20

Above left: *Cover art, Nick Cardy, March–April 1969.*

WITZEND No. 1

Below: *Cover art, Archie Goodwin (layout) and Wally Wood, summer 1966.*

witzend, which Wood started in 1966, was a showcase for veteran artists eager to break free of mainstream comics' confines—many of them, like "Woody," industry giants: Gil Kane, Al Williamson, Frank Frazetta, Reed Crandall, and others.

than sound business models, the fact that their creators could control their copyrights became a tempting goal for more mainstream talent.

More important for the future of comics, some of the distributors who began selling these undergrounds were dealers in back-issue comics, inexpensive "collector's items" like *Action Comics* No. 1 (still available at that time for as little as $100, less than .0001% of its current value). The combined opportunity for selling back issues, undergrounds, even some of the more sophisticated and well-produced fanzines like *witzend*, led a few dealers to believe there was money to be made selling new comics as well. Dealers worked out arrangements to buy from their local newsstand wholesalers and opened the first comic shops, usually selling comics from their own collections as their first stock and to provide capital. *Zap!* pointed to a future beyond the Bronze Age, empowering talent in a way that would pay off big for their successors two decades later, and offering counterculture retailers running comic shops and head shops a first hint of the excitement unleashed creativity could provide.

The wider culture was shifting too, and DC took its first, halting steps to keep pace. A perfect example of the contradictory moment can be found in *Teen Titans*. Newly arrived from Charlton Comics, Dick Giordano had taken over as editor from George Kashdan and tried new, younger writers in place of Bob Haney, who had guided the series from its inception. Fans-turned-pros Marv Wolfman and Len Wein did a story featuring a Russian communist superhero teen, and then returned with a multipart story that would feature an African American hero. At some point after longtime *Titans* artist Nick Cardy started pencilling the tale, the company changed its mind about proceeding— and Neal Adams was brought in to rewrite and redraw "The Titans Fit the Battle of Jericho" without a character who might offend Southern wholesalers. Wolfman and Wein were sidelined for a while, but would soon return to important roles at DC...perhaps none as important as when they would again join forces on *Teen Titans* at the end of the Bronze Age.

By 1970, the last economic marker of the Silver Age disappeared as comics moved from 12 cents to 15 cents, and three seismic changes were on the horizon. Two were big decisions, reflected in multiple titles...and the third was a little experiment that many fans point to as the official moment the ages shifted.

JACK KIRBY HOUSE AD

Top: *Lettering, Gaspar Saladino, July 1970.*

SUPERMAN No. 234

Above: *Cover art, Neal Adams, February 1971.*

In the interest of greater suspense and character vulnerability, Superman's awesome powers were progressively scaled back in a 1971 story line.

SUPERMAN'S PAL JIMMY OLSEN No. 146

Opposite: *Original cover art, Jack Kirby and Mike Royer, February 1972.*

Jack Kirby's arrival at DC was explosive, so much so that a skittish Carmine Infantino assigned Neal Adams to draw the covers on many of Kirby's *Jimmy Olsen* issues, intending to maintain continuity with the more familiar Superman look. Even on the covers that Kirby actually drew, Murphy Anderson sometimes redrew Superman's face.

The first shift was the retirement of longtime editor Mort Weisinger, whose Superman family had paid DC's bills for two decades. *Superman* sales were slipping, and the days when his appearance in a *Lois Lane* comic was enough to allow it to outsell *Batman* were over. The line was split up, with Weisinger's old fanzine buddy, Julius "Julie" Schwartz, taking over *Superman* and *World's Finest* (promptly converted into a Superman team-up book with Batman banished), and the other titles spread among the staff.

Schwartz's success at revitalizing heroes had kicked off the Silver Age, and Infantino hoped he could do it again. Schwartz's approach was to modernize Superman by making him a television reporter, reduce his powers somewhat, and generally humanize the stories under new lead writer Denny O'Neil, who famously mused, "How do you write stories about a guy who can destroy a galaxy by listening hard?" Lead penciller Curt Swan was paired with Murphy Anderson on inks, to create the "Swanderson" look…a bolder version of the familiar hero.

The other big shift at DC was the arrival of Kirby, fresh from a decade of phenomenal success, after disagreements with Lee over credit for their work together—and, invariably, over money. Kirby had a hand in developing virtually all the titles that were challenging DC's fading dominance of the newsstands, and the excitement around his switch was palpable. "Kirby Is Coming" tags snuck into the margins, and fans began to debate which titles he should pencil, and then were shocked to hear he was going to write and edit his books as well, starting with the weakest of the Superman books, *Jimmy Olsen*. Marketed as a star talent (curiously, the first artist to receive such treatment since DC had singled out him and his old collaborator, Joe Simon, in the 1940s), Kirby began introducing new elements to the DC Universe, building toward the introduction of a trio of new titles based on a complex mythology he called the Fourth World. *New Gods*, *Forever People*, and *Mister Miracle* were the first comics to tell an interlocking tale and simultaneously introduce a new connected cast—a clear forerunner to how much of comics would function after the Bronze Age.

The story was built on a galactic scale, with the leaders of opposing worlds of gods trading their children in a pact to bring peace…and when that was broken by Darkseid of Apokolips' betrayal, a universal war came to Earth, as

As if in **ANSWER** to its attacker, the wooden ship blasts **OPEN!** and **SOMETHING** inside **RUSHES** out into the calamitous night--- singing and shining and sleek and deadly!!! What Lightray has "IMPRINTED" on the "LIFE CUBE" is now fully "GROWN!" and it carries on its GLISTENING warhead the LIVING --the DEAD -- and the FIERY trumpets of the SOURCE!!!

"IF WE MUST DIE! LET NEW GENESIS LIVE!!"

"IF WE GO TO THE SOURCE --YOU DEMONS GO WITH US!!!"

THE NEW GODS No. 6

Opposite: *Interior, "The Glory Boat"; script and pencils, Jack Kirby; inks, Mike Royer. December 1971–January 1972.*

FOREVER PEOPLE No. 4

Left: *Interior, "The Kingdom of the Damned"; script and pencils, Jack Kirby; inks, Vince Colletta. August–September 1971.*

"The kids at Yale think Kirby's new books are more tuned in to them than any other media. They're reading transcripts from *New Gods* over their radio station. The Kirby books are a conscious attempt to show what things look like when you're out where the kids are. The colleges, the influence of the drug culture. We're showing them basically what they're seeing. We're turning into what they're experiencing." —Carmine Infantino

Darkseid came in search of the Anti-Life Equation. The concepts were enormous, and would fuel generations of creators in comics and other media. Getting Kirby was a coup, for not only was a legend working on a passion project of his own, but he remained among the fastest artists in the field, meaning he'd have impact across many books. To many of his fans, the Fourth World would be the high water mark in Kirby's astounding four decades in comics.

For all his characters' bravado—and his own toughness honed on the streets of New York and in combat during World War II—Kirby preferred not to take work from other artists, and if he could, not to work on other people's ideas. For him, the shift to DC was about finally about doing his own thing, in the jargon of the moment, after having been the nominal junior partner in two of comics' most successful partnerships ever. With Simon he had created the first spectacularly successful patriotic comics character, Captain America, and the enormously profitable genre of romance comics. With Lee, he had produced a seemingly infinite stream of heroes and ideas that would fuel the competition for decades. This was going to be *his* moment.

Kirby's arrival also broke another established DC tradition: For the first time an editor worked from outside the building, and the writing and artwork for a mainstream DC title was produced across the country, where Kirby had settled in California. The funny animal comics that had been based on cartoons had often been drawn by California artists who were moonlighting animators, but the move with Kirby placed DC's production at the occasional mercy of the United States Postal Service—in an era before Federal Express, much less digital transmission—and beyond easy supervision or input from others.

A RADICAL MOMENT

A seemingly smaller step was to gamble with *Green Lantern*, which like most of the super-hero books was suffering. Schwartz gave the assignment to Denny O'Neil, and added Green Arrow as a costar and combative voice. O'Neil was a former journalist, who had begun to work in comics after returning from a Vietnam-era stint in the Navy. He was joined by rising-star artist Neal Adams, and together they would hit their creative peaks and forever change the voice of comics. Green Lantern was recast as the

JACK KIRBY

Above: *Photograph, Jack Kirby at home in Southern California, 1971.*

MISTER MIRACLE No. 6

Below: *Cover art, Jack Kirby and Mike Royer, January–February 1972.*

The former escape artist career of cartoonist Jim Steranko served as Jack Kirby's inspiration for Mister Miracle.

GREEN LANTERN No. 76

Right: *Interior, "No Evil Shall Escape My Sight"; script, Denny O'Neil; pencils and inks, Neal Adams. April 1970.*

These are probably the most reprinted panels from any DC story.

GREEN LANTERN No. 86

Above: *Interior, "They Say It'll Kill Me…But They Won't Say When"; script, Denny O'Neil; pencils, Neal Adams; inks, Dick Giordano. October–November 1971.*

Dealing with issues like addiction in *Green Lantern/Green Arrow* led to a modernization of the Comics Code.

GREEN LANTERN No. 86

Opposite: *Cover art, Neal Adams, October–November 1971.*

Though award winning and attention getting, "relevance" couldn't save *Green Lantern*, and the book expired with No. 89 (April–May 1972).

cosmic cop, not fully aware of the consequences of his actions and priorities as he followed the dictates of the distant Guardians, and Green Arrow was his liberal conscience. Over the next dozen or so stories, O'Neil and Adams would discuss racism, overpopulation, treatment of American Indians, ecology, and women's liberation, bringing a level of enlightenment to the forefront at DC and winning every prize the comics industry had available. One story even introduced the character of John Stewart as the designated substitute for Earth's regular Green Lantern, Hal Jordan…and Stewart was an unemployed black architect.

O'Neil and Adams were joined on many issues by Dick Giordano, who left his editorial desk to become Adams' studio partner and DC's premier inker. A poignant story revealing that Green Arrow's sidekick, Speedy, had become a heroin addict received national press. But the real story behind the scenes was DC pushing back on the restrictive Comics Code to force approval of *Green Lantern/Green Arrow* No. 85, thus forcing major changes in the Code for the first time since its institution in 1955.

Collaborations like O'Neil and Adams', though often fraught with tension between the contributors, were indicative of another major change since the Silver Age. The writers and artists knew each other, and often connected outside the control (or even knowledge) of their editors. They brought new levels of personal commitment to their work beyond the quiet professional dedication of the previous generation, and often an overt agenda of subjects they wanted to bring to readers' attention. The coffee room attached to DC's offices at 909 Third Avenue became a crucible of change.

The formality of DC's offices in the Silver Age broke down: Infantino and the new generation of editors tolerated life-drawing classes for the artists in the coffee room, and long discussions of what the potential of comics could be, as more and more of the freelance talent pool were young people who had grown up loving comics, and wanting to make their own. Most of the masterminds of the first two eras of DC's history had aspired to be newspaper cartoonists, or writers in other media…now the balance was tipping to people who had grown up on comic books, and wanted to help them break away from the last remnants of the 1950s witch hunt that had led to the Comics Code and a culture of caution.

TARZAN No. 209

Opposite: *Interior, "Origin of the Ape Man Book Three: A Mate For the Ape Man"; script and art, Joe Kubert. June 1972.*

"What I want is the kind of illustration that will engender the same kind of excitement in my readers as it did me when I was a kid," Joe Kubert explained in a 1974 interview. "I tried to analyze the elements in the old *Tarzan* strips to find out just what it was in the old [Hal] Foster that created this effect in me, so many years ago. I decided that it was a matter of simplification and directness."

The marketplace for these ideas remained a very difficult one: It took months to get sales figures back from the newsstands, and when they came in they were usually depressing. Most new ideas did poorly, often getting lost in the overcrowded and unorganized comics spinner racks...and even a heavily marketed (for comics) project like Kirby's Fourth World could be canceled before it was completed, simply because it didn't live up to the company's hopes that Kirby could immediately duplicate his triumphant sales of the previous decade.

INNOVATION DESPITE FRUSTRATION

The early 1970s saw other creative high points for DC as the company relocated to 75 Rockefeller Plaza, moving in with its parent company, Warner Communications. Len Wein and Bernie Wrightson created Swamp Thing for a short story in *House of Secrets*, then took him into his own title, with extraordinary sales as the mystery genre titles continued to expand and flourish. John Albano and Tony DeZuniga launched Jonah Hex in a revived *All-Star Western*, and DeZuniga's reception opened the door to a generation of his fellow Filipino artists, who brought with them a detailed illustrative style new to American comics. Joe Kubert did a stunning run of Tarzan adaptations as the Edgar Rice Burroughs stable of characters shifted to DC from fading rival Western Publishing (whose deal to publish through Dell had ended, leading it to market its comics under its own Gold Key label for a number of years). Even Superman's old rival, Captain Marvel, joined the fold in *Shazam!* Kirby moved on from the Fourth World to a post-cataclysmic world starring *Kamandi, the Last Boy on Earth*, and writer-editor Archie Goodwin worked on the acclaimed Manhunter series with Walter Simonson.

The last talent to update Manhunter, Joe Simon, even returned to edit a handful of new experiments (including a new approach to the romance comics he'd helped invent), and to join forces with Kirby for one last time on a new *Sandman*. Some of these projects came from returning vets, like original *Captain Marvel* artist C. C. Beck on *Shazam!*, and even Infantino stepped in to draw the first story of the Human Target for the back of *Action Comics*, introducing the detective who would star on television.

HOUSE OF SECRETS No. 92

Left: *Interior, "Swamp Thing"; script, Len Wein; pencils and inks, Bernie Wrightson. June–July 1971.*

Bernie Wrightson agreed to draw the first "Swamp Thing" short story knowing he had a very short deadline. To speed up the process, he photographed many scenes for reference, casting Louise Jones (later Simonson) as Linda Olsen, and Michael Kaluta as Damian Ridge.

ALL-STAR WESTERN No. 10

Above: *Cover art, Tony DeZuniga, February–March 1972.*

"Carmine and I found out that the word 'Weird' sold well. So we started creating *Weird War*, *Weird Western*, and out of *Weird Western* came Jonah Hex....I told John [Albano], 'John, give me a weird concept for Westerns.' And I had certain writers that I could rely on to deliver interesting concepts. It was like ordering pizza pie. You know, with tomatoes or without, vegetable or salami?" —Joe Orlando

THE SANDMAN No. 1

Right: *Interior, "The Sandman"; script, Joe Simon; pencils, Jack Kirby; inks, Mike Royer. Winter 1973–1974.*

While at DC in the 1940s, Kirby and partner Joe Simon took over the *Adventure Comics* feature The Sandman for several issues. Later, artist-editor Kirby reunited with Simon for old times' sake, developing another iteration of the Sandman, which had no connection to any previous version. Their single effort sold well and inspired a brief series that was less successful. Kirby didn't edit the rest, and contributed only covers and most issues' interior pencils.

ACTION COMICS No. 419

Opposite: *Interior, "The Assassin-Express Contract!"; script, Len Wein; pencils, Carmine Infantino; inks, Dick Giordano. December 1972.*

Reworking a concept originally intended for 1968's Jonny Double, Len Wein's Human Target was a detective who disguised himself as his clients.

SHAZAM IS COMING

Above: *Promotional button, Fall 1972.*

RIP VAN MARVEL

Below: *Photograph, C.C. Beck and Julius Schwartz, by Jack Adler, 1972.*

After DC acquired the rights to Fawcett's late Captain Marvel, editor Julius Schwartz mulled possibilities for an artist with an eye toward DC regulars. Kurt Schaffenberger seemed a natural choice given his long association with the *Marvel Family* comic book, while Bob Oksner's ability to shift between humorous and dramatic made him a good prospect. The discovery of C.C. Beck's phone number led to an offer being extended to the Big Red Cheese's original artist, and—*Shazam!*—a short-lived partnership began. Creative differences prompted Beck's departure within a year, with Schaffenberger and Oksner ably succeeding him.

More and more of the creative work, though, was coming from a new generation of comics fans turned pros. Silver Age editors had used their letter columns to connect the thinly scattered serious readers of comics, and once united, they began to create their own social network of sorts. Fans used primitive technologies to put out their own magazines, often as crude and unconventional as Russian samizdat, and then began to assemble in the conventions they ran. And a lot of the fans didn't just love reading and collecting comics—they were creative folks who wanted to write and draw, as well. *Game of Thrones* author George R. R. Martin would proudly display his badge from the first comic convention almost five decades later, boasting that its serial number one meant he was officially the first comic fan.

I was one of these fans, and at the age of 16 I gave up my fanzine publishing and took over DC letters columns and fan pages like *Direct Currents*, beginning a career that would lead to being DC's publisher for two decades, and president and publisher for the last seven of those years. As the new "house fan" I arrived just in time to advise the company that a proposal from New York Comic-Con impresario Phil Seuling to distribute directly to the growing comic shops could be a good plan. This would provide a way around the failing newsstand system, and one more oriented to the sales potential of individual talent.

The changed attitudes of a younger generation changed the business, too: With fan recognition of credits and art styles, original artwork acquired value, and artists wanted it returned to them after publication. The company had begun warehousing old art instead of destroying it, and after agitation by the talent community (notably led by Adams), Infantino opened the warehouse and returned all the art that had survived, as well as current production.

There were fondly remembered developments beyond the drawing boards, as well: new formats for reprints (and a new technique developed by longtime production wizard Jack Adler for reprinting stories from before the fateful decision to preserve the negatives allowed restoration of Golden Age material) including *100-Page Super-Spectacular* comics and giant tabloid editions. And beyond the DC offices as well, new television programs debuted starring the Justice League as the cartoon *Super Friends*; *Shazam!*, starring Jackson Bostwick; and *Wonder Woman*, starring Lynda Carter.

"BEFORE WE GET DOWN TO BUSINESS, A TOAST-- LONG LIFE!!"

"IT'S MOUTON ROTHSCHILD '29-- AN EXCEPTIONAL YEAR!"

"I'VE BEEN SAVING IT FOR A SPECIAL--"

BLAM CHINKLE! BLAM KRAASH

"PARDON THE UNTIMELY INTERRUPTION--"

"THAT SORT OF THING HAPPENS AROUND HERE ALL THE TIME!"

JOURNEY INTO DANGER WITH... CHRISTOPHER CHANCE-- A MAN OF STEEL-HARD NERVES AND HAIR-TRIGGER REFLEXES--WHO STANDS IN FOR PEOPLE MARKED FOR *MURDER*... IN THE HOPE THAT HE CAN *STOP A KILLER*-- BEFORE THE KILLER STOPS *HIM!*

THE HUMAN TARGET
THE ASSASSIN-EXPRESS CONTRACT!

A NEW **ACTION-PLUS** FEATURE BY: LEN WEIN--WRITER; CARMINE INFANTINO & DICK GIORDANO--ARTISTS

Ms.

GLORIA STEINEM ON HOW WOMEN VOTE

MONEY FOR HOUSEWORK

NEW FEMINIST: SIMONE DE BEAUVOIR

BODY HAIR: THE LAST FRONTIER

WONDER WOMAN FOR PRESIDENT

JULY/1972 $1.00

PEACE AND JUSTICE IN '72

THE SUPER FRIENDS

Left: *Wonder Dog, Aquaman, Robin, Batman, Superman, Wonder Woman, Wendy, and Marvin,* 1973.

The increasing disconnect between the audience for cartoon "kidvid" and the older comics fan base was becoming apparent. TV's smash-hit Justice League for juveniles did not confer its success on its comics adaptation.

A generation would grow up on slightly different versions of *Super Friends* produced by Hanna-Barbera, the leading TV animation house, but with Saturday-morning television being the prime time for kids, it was a perfect introduction to the heroes of the Justice League. Whether on their own or assisted by characters H-B writers added—like Wendy, Marvin, and Gleek (to make the show more kid friendly) or Black Vulcan and Apache Chief (to make it more ethnically balanced)—the melodramatic tones of *Super Friends* programmed new readers' ideas of what the DC heroes were. Working with inexpensive animation techniques, the visual excitement was rarely a match for the worlds routinely being blown up in the comics, but the dynamics of motion and voice acting made up for it...at least for the under-12 set.

Lynda Carter, a beauty queen with athletic gifts, brought Wonder Woman to life in a show that went through two networks and several identities, switching from World War II period stories to contemporary ones, but somehow always connecting with the ideals the character represented. Wonder Woman fan No. 1, Gloria Steinem, had already featured her on the first cover of *Ms.* magazine, and the show served to further connect the Amazon Princess with the women's movement as an icon.

BUSINESS AS UNUSUAL

Infantino was named publisher and then president during a very competitive period. DC briefly tried to move comics back to a larger format at 48 pages for 25 cents, only to have Marvel offer wholesalers a deeper discount on 20-cent 32-pagers. DC was forced to match the price, and the publishers were fated to permanently survive on thinner margins. Marvel took advantage of this moment to surpass DC in title production for the first time since 1957, and in sales for the first time ever.

With newsstand sales slipping, Bill Gaines was even invited to help the DC executive team, visiting once a week from his office at the now more-successful *MAD* magazine (which ironically had come under the same corporate umbrella through a series of financial maneuvers in the 1960s after becoming the last surviving part of the company Bill's father, Max, had run in partnership with DC in the 1940s), but it wasn't enough. Infantino

WONDER WOMAN LIVES!

Above: *Photograph, Lynda Carter as Wonder Woman,* 1975.

Although a 1974 *Wonder Woman* TV movie starring Cathy Lee Crosby had earned strong ratings, it played down the costume and lore that had originally made the Amazing Amazon such a success. It took a more traditional approach—and Lynda Carter's casting—to make Wonder Woman a true film phenomenon.

WONDER WOMAN FOR PRESIDENT

Opposite: *Cover,* Ms. *magazine No. 1; art, Murphy Anderson, July 1972.*

IT'S A MAD, MAD WORLD

Left: *Photograph, William M. Gaines, 1970.*

William Gaines took his *MAD* team on annual trips abroad, beginning with an impromptu 1960 jaunt to Haiti in which the crew knocked on the door of its lone subscriber in the country and begged him to re-subscribe.

SUPERMAN VS. THE AMAZING SPIDER-MAN No. 1

Opposite: *Cover art, Carmine Infantino (layout), Ross Andru (pencils), Dick Giordano (inks), and Terry Austin (backgrounds), 1976.*

The most familiar of the extraordinary comics formats is the 11-by-17-inch trim, called "tabloid," at which size DC published a number of well-remembered special editions. Best-loved of these was the unprecedented "teaming" of the Big Two major publishers' flagship heroes—so successful that it led to many more such crossovers over the years.

THE COMICS JOURNAL No. 37

Above: *Interior cartoon, W. M. Neville and Sam de la Rosa, December 1977.*

This cartoon, which accompanied a 1977 interview with Jenette Kahn just a year into her two-and-a-half decade tenure at DC, lampoons the transition from Carmine Infantino to DC's young female publisher, with caricatures of editors Julius Schwartz and E. Nelson Bridwell peering nervously from behind the door.

would continue with more experiments and recruiting: allowing Batman to meet his pulp inspiration, the Shadow; trying sword and sorcery to match the success of *Conan*; bringing in writer-editor Gerry Conway to revive or launch a new batch of heroic titles.

Finally, Infantino teamed up with Marvel for an original, if previously unthinkable, collaboration: a tabloid *Superman vs. Spider-Man* by Conway, Ross Andru, and Giordano. Up until then the tabloid format had been principally used for reprints, or inexpensive ventures that might benefit from its obviously larger presence on a newsstand. But this was a project of ambition: Conway and Andru had each had successful runs on both characters, and so were a natural combination, and they took full advantage of the double-size canvas that the tabloid pages represented as well as the unprecedented 96-page length. The project got significant press coverage, and in many ways was the first "event" comic—a creative and marketing model that would become more important over ensuing decades. It was the capstone of Infantino's tenure: a massive sales success published just as his executive career ended.

A NEW WORLD ORDER

Replacing Infantino in 1976 was a balance of experience and the improbable: 55-year-old production exec Sol Harrison, who had worked on National's very first comics as a color separator before being moved up to president. He was teamed with an unlikely equal partner as publisher: a 28-year-old woman from outside comics, Jenette Kahn. Kahn came in with a track record from *Kids*, *Dynamite*, and *Smash* magazines, creative and commercial successes with the children who had long been the core of comics' audiences. But she also came in with a style uniquely her own, a respect for artistic creativity forged in time spent with Milton Glaser, Andy Warhol, and at the Museum of Modern Art…and a mandate for further experimentation. Kahn's world was a moveable salon of talent from different fields—artists, athletes, politicians, and scientists, many of whom she ultimately connected to the comics.

Within her first year, Kahn changed the company's name from National Periodical Publications to the more familiar and fan-friendly DC Comics, commissioned a new DC symbol from legendary designer Glaser (whose work included the "I ♥ NY" icon), and overturned decades of precedent by

DC AND MARVEL PRESENT

THE GREATEST SUPERHERO TEAM-UP OF ALL TIME!

THE BATTLE OF THE CENTURY

SUPERMAN VS the AMAZING SPIDER-MAN

$2.00

37995

THE DC EXPLOSION

Left: *Art, Jim Aparo and unknown, 1978.*

THE NEW DC

Below: *Logo, Milton Glaser, 1976.*

Glaser upgraded DC's logo with a bold starred border, the color of which could be changed to complement any cover it appeared on.

BLACK LIGHTNING No. 1

Opposite: *Cover art, Rich Buckler and Frank Springer, April 1977.*

African Americans began to achieve exposure as action stars in "blaxploitation" films, beginning with 1971's *Shaft*. The comics soon saw the potential for similar heroes in spandex. DC's first offering was Black Lightning, written initially by Tony Isabella and drawn by Trevor von Eeden.

THE GREATEST OF ALL TIME

Below: *Publicity photo, Muhammad Ali as Superman, ca. 1977.*

giving talent equity in new characters created for the line. This change, while invisible to the public, began a critical shift in the search for a new future for comics. Combining her own frustrations with the deals for the magazines she had created before coming to DC, with the feedback she was hearing from writers and artists influenced by the underground movement and the counterculture itself, she made them stakeholders in the company's success.

The pace of change forced by the newsstand shifts accelerated: Formats were adjusted, titles changed, the fading romance and teen lines were canceled and efforts were concentrated on the heroes, war, and mystery lines. Less obvious changes happened as well: Orlando became the managing editor, now backed up by a mixture of veterans like Schwartz and a host of younger editors; new titles that would have been taboo a few years before were introduced, like *Black Lightning* and *Men of War*, featuring Code Name: Gravedigger...and the unique tabloid *Superman vs. Muhammad Ali*, by Adams and O'Neil.

Behind-the-scenes creative arguments made *Superman vs. Muhammad Ali* as colorful as any of the champ's fights, and the last time the two top talents crafting it would collaborate. But the result was a unique project, even down to the ringside crowd featured on the cover, where every visible attendee was a caricature of a distinct person—from U.S. President Jimmy Carter to DC staffers and Warner executives.

As the population shifted to suburbia and chain stores were less welcoming homes for spinner racks, newsstands continued to vanish as a place to sell comics. This combined with a rough winter in 1977 to drive returns of unsold copies way up, and forced a famous "DC Implosion" the next summer—an abrupt retreat from many of Kahn's expansion plans. The line (and the staff) shrank to its smallest size in decades...until it was saved by Superman.

YOU'LL BELIEVE A MAN CAN FLY!

Producer Alexander Salkind obtained the right to make a Superman movie in 1974, subject to an astounding list of controls by DC, including a requirement to offer it to DC's now-affiliated Warner Bros. for distribution. A long search led to Christopher Reeve as the new Man of Steel. He was unknown enough that on his first visit to DC's offices no one blinked at the

SUPERMAN THE MOVIE

Opposite: *Poster, Warner Bros. Pictures, 1978.*

In 1978, there had never been anything like the first, smash-hit *Superman* film, with its state-of-the-art effects and star-studded cast. Most happily for comics fans, it restored the Man of Steel's popularity, and led to long-deferred public recognition of Siegel and Shuster as the character's creators.

THE GREAT SUPERMAN MOVIE CONTEST

Right: *Photograph, left to right, Jenette Kahn, Christopher Reeve, and Sol Harrison, 1977.*

Superman No. 314 contained entry instructions for a sweepstakes offering two chances to be an extra in the *Superman* movie. The winners, Edward Finneran and Tim Hussey, were chosen by Christopher Reeve himself, in a random drawing held at DC's offices.

WIRE WORK ON 57TH STREET

Above: *Photograph, on location for* Superman, *New York City, July 19, 1977.*

"'You will be picked up at 7 P.M. and taken to a spot 25 minutes away by car. Where? We can't tell you that. We will say only that it is not on the island of Manhattan.' Mission: Impossible? No, just a reporter being escorted last week to the set of Superman, possibly the most supersecret, superpublicized movie ever to be shot—at least within 25 minutes of midtown Manhattan." — *Time* magazine, 1977

tall, thin young man, but was charismatic enough that by his second trip, after his casting was announced, he had to run a gantlet of young women to leave. *Godfather* novelist Mario Puzo haunted the halls as well, as he worked on the film treatment.

Sections of the movie were filmed in New York, with the *Daily News* headquarters transformed into the *Daily Planet*, and Reeve being hoisted on a crane to pluck a cat burglar off an office tower on West 57th Street. The technology to depict Superman's powers had changed radically since the 1950s television series, and the more lavish budgets for the film unleashed its potential...but there was still no way of predicting how it would all turn out, and whether audiences would respond.

More visitors, more discussions, and at Christmas 1978 director Richard Donner's *Superman* premiered. "You'll believe a man can fly!" announced the posters and ads, and we did. Coming a year after George Lucas' *Star Wars*, *Superman* demonstrated that the classic heroes of the comics remained important modern myths, and that when taken seriously by filmmakers, they would be taken seriously by a wide audience.

The merchandising money started flowing again in the film's wake, a new *World's Greatest Superheroes* newspaper strip launched in 1978, and *Superman II* was already in progress, thanks to Salkind's unusual production technique of working on sequel filming simultaneously. Media opportunities expanded as well, with a new *Plastic Man* cartoon series joining the long-running *Super Friends* on Saturday-morning television, and the company breathed a sigh of relief.

The publishing side of the business, though, was the weaker link, so some new thinking was called for. *Roots* had brought the television miniseries format into blockbuster territory, so a miniseries for comics seemed like a natural extension, breaking the ongoing magazine publishing model in search of better results. Leftover material from an Implosion-canceled *Showcase* revival, a three-issue *World of Krypton* crafted by Paul Kupperberg and Howard Chaykin for editor and DC myth master E. Nelson Bridwell, became the first comics limited series in 1979, and gave the industry a new and enduring business model. Difficult as it is to conceive from a vantage point three decades later, the possibility of doing finite stories that had perhaps permanent end points

SUPERMAN
THE MOVIE

ALEXANDER SALKIND PRESENTS MARLON BRANDO GENE HACKMAN IN A RICHARD DONNER FILM
CHRISTOPHER REEVE · NED BEATTY · JACKIE COOPER · GLENN FORD · TREVOR HOWARD
MARGOT KIDDER · VALERIE PERRINE · MARIA SCHELL · TERENCE STAMP · PHYLLIS THAXTER · SUSANNAH YORK
DIRECTED BY RICHARD DONNER · PANAVISION "TECHNICOLOR" DIRECTOR OF PHOTOGRAPHY GEOFFREY UNSWORTH B.S.C

A Warner Communications Company

DOLBY STEREO

THE WORLD'S GREATEST SUPERHEROES

Right: *Newspaper strip; script, Martin Pasko; pencils, George Tuska; inks, Vince Colletta. April 9, 1978.*

Several years after the cancellation of the *Batman* newspaper strip, DC returned to that arena with a feature starring the Justice League of America and other heroes like Robin and Black Lightning. The focus shifted to Superman in 1979 to capitalize on the blockbuster movie but heroes like Batman, Wonder Woman, and the Flash continued to guest-star for a time. Ultimately re-titled *Superman*, the strip ended in 1985.

WORLD OF KRYPTON No. 3

Above: *Cover art, Ross Andru and Dick Giordano, September 1979.*

As caretaker of Superman's continuity, E. Nelson Bridwell had sifted through years of disparate stories to develop a consistent history of the Man of Steel's home planet when the fabulous "World of Krypton" backup series began in 1970. That research later formed the backbone of 1979's miniseries and its spotlight on Superman's father, Jor-El.

was a new idea to American comics, which had grown up creatively entirely in the shadow of the pulps—a magazine mentality that said endless iterations of a character's adventures were the ideal. The first miniseries designed for the form was one I edited, *The Untold Legend of the Batman*, crafted by Wein, John Byrne, and Jim Aparo. And in a further effort to find new distribution, a *Superboy Spectacular* was produced for Random House's in-school book club program, and offered to comic shops but not to newsstands.

The comic shops were rapidly becoming the only growth area for DC's publishing program, and although still just 10% of the business, they became more and more the focus for the future. There were only a few hundred of them scattered across the country, almost all opened with very little investment by young comic fans who viewed them as a cross between bookstores and sports bars: places where people could come to get the entertainment they enjoyed, but also hang out and talk about it with like-minded folks. This was an audience more committed to comics, and waiting for DC to publish titles with them in mind.

Understanding the tastes of this emerging audience, Wein recruited his lifelong friend Marv Wolfman (they had taken the Silver Age DC tours together, collaborated on early comics work, and each done stints as editor-in-chief of the Marvel comics line) and rising team-book artist George Pérez to relaunch *Teen Titans*. Mixing a touch of romance with classic heroic melodrama, and adding distinctive new characters Cyborg, Raven, and Starfire to the sidekicks, all tuned for the slightly older comic shop customers, they created a title that would be DC's sales leader throughout the 1980s. Giordano was recruited to come back on the editorial staff and replace me, as I moved to the business side of the company to find better ways to build sales to the comic shops.

Giordano in turn brought over Roy Thomas, and Thomas scripted *Arak, Son of Thunder* and *All-Star Squadron*. Thomas was yet another former Marvel editor-in-chief with an early DC connection, having moved to New York for a disastrous week as Mort Weisinger's assistant in the 1960s. His two titles became part of the first push to replace newsstand-oriented books with ones created for the comic shops. If the shops were going to be the next phase of DC's future, the company was going need to reorient the line accordingly.

ALL-STAR SQUADRON No. 1

Far left: Cover art, Rich Buckler and Dick Giordano, September 1981.

Beyond being a dream project for writer Roy Thomas, *All-Star Squadron* breathed new life into DC's mostly dormant Golden Age heroes. Bypassing the standard depiction of the characters as gray-haired old-timers, the series presented its cast in their youthful prime circa 1941–1942 and made them relevant to young readers who now saw the Squadron counterparts in the same light as the modern Justice League and Teen Titans.

THE NEW TEEN TITANS No. 1

Left: Cover art, George Pérez and Dick Giordano, November 1980.

The third time's the charm. The Titans' first series had lasted seven years, their second a scant ten issues, but with several new characters and a perfect-pitch pairing of sharp writing and exquisitely detailed art, this revival became DC's first breakout hit of the '80s, rivaling the *X-Men*.

BIG HAPPENINGS... AND SMALL PUBLISHERS

One important development for the future of comics during these years was percolating in many minds and many ways, but ended up with a name popularized by comics pioneer Will Eisner, who had made his reputation creating *The Spirit* in the 1940s. Eisner had been one of the first cartoonists to voice the belief that comics were a true art form, and would one day be considered their own branch of literature, and by the late 1970s he was determined to be part of that movement. While established comics publishers like DC were experimenting with longer forms for the newsstand (like the *Superman vs. Spider-Man* success), innovative small publishers were allowing talent to develop longer tales for comic shops, but Eisner wanted to be in the bookstores with the support of a traditional book publisher, in search of a wider audience than comics' readers. He used the term "graphic novel" for his *A Contract with God* when Baronet published it in 1978, and went on to produce a stream of projects that were inspirational to a younger generation of talent.

New publishing ventures weren't limited to the long form, either. The growth of direct distribution to the comic shops had opened the possibility of starting a new comics company without the large investments required by returnable newsstand distribution. Former DC writer Mike Friedrich experimented with a "ground-level" comic called *Star*Reach*, playing by underground rules for talent deals and distribution, but with a style between the undergrounds and the traditional publishers. More of a business than the fanzines that had preceded it, but vastly less corporate than the established players, it opened the path—and brand new entrants like Pacific Comics (featuring new heroes by Kirby) and First Comics (edited by former DC public relations man Mike Gold) followed as more shops opened.

In the midst of these changes, Harrison retired at the end of 1980, and Kahn became president and publisher. With this new authority, she worked with me to make fundamental changes in the company's business. Looking at the emerging experimental small comics companies that combined elements of the underground comix philosophy of creator ownership and the wider publishing world's economic models, we acted to align the talents' interests with the company's. For the first time, all writers and artists would receive royalties on the sales of their comics once the initial page rates had

THE UNTOLD LEGEND OF THE BATMAN No. 1

Below: Cover art, José Luis García-López, July 1980.

The first Batman miniseries led to decades of limited series that explored the Dark Knight's past, present, and future.

MADAME XANADU No. 1

Far left: *Cover art, Michael Kaluta, 1981.*

DC's editors knew they had something special on their hands in the form of a Madame Xanadu story by the star team of Steve Englehart and Marshall Rogers; they just didn't know what to do with it. After the 1978 cancellation of *Doorway to Nightmare* (its intended home), the story was earmarked for 1980's *The Unexpected* No. 200, but failed to appear there, too. Noting the phenomenal sales growth in comic book shops, DC ultimately released the story as a direct market exclusive, their second after 1979's *Superboy Spectacular*. The one-shot also included a story by J. M. DeMatteis and Brian Bolland that was intended for the recently canceled *Mystery in Space*.

CAMELOT 3000 No. 4

Opposite: *Cover art, Brian Bolland, March 1983.*

CAMELOT 3000 No. 7

Top center: *Interior, "Betrayal"; script, Mike W. Barr; pencils, Brian Bolland; inks, Terry Austin. August 1983.*

DC's first "maxiseries" was also its earliest project created exclusively for the direct sales market, allowing for moments like DC's first lesbian kiss.

THE GREAT SUPERMAN COMIC BOOK COLLECTION

Above: *Cover art, José Luis García-López and Dick Giordano, 1981.*

After licensing book publishers reprint collections of its comics since the 1960s, DC finally produced a book of its own. Intended as a mail-order premium for an offer stuffed into credit card bills, it became DC's first trade paperback for the comic shops a year later.

been earned out. This gave talent the incentive to create new projects and to invest more time in their work, and would be a key factor in the creative explosion to follow only a few years later. Royalty checks began to go out on successes like *Teen Titans*; the industry followed suit, and comics would never be the same.

TO THE SHOPS!

Because the comic shops were few and far between compared to the ever-present newsstands of old, they attracted primarily comic book readers who were old enough to get there on their own — by bike, bus, or car — rather than the younger kids who bought comics to keep themselves amused while their parents went shopping. This meant readers old enough to follow the credits and star artists and writers, and customers who probably had enough money in their pocket to support higher prices and better formats...and who could be marketed to, with posters and other in-store promotions. The first DC for comic shops only was *Madame Xanadu* No. 1 in 1981, reuniting Steve Englehart and Marshall Rogers (who had made their reputation on an acclaimed *Batman* arc a few years before), priced at $1, compared to the usual newsstand title at 50 cents...and the Comics Code seal came off. The retailers running comic shops disliked the Code, seeing it as "establishment" and restrictive of creative freedom, and now that their orders could support a project without the newsstands, dropping the Code would be a way of signaling "not just for kids" — even though many of the titles from DC and others that would skip the Code in the next few years could have passed its strictures.

Other tests and distribution methods were attempted, including DC's first publication of a book — *The Great Superman Comic Book Collection* — issued in 1982 primarily as a direct-mail test with credit card companies. But the comic shops were clearly the way to go. A pioneering maxiseries project (which extended the miniseries concept to a yearlong effort), Mike W. Barr and Brian Bolland's *Camelot 3000*, was shifted off the giant letterpresses that had printed comics since their beginning and moved to offset printing, permitting better reproduction. The art was soon prepared with this new process in mind, allowing it to "bleed" off the page instead of being in bordered margins, as well as being rendered in a richer color palette.

NATHANIEL DUSK No. 1

Right: *Interior, "Lovers Die at Dusk, Part 1"; script, Don McGregor; pencils, Gene Colan. February 1984.*

This experimental, noirish detective miniseries by frequent collaborators McGregor and Colan was noteworthy for its art reproduced largely from uninked pencils.

THE OMEGA MEN No. 3

Far right: *Cover art, Keith Giffen and Mike DeCarlo, June 1983.*

The infamous and ever-outrageous Lobo made his bounty-hunting debut in this space-faring issue, featuring the tale "Assault on Euphorix!"

HOUSE OF MYSTERY No. 321

Above: *Cover art, Michael Kaluta, October 1983.*

No eponymous character ever stays dead in comics, and that goes for houses, too. Frequent cover artist Kaluta's fitting coda to the first series notwithstanding, the title has been revived many times since.

RONIN No. 4

Opposite: *Interior, "Ronin"; script, pencils, and inks, Frank Miller. January 1984.*

This miniseries, about a masterless samurai reincarnated in a nightmarish New York of the future, was collected into a single volume in 1987 and has remained on DC's backlist ever since.

The shift to offset represented a reversal of a 40-year-old trend. Almost from the beginning of American comics, whenever faced with cost pressures publishers had made the decision to cheapen the product in order to keep the price low. Page counts had dropped steadily from the end of World War II, and paper and printing quality had been diminished in subtle steps, but cumulatively making for a significantly poorer package. *Camelot 3000* was a loud proclamation that that behavior was over, and DC was proud of its publications, prepared to show off its stories and art with the most modern presentation available.

With these possibilities opened up, comics began to change. New titles like *Omega Men* by Roger Slifer and Keith Giffen introduced characters like the highly antiheroic Lobo, in so many ways the antithesis of the very socially responsible Silver Age pantheon. Lobo smoked a cigar, drank, and rejoiced in the destruction of his enemies…and if an innocent bystander was caught in his wake, it was no big deal as long as it was amusing. *Nathaniel Dusk* became the first DC comic to be reproduced directly from the artist's pencils, capturing the beauty of Gene Colan's work in a new way, while telling Don McGregor's noir detective story in a miniseries. To make room for these projects, the old line was pared down, book by book, and the mystery titles that sustained the company through the Bronze Age ended as they had begun when *House of Mystery* was canceled.

The straddling era of transition from the newsstand to the comic shop was ending, and DC was preparing to help create a new era of comics. The metallic gleam of the Bronze Age had been tarnished by the challenges of declining circulation, but the lessons learned during this time would put a new polish on the medium. Kahn believed that the more sophisticated purchasers in comic shops would follow star talent by name, not just characters, and that the business practices she had put in place would allow her to attract people to fulfill comics' potential in this next era. In fact, she had set her eye on just the daredevil to pull it off…but that's a tale for another age.

DC 100 PAGES SUPER SPECTACULAR 100

WORLD'S GREATEST SUPER-HEROES!

100 action-packed pages — story and art from cover to cover

50¢

Jack Kirby

"I won't tell you any lies, I might fantasize, I might dramatize, and I might make my characters with a little more flourish, but they'll never lie to you. They'll always be the truth. You'll find that element in them and you'll accept them." — JACK KIRBY

KIRBY AT WORK

Above: *Photo, Jack Kirby at his drawing board, ca. 1975.*

THE NEW GODS No. 1

Opposite: *Cover art, Jack Kirby and Don Heck, February–March 1971.*

Since the debut of the Flash in 1956, DC had followed a pattern of introducing nearly all of its new titles in a tryout comic book like *Showcase* first before releasing them under their own name. Jack Kirby's arrival at DC changed that equation as the company's editorial team recognized the growing appeal that true first issues had to fans. Simply put, *New Gods* No. 1 was more commercial than *Showcase Featuring... New Gods* No. 94.

DC 100-PAGE SUPER-SPECTACULAR No. 6

Previous pages: *Cover art, Neal Adams, 1971.*

Fans marveled at the wraparound cover of the "World's Greatest Super-Heroes," all of whom were identified with capsule descriptions on the inside back cover. As a bonus, editor E. Nelson Bridwell also compiled a comprehensive list of all of DC's costumed heroes to date—and their first appearances—interspersed throughout the issue.

KIRBY'S THE NAME!

Above: *Interior, Forever People No. 4; script and pencils, Jack Kirby; inks, Vince Colletta. August–September 1971.*

SUPERMAN'S PAL, JIMMY OLSEN No. 143

Right: *Interior, "Genocide Spray"; script and pencils, Jack Kirby; inks, Vince Colletta. November 1971.*

Kirby filled the Fourth World with concepts from DNA-based cloning to the Source, which nurtured and guided the New Gods themselves. The ideas live on in other writers' tales for DC...and in some of the most successful films of our time.

MISTER MIRACLE No. 1

Opposite: *Interior, "Murder Missile Trap"; script and pencils, Jack Kirby; inks, Vince Colletta. March–April 1971.*

Escape artist Scott Free was a linchpin in the Fourth World saga's cosmic struggle. The heir to New Genesis' throne, Free was instead raised on hellish Apokolips as *its* leader's son. After discovering the deception, he became Darkseid's implacable foe.

THE NEW GODS No. 2

Above: *Interior, "O Deadly Darkseid"; script and pencils, Jack Kirby; inks, Vince Colletta. April–May 1971.*

Jack Kirby saw Darkseid as a distillation of every evil person he'd ever heard of, but the villain's face was based on one person in particular. An admirer of film star Jack Palance, Kirby used the actor's craggy features and distinctive cheekbones as the foundation for Darkseid's visage.

SUPERMAN'S PAL, JIMMY OLSEN No. 137

Above: *Cover art, Jack Kirby and Neal Adams.* Right: *Interior, "The Four-Armed Terror"; script, pencils, and photo collage, Jack Kirby; inks, Vince Colletta. April 1971.*

"There was something about the interconnectedness of those Fourth World titles, which hit me at a time when I was just starting to think about questions of narrative, storytelling, and world-making. The way that Kirby came into the DC world that I was already familiar with and reoriented the entire thing with his own vision of super-hero myth. And did it in a way that has turned out to be very lasting…"
—Michael Chabon

Readers accustomed to DC's more traditional and sedate storytelling techniques must have found Kirby's arrival—especially on *Jimmy Olsen*—eye popping. The use of photo collage, such as in this spread and the cover for *New Gods* No. 3, was just one of many innovations "The King of the Comics" brought with him.

CLINK-INK-INK-IN

KEN LANDRY SAW THE STARK, *REALISTIC* VISION IN A DREAM! SHE WAS LIKE SOME *SENSUOUS* GODDESS RISEN FROM THE SEA!!!

SHE SEEMED TO BE DRAWING A FISH-LINE FROM THE WATERS, AT FIRST!! BUT THE OBJECT AT THE END OF IT PROVED TO BE A TELEPHONE!!

IT WAS TYPICAL "DREAM-ACTION" -- OPEN TO ANALYSIS!!

SPEAK INTO IT, KEN LANDRY! SPEAK INTO IT-- OR DIE!!!

THERE WAS SOMETHING *SINISTER* AND FOREBODING IN HER SPEECH -- AND THE *CLARITY* OF IT CAUSED A FEELING OF *FEAR* AS SHE LOOMED CLOSE--CLOSER---!!

WITHOUT WARNING THE PHONE BECAME THE DARK, GAPING BARREL OF A GUN AND EXPLODED WITH A *TERRIFYING* FLASH AND ROAR!! KEN WOKE WITH A START!! HE COULD *STILL* HEAR THE ECHOES OF THAT DEADLY SOUND!!

BAM!

2

BLACK MAGIC No. 1

Above: *Cover art, Jerry Grandenetti, October–November 1973.*

During his brief early-'70s editorial return to DC, Joe Simon revived *Black Magic*, the long-running horror comic book that he'd done with Jack Kirby for Prize Comics from 1950 to 1961. DC's nine-issue run (1973–1975) featured new covers that opened to 1950s reprints, edited to revise characters' hairstyles and apparel to suitably '70s fashions.

WEIRD MYSTERY TALES No. 1

Opposite: *"Horoscope Phenomenon or Witch Queen of Sumeria?"; script and pencils, Jack Kirby; inks, Mike Royer. July–August 1972.*

MISTER MIRACLE No. 6

Left and above: *Interior, "Funky Flashman"; script and pencils, Jack Kirby; inks, Mike Royer. January–February 1972.*

Jack Kirby's resentment over perceived slights manifested in the form of Funky Flashman, a charming-if-shady businessman satirizing the cartoonist's former collaborator. Along with his assistant Houseroy, Funky ingratiated himself into Mister Miracle's life but fled when things got tough. The character was revived several times in the decades that followed, even joining '70s supergroup the Secret Society of Super Villains.

MISTER MIRACLE No. 6

Left: *Original cover art, Jack Kirby, January–February 1972.*

As his own editor, Kirby enjoyed creative freedoms previously denied him, such as occasionally inking a cover when *he* chose—as he did here—or using his writing to vent professional pique.

SUPERMAN'S PAL, JIMMY OLSEN No. 134

Opposite: *Original interior art, "The Mountain of Judgment"; script and pencils, Jack Kirby; inks, Vince Colletta. December 1970.*

Despite the amount of time it took to create them, the collage pages developed by Jack Kirby were a passion for the cartoonist, so much so that he would even ask visitors to his home to bring along magazines that he could use for additional clippings.

THE NEW GODS No. 3

Top right: *Cover art, Jack Kirby and Vince Colletta, June–July 1971.*

Kirby, too, contributed an African American hero to DC's mythology, introducing the Black Racer, secretly a paralyzed Vietnam vet. Airborne on flying skis the way an earlier Kirby character used a silver surfboard, he was Death, gathering the souls of fallen New Gods and taking them to the Fourth World's version of Hades.

THE DEMON No. 1

Right: *Interior, "Unleash the One Who Waits"; script and pencils, Jack Kirby; inks, Mike Royer. August–September 1972.*

Like the enduring Green Lantern oath created in 1943, the recitation used by Jason Blood to transform into the Demon became a staple and eventually inspired the 1980s decision to have the character speak entirely in rhyme.

OMAC No. 1

Above: *Cover art, Jack Kirby and Mike Royer, September–October 1974.*

Contractually obligated to produce a certain number of pages per month for DC, Kirby began work on OMAC following the 1973 cancellations of *The Demon* and *Mister Miracle* and had finished six issues before the title's debut in 1974. Filled with bizarre, paranoid imagery, the series took place in a future wherein an A.I. satellite dubbed Brother Eye transformed frail Buddy Blank into the super-heroic OMAC, short for One Man Army Corps.

KAMANDI No. 1

Opposite: *Cover art, Jack Kirby and Mike Royer, October–November 1972.*

Set on "Earth After Disaster," Kamandi followed the adventures of a teenager in a world populated by mutated animals who walked, talked, and dressed like humans. The most successful of Kirby's 1970s creations, the title had a 59-issue run through 1978.

THE SANDMAN No. 1

Above: *Cover art, Jack Kirby and Frank Giacoia. Winter 1973–1974.*

While at DC in the 1940s, Kirby and partner Joe Simon took over the *Adventure Comics* feature *The Sandman* for several issues.

MANHUNTER!

Left: *Interior, 1st Issue Special No. 5; script and pencils, Jack Kirby; inks, D. Bruce Berry. August 1975.*

Kirby's 1975 revival of his and Joe Simon's Manhunter featured the final mission of the aged 1940s hero, who passed his baton to a younger successor named Mark Shaw. Kirby was apparently unaware that the original Manhunter had already reappeared in Archie Goodwin and Walter Simonson's celebrated *Detective Comics* series.

IN THE DAYS OF THE MOB No. 1

Opposite: *Interior, "Pretty Boy Floyd"; script and pencils, Jack Kirby; inks, Vince Colletta.* Above: *Cover art, Jack Kirby. Fall 1971.*

DC Editorial supported Kirby's experimentation even if the salesmen couldn't. This reality-based, black-and-white magazine was essentially a comic-format *Untouchables*. Here Kirby indulged the same love of Roaring '20s mobsters that inspired other, more lasting contributions, such as the Superman villains Intergang. Still wary of anything "adult looking" that might scare newsstands away from DC product, the company published this under the name of a British venture it controlled, Hampshire Distribution. *Mob* lasted only one issue.

SPIRIT WORLD No. 1

Above and right: *Interiors, "The Screaming Woman"; script and pencils, Jack Kirby; inks, Vince Colletta. Fall 1971.*

Although Jack Kirby had envisioned a glossy, full-color package, the one and only issue of *Spirit World* offered readers a rare opportunity to see his artwork in toned black and white. Unfortunately, few people ever saw it thanks to poor distribution.

BATMAN No. 358

Opposite: *Cover art, Ed Hannigan and Dick Giordano, April 1983.*

After becoming *Batman*'s editor in 1982, Len Wein brought in penciller Ed Hannigan, whose imagination and strong design sense produced some of the cleverest covers since Jerry Robinson's in the 1940s.

DETECTIVE COMICS No. 426

Above: *Interior, "Killer's Roulette"; script, pencils, and inks, Frank Robbins. August 1972.*

The extremity of Batman's aversion to guns varied depending on the writer. In most stories, he was unwilling to touch a gun, but in this tale, he played Russian roulette in a sequence that remarkably garnered no objection from the Comics Code Authority.

DETECTIVE COMICS No. 428

Left: *Cover art, Michael Kaluta, October 1972.*

The popularity of 1971's *The French Connection* and its "Popeye" Doyle character (played by Gene Hackman) inspired Batman's encounters with a tough narcotics detective named Steve "Shotgun" Smith.

DETECTIVE COMICS No. 423

Above: *Cover art, Michael Kaluta, May 1972.*

Batman's refusal to use firearms periodically resulted in cover hooks that either tested his resolve or suggested that he'd gone over the edge. The rifle that the Dark Knight carried on this cover was revealed in the story to actually be a long-range camera.

BATMAN No. 232

Left and opposite: *Interiors, "Daughter of the Demon"; script, Denny O'Neil; pencils, Neal Adams; inks, Dick Giordano. June 1971.*

Even after leaving the nest and establishing an active career outside of Gotham City, Robin was still viewed as one of Batman's vulnerabilities. Denny O'Neil saw the Teen Wonder as a contradiction, someone whose bright colors and optimism were at odds with the Dark Knight and whom he portrayed as a clear subordinate if not someone in need of rescuing.

DETECTIVE COMICS No. 500

Right: *Interior, "To Kill a Legend"; script, Alan Brennert; pencils and inks, Dick Giordano. March 1981.*

A much-praised Batman story by screenwriter Alan Brennert hinged on Batman preventing the death of Thomas and Martha Wayne on a parallel Earth. The epilogue revealed that the Bruce Wayne of this reality would still grow up to be a costumed hero, motivated by a sense of wonder rather than vengeful grief.

BATMAN

HA-HA HA HA HA HA HA HA HA HA HA HA HA HA HA HA HA HA HAHA HAHAHA

FROM THE DARKNESS OF A COUNTRY ROAD SOMEWHERE NORTH OF GOTHAM CITY... AND FROM THE GREATER DARK OF A PAST FILLED WITH EVIL... COMES A TERRIFYINGLY FAMILIAR FACE!

THUNDER RACKS THE EARTH AND LIGHTNING SCARS THE SKY AND WETNESS STREAMS FROM THE CLOUDS LIKE TEARS OF MOURNING! IT IS AS THOUGH NATURE ITSELF WERE WEEPING!

AND WELL IT MIGHT, FOR THERE IS DEATH ABROAD THIS NIGHT!

THE JOKER'S FIVE WAY REVENGE!

STORY: DENNY O'NEIL
ART: NEAL ADAMS
EDITOR: JULIUS SCHWARTZ

Neal Adams

"Batman was a near-perfect vehicle for Neal's emergent, magically realistic approach to comics narrative. There isn't a great stretch between Batman's world and ours; he is the most 'realistic' of the great super heroes... and that, I submit, made him the ideal vehicle for the kind of work Neal wanted to do."
— DENNIS O'NEIL

AT THE DRAWING BOARD

Above: *Photograph, Neal Adams by Jack Adler, early 1970s.*

BATMAN No. 251

Opposite and left: *Interiors, "The Joker's Five-Way Revenge"; script, Denny O'Neil; pencils and inks, Neal Adams. September 1973.*

Just as O'Neil and Adams helped restore credibly dangerous recurring villains with their introduction of Rā's al Ghūl, so too did they rehabilitate some old, familiar foes. They spearheaded the return of a more lethal than laughable Joker, after having performed a similar service for Two-Face in *Batman* No. 234. Likewise, Adams' image of a running Batman quickly became iconic. It was repurposed just months after its first publication as the cover of *Limited Collectors' Edition* No. C-25, the first tabloid-sized Batman collection.

DC SPECIAL SERIES No. 15

Above: *Interior, "Death Strikes at Midnight and Three"; script, Denny O'Neil; pencils and inks, Marshall Rogers. Summer 1978.*

BATMAN No. 227

Opposite: *Cover art, Neal Adams, December 1970.*

After Batman left TV in 1968, his comics sales plummeted. The solution: return him to his "dark" origins. No artist aided that effort more than Adams: this homage to Bob Kane's cover for *Detective* No. 31 (September 1939), borrows the symbolic giant figure and the placement of the hilltop mansion, changing the foreground figures to reflect the story.

DETECTIVE COMICS No. 471

Above: *Interior, "The Dead Yet Live"; script, Steve Englehart; pencils, Marshall Rogers; inks, Terry Austin. August 1977.*

DETECTIVE COMICS NO. 439

Left: *Interior, "Night of the Stalker"; plot, Vin and Sal Amendola; script, Steve Englehart; pencils, Sal Amendola; inks, Dick Giordano. February–March 1974.*

Inspired by Neal Adams' description of a scene in which Batman pulled a criminal underwater, artist Sal Amendola was inspired to plot a story with his brother Vin that built around that incident.

BATMAN No. 232

Above: *Interior, "Daughter of the Demon"; script, Denny O'Neil; pencils, Neal Adams; inks, Dick Giordano. June 1971.*

Despite O'Neil and Adams' efforts at forging a darker knight, the Caped Crusader's expression upon receiving a kiss from Talia wouldn't have been out of place on the campy TV show.

BATMAN No. 345

Above: *Interior, "Calling Doctor Death"; script, Gerry Conway; pencils, Gene Colan; inks, Klaus Janson. March 1982.*

Bruce Wayne flashed his bare chest on occasion during the 1980s but he rarely showed more skin than in a 1982 sequence wherein he was attacked by a "mandroid" while in the shower—and spent two pages fighting it in the nude.

BATMAN No. 366

Right: *Interior, "The Joker Is Wild"; script, Doug Moench; pencils, Don Newton; inks, Alfredo Alcala. December 1983.*

After months of build-up, young acrobat Jason Todd claimed the mantle of Robin and saved Batman from the Joker, setting the stage for Dick Grayson formally declaring the boy his successor.

DETECTIVE COMICS No. 492

Opposite: *Interior, "Vengeance Trail"; script, Cary Burkett; pencils, Don Newton; inks, Dan Adkins. July 1980.*

A year after drawing the death of Batwoman, Don Newton seemed to be a party to the demise of Batgirl, as well. In fact, the red-haired heroine had survived but Newton's shadowy, realistically rendered pages conveyed the script's somber mood.

"EXCUSE ME, SIR... BUT ONCE YOU READ THE *HEADLINE*, I-I THINK YOU'LL *UNDERSTAND!*"

"GOOD LORD!"

GOTHAM D
90th year No. 163
COPYRIGHT 1980

Batgirl slain by assassin

End comes crusading

ASSOCIATED PRESS

VENGEANCE TRAIL

SLAAAM

Dennis O'Neil

"Creators of popular culture seldom have a Big Plan; they're generally concerned with little beyond the next deadline, which is usually imminent. But it is the genius of popular culture to supply what the audience wants or actually needs, and that genius is manifested through the instincts of the harried folk who do the day-to-day work."
— DENNIS O'NEIL

DENNIS O'NEIL

Above: *Publicity photo, 1970s.*

"[T]he 'new journalists'—Wolfe, Mailer, Jimmy Breslin, Pete Hamill, Gene Marine, Hunter S. Thompson, these men I admired tremendously—weren't they combining fiction techniques with reporting? Could a comic-book equivalent of the new journalism be possible?... Not fact, not current events, presented in panel art rooted in the issues of the day? Now *there* was a possibility."
—Dennis O'Neil

GREEN LANTERN No. 86

Right: *Interior, "They Say It'll Kill Me...But They Won't Say When"; script, Dennis O'Neil; pencils, Neal Adams; inks, Dick Giordano. October–November 1971.*

SUPERMAN No. 242

Above: *Cover art, Neal Adams, September 1971.*

BATMAN No. 244

Opposite: *Cover art, Neal Adams, September 1972.*

"[Rā's face was] not tied to any race at all. It had to have evidence of a great many things having happened, a face that showed the man had an awareness of his own difference at a very early age....His face had to convey the feeling that he'd lived an extraordinary life long before his features were ever committed to paper."
—Neal Adams

BEHIND THE SCENE

Above: *Film still, Canadian Television broadcast; left to right, Denny O'Neil, Julius Schwartz, Neal Adams; 1978.*

At their height, O'Neil said in 1983 of his collaborations with Adams, "We hummed in unison like tuning forks, our psyches were twins. Only the best marriages approximate the closeness of such an artistic pairing. As marriages have an alarming tendency to culminate in divorce, close collaborations generate jealousy, rivalry, and pettiness. Neal and I never became actively hostile, but the relationship did get edgy and strained toward the end. It might have gotten worse had we continued working exclusively with each other."

BEST IN SHOW

Left: *House ad, "A.C.B.A. Awards": script, unknown; art, Neal Adams. November 1971.*

Voted on by comic-book professionals, the results of the first annual Shazam Awards were a clear validation of O'Neil and Adams' Green Lantern/Green Arrow.

GREEN LANTERN No. 86

Right: *Cover art, Neal Adams, October–November 1971.*

"I'd like to say I had a great dream, but it didn't happen that way. Green Lantern was dying. The whole super-hero line was dying. Everything was sagging, everything.... We started interviewing groups of kids around the country. The one thing they kept repeating: they want to know the truth."
—Carmine Infantino

GREEN LANTERN No. 86

Opposite: *Interior, "They Say It'll Kill Me…But They Won't Say When"; script, Denny O'Neil; pencils, Neal Adams; inks, Dick Giordano. October–November 1971.*

Denny O'Neil recalled in 1974 that some readers objected to the revelation that a long-standing costumed hero was also a drug addict. "We had a total of around 44 pages to work with and that was not really enough room to create a character from scratch, build sympathy for him, get him addicted, kick, and also get action and plot. The only way to go was with a character already established, and Speedy was the logical choice."

"THEY SAY IT'LL KILL ME... BUT THEY WON'T SAY WHEN!"

FOR A MOMENT HE REFUSED TO BELIEVE IT! SEEING HIS WARD *SPEEDY* ABOUT TO PLUNGE A NEEDLE INTO HIS ARM, *GREEN ARROW* STOOD STUNNED, STRIVING TO COMPREHEND! AND *NOW*, HE ERUPTS INTO HOT *FURY*--!

YOU'RE A LOUSY *JUNKIE*-- NO BETTER THAN THE *REST* OF THE SNIVELING PUNKS!

IF THAT'S THE WAY YOU SEE IT, *ARROW*--!

GO AHEAD... *HIT* ME! MAYBE THAT'LL MAKE YOU *FEEL* BETTER!

Story by: Denny O'Neil
Art by: Neal Adams & Dick Giordano
Edited by: Julius Schwartz

S-922

Panel 1:

"WE MAY AS WELL BEGIN YOUR *FIELD TRAINING!* YOU'LL NEED A PROPER *OUTFIT*--"

"THESE AREN'T ANY THREADS *JAMES BROWN* WOULD WEAR... BUT THEY BEAT MY USUAL *SALVATION ARMY SPECIAL!*"

"ONLY ONE THING... I WON'T WEAR ANY *MASK!* THIS BLACK MAN LETS IT *ALL* HANG OUT!"

"MAN, THAT'S PRETTY *CORNY*... EXCEPT FOR THE PART THAT SAYS, *"BEWARE MY POWER"!*"

"MMM--HUM... I *DO* DIG THOSE WORDS!"

"I'VE GOT *NOTHING* TO HIDE!"

Panel 2:

FOR HOURS, THEY PRACTICE IN THE SKY ABOVE THE CITY...

"YOU HAVE A REAL *TALENT*, JOHN! YOU'VE QUICKLY *MASTERED* THE SKILLS NECESSARY TO SUSTAIN FLIGHT--"

"IT'S *EASY* COMPARED TO THE SKILLS NEEDED TO REACH MY PAD AFTER DARK! THOSE *MUGGERS*-- SOMETHING *ELSE!*"

Panel 3:

"HEY, LOOK DOWN THERE... AT THE *AIRPORT!*"

"MUST BE A *CELEBRITY* ARRIVING!"

"RIGHT! AND I KNOW *WHICH* CELEBRITY! WHAT SAY WE DROP IN FOR AWHILE?"

7

GREEN LANTERN No. 87

Opposite: *Interior, "Beware My Power"; pencils Neal Adams; inks Dick Giordano; December 1971–January 1972.*

Conceived as a one-shot character, substitute Green Lantern John Stewart was revived in a late 1973 *Justice League* story and made an escalating series of returns that culminated in his promotion to a full member of the Corps.

JUSTICE LEAGUE OF AMERICA No. 173

Right: *Cover art, Dick Dillin and Dick Giordano, December 1979.*

Months after meeting the Justice League in the *World's Greatest Superheroes* newspaper strip, Black Lightning passed on joining the team in favor of keeping his focus on more street level threats.

BLACK LIGHTNING No. 1

Left: *Interior, "Black Lightning"; script, Tony Isabella; pencils, Trevor von Eeden; inks, Frank Springer. April 1977.*

As Tony Isabella talked out Black Lightning's costume with Trevor von Eeden, others had input of their own. Joe Orlando asked that the hero's shirt be more open while Bob Rozakis suggested a mask with an afro wig that concealed Jefferson Pierce's short hair.

GREEN LANTERN No. 85

Left: *Interior original art, "Snowbirds Don't Fly"; script, Denny O'Neil; pencils and inks, Neal Adams. August–September 1971.*

Although O'Neil/Adams' landmark two-parter focused primarily on drug addiction, Denny O'Neil also included a scene wherein affluent partygoers condemned the "filthy, dope-swilling beatniks" as they indulged themselves on drinks. "We were trying to be subtle," he said of his implied denouncement of alcohol addiction, "and we were so subtle nobody saw it."

GREEN LANTERN No. 87

Opposite: *Interior, "What Can One Man Do?"; script, Elliot S! Maggin; pencils, Neal Adams; inks, Dick Giordano. December 1971–January 1972.*

Writer Maggin was a student at Brandeis University who was captivated by the issue-oriented *Green Lantern* series and wrote this story on speculation, at a time when such submissions were unheard of at DC. Neal Adams got hold of the script and begged editor Julius Schwartz to acquire it for him to draw. Both an unforgettable story and a distinguished comics career were born.

COMIX THAT GIVE A DAMN!

Right: *Paperback book cover original art*, Green Lantern/Green Arrow; *script, Denny O'Neil; pencils and inks, Neal Adams. 1971.*

Capitalizing on positive press coverage, the early issues of *Green Lantern/Green Arrow* went back into print in two paperbacks, albeit with the original pages reformatted to fit the smaller dimensions. "No Evil Shall Escape My Sight"—the pilot episode of the series—eventually became one of the most reprinted stories in DC Comics' history.

WHO ARE YOU, GREEN-CLAD BOWMAN-- THE FLAMBOYANT CRIME-FIGHTER-- THE LATTER-DAY *ROBIN HOOD*...? OR THE BROKEN BUSINESSMAN-- ONCE ADMIRED AND ENVIED-- NOW SCRAPING ALONG ON WHAT LITTLE IS LEFT! WHO ARE YOU, YOU WHO CALL YOURSELF...

GREEN ARROW

WHAT DOES A MAN DO WHEN HIS WORLD IS TORN DOWN AROUND HIM-- WHEN HE FALLS TO THE SAME INJUSTICES FROM WHICH HE HAS SOUGHT TO PROTECT OTHERS?
WHAT DO *YOU* DO, OLIVER QUEEN, AS YOU WALK AMONG *STAR CITY'S* MILLION SOULS AND ASK....

What Can One Man Do?

ELLIOT MAGGIN -- WRITER
NEAL ADAMS & -- ARTISTS
DICK GIORDANO
JULIE SCHWARTZ -- EDITOR

YOUNG ROMANCE No. 175

Above: *Interior, "Man's View" (originally, "Sealed with a Kiss"); script, Robert Kanigher; pencils and inks, John Romita. October 1971.*

In the 1970s, DC regularly reprinted vintage romance stories, revising the titles and updating hairstyles and fashions, as in this 1971 example originally published in *Girls' Love Stories* No. 92 (1962).

SUPER DC GIANT No. S-21

Opposite: *Cover art, Charlie Armentano, January–February 1971.*

FALLING IN LOVE No. 121

Above: *Cover art, Tony DeZuniga, February 1971.*

Noting DC's heavy reliance on reprints, artist Tony DeZuniga argued to Joe Orlando and Carmine Infantino that they publish new material by tapping the abundant artistic community in his native Philippines. At his prompting, DC found a new talent pool that spread across much of the line by the mid-'70s.

YOUNG LOVE No. 73

Left: *Interior, "When Love Has Gone"; script, unknown; pencils and inks, Alex Toth. March–April 1969.*

With little interest in drawing super heroes, industry legend Alex Toth preferred the challenges offered by other genres. He brought his innovative layouts to a number of romance stories during the late 1960s/early 1970s including a four-issue serial dealing with race and class differences called "20 Miles to Heartbreak."

79

A GOTHIC MYSTERY LOVE STORY...

BRIDE of the FALCON

by FRANK ROBBINS

ART: Alex Toth — Frank Giacoia

"I COULDN'T HAVE PICKED A WORSE TIME TO ARRIVE IN VENICE. A DAY THAT HAD BEGUN IN BRIGHT, HOPE-FILLED EXPECTATION... BUT NOW SUDDENLY TURNED BLACK AND STORMY! ICY WINDS, OR PERHAPS IMAGINED FOREBODING, CHILLED ME..."

THE YOUNG SIGNORINA WISHES PASSAGE TO THE "ISOLA TRANQUILLO"?

ARE YOU SURE *THAT* IS WHERE YOU WISH TO GO?

THE SINISTER HOUSE OF SECRET LOVE No. 3

Opposite: *Interior, "Bride of the Falcon"; script, Frank Robbins; pencils, Alex Toth; inks, Frank Giacoia and Doug Wildey. February–March 1972.*

After two decades of adhering to a romance comic book formula comprised mostly of short stories, DC tried modeling a few titles on the then-popular gothic romance paperbacks. Along with the stylistic difference, the stories were also longer: 36–39 pages versus the typical 8–12.

GHOSTS No. 102

Right: *Interior, "One Last Kiss"; script, Joe Gill; pencils and inks, Tony DeZuniga. July 1981.*

By the early 1980s, genres like romance and science fiction could be found at DC only within the pages of its horror anthologies.

SINISTER HOUSE OF SECRET LOVE No. 2

Far left: *Cover art, Jerome Podwil (painting) and Tony DeZuniga (frame). December 1971–January 1972.*

Curiously, this was the very first use of the words "graphic novel" on the cover of any comic or book published in America.

THE DARK MANSION OF FORBIDDEN LOVE No. 3

Left: *Cover art, Jeffrey Jones, January–February 1972.*

In developing DC's gothic romance comic books, Joe Orlando remarked in 1998 that he "studied the covers on the paperbacks and they always had the woman in the foreground, a sinister guy pursuing them, and a house or castle in the background with always one window lit. So that was a formula I used."

THE DARK MANSION OF FORBIDDEN LOVE No. 1

Opposite: *Cover art, George Ziel, September–October 1971.*

WONDER WOMAN No. 200

Below: *Cover art, Jeff Jones, May–June 1972.*

As interim editor for only five issues, series writer Denny O'Neil felt free to experiment, resulting in two very offbeat covers by illustrator Jeff Jones. Jones was best known at the time for the paperback covers that prompted the renowned Frank Frazetta to call him the medium's "greatest living painter." These two covers are Jones's only super-hero work for DC.

WONDER WOMAN No. 190

Above: *Cover art, Mike Sekowsky and Dick Giordano, September–October 1970.*

Although much of Mike Sekowsky's *Wonder Woman* run had grounded Diana Prince in the real world, three 1970 issues represented some of the comic-book industry's earliest explorations of the sword and sorcery genre that would heat up later in the decade.

The Dark Mansion of FORBIDDEN LOVE

DC — No. 1 OCT. 31185 — 25¢

Approved by the Comics Code Authority

A full-length novel of love and danger complete in this issue!

THE SECRET OF THE MISSING BRIDE

What was the meaning of Bettina's last phone call? In a house of sinister secrets, Laura Chandler seeks the shocking truth!

HOUSE OF MYSTERY No. 203

Above: *Cover art, Russ Heath, June 1972.*

Primarily known at DC as a war comics artist by the mid-1970s, Russ Heath was an unexpected contributor to the company's horror books, but his polished design and the beautiful woman in the composition silenced any doubters.

HOUSE OF SECRETS No. 90

Opposite: *Cover art, Neal Adams, February–March 1971.*

HOUSE OF SECRETS No. 91

Above: *Cover art, Neal Adams, April–May 1971.*

GHOSTS No. 3

Left: *Cover art, Nick Cardy, January–February 1972.*

Editor Murray Boltinoff's mystery titles usually outsold those of his peers, and he added *Ghosts* to his successful line, making the unusual choice to work with a single writer, DC veteran Leo Dorfman, and labeling the stories "True Tales." It worked well, until Dorfman's passing led to a weaker shade of successors.

THE WITCHING HOUR No. 13

Above: Cover art, Neal Adams, February–March 1971.

A gradual weakening of the Comics Code, and the increasing sales of the mystery titles after Joe Orlando's injection of an "EC-lite" sensibility made the line an important part of DC through the 1970s, running through titles edited by several other editors as well.

HOUSE OF MYSTERY No. 226

Left: Interior, "The Wisdom of Many, the Wit of One"; plot, Doug Moench; script, pencils, and inks, Frank Robbins. December 1973–January 1974.

Newspaper strip creator Frank Robbins (*Johnny Hazard*) came to DC as a writer in 1968. Editor Joe Orlando knew at once that Robbins would be a natural for the mystery titles, and he soon began drawing as well, eventually lending his idiosyncratic, Milton Caniff–influenced style to the Batman titles as well as *The Shadow* revival.

THE PHANTOM STRANGER No. 27

Opposite: Interior, "Dr. Zorn: Soul Master"; script, Arnold Drake; pencils and inks, Gerry Talaoc. October–November 1973.

DC SPECIAL No. 4

Right: Interior, "Let the Secret Trial Begin"; script, Mark Hanerfeld; pencils and inks, Bill Draut. July–September 1969.

Before his debut in *House of Secrets* in 1969, Abel was introduced in the framing sequence of a reprint giant that united all of DC's mystery hosts for the first time. Although *The Witching Hour*'s Mildred, Mordred, and Cynthia would be a constant through the 1970s, the Mad Mod Witch and Judge Gallows were soon dropped from *The Unexpected* as editor Murray Boltinoff gave the book a distinct identity from the other horror books.

86

THE PHANTOM STRANGER

RAGE IS A SPECIAL HUMAN ENERGY THAT CAN BE DETECTED AND MEASURED EVEN BEFORE IT *EXPLODES*-- IF THE *KEY* IS KNOWN!

IN THIS HALL THAT RINGS WITH JOY AND LOVE OF LIFE, A *MONSTROUS* RAGE IS ON THE RISE! A BLIND, *ARMED MISSILE* THAT CAN FALL ON ANY UNCHARTED TARGET--EVEN BACK UPON ITS *LAUNCHER!*

FOR, LIKE *MOST PARASITES*, RAGE, IN THE END, ALWAYS DESTROYS ITS *HOST!*

♪ DARK CLOUDS ARE MY SOMBRERO
LEAD INGOTS ARE MY SHOES
SKULLFUL O' KODACOLOR NIGHTMARES
WHEN JANGO'S GOT THE BLUES! ♪

SING IT, JANGO! SING IT!

I'LL ALWAYS LOVE YOU, JANGO!

DR. ZORN: SOUL-MASTER

Script: ARNOLD DRAKE
Art by: GERRY TALAOC

SECRETS OF HAUNTED HOUSE, Vol. 1, No. 5, Dec.-Jan., 1975/1976. Published bi-monthly by NATIONAL PERIODICAL PUBLICATIONS, INC. 75 Rockefeller Plaza, New York, N.Y. 10019. Carmine Infantino, Publisher. Joe Orlando, Editor. Paul Levitz, Assistant Editor. Sol Harrison, Vice President—Director of Operations. Bernard Kashdan, Vice President—Business Manager. Jack Adler, Production Manager. Advertising Representative, Sanford Schwarz & Co., Inc., 355 Lexington Avenue, New York, N.Y. 10017, (212) 391-1400. Copyright © 1975 by National Periodical Publications, Inc. All Rights Reserved. The stories, characters and incidents mentioned in this magazine are entirely fictional. No actual persons, living or dead, are intended or should be inferred. Printed in U.S.A.

SUBSCRIPTION DEPT.: National Periodical Publications Inc., 155 Allen Blvd., Farmingdale, N.Y. 11735. Rate $3 in U.S.A. ($4 elsewhere). Subscription is for consecutive issues totalling $3.00 of their cover prices.

This periodical may not be sold except by authorized dealers and is sold subject to the conditions that it shall not be sold or distributed with any part of its cover markings removed, nor in a mutilated condition, nor affixed to or part of any advertising, literary or pictorial matter whatsoever.

Joe Orlando

"Joe Orlando roared through life: he roared with laughter — at his own jokes, at ours, and the foolishness of humanity; he roared in anger at imperfection and failure, whether his own, that of others, or that of a ridiculous system; and he roared with passion for life itself, for those he loved, and for a perfect line, sketched on paper by pencil, brush, or keystroke. He roared at us, with us, and we admired the lion of our pride." — PAUL LEVITZ

THE LIVING LEGEND

Above: *Photograph, EC Comics offices, New York City, ca. 1952.*

"For the first time, we [the artists] were working with intelligent people putting out intelligent products," Joe Orlando said of his time at EC. "They really cared about what they were doing. They had a high regard for their writers and artists and that gave the people a sense of security."

WHY DON'T YOU HAVE YOUR OWN BOOK?

Opposite: *Original art, Secrets of Haunted House No. 5: "If You're So Smart..." script, Steve Skeates (attributed); pencils and inks, Nestor Redondo. December 1975–January 1976.*

Created in 1972 by Marv Wolfman for *Weird Mystery Tales*, Destiny appeared sporadically throughout the '70s before making a more enduring mark as one of the Endless in the 1990s *Sandman* series.

CLASS IS NOW IN SESSION

Above: *Interior, "The Living Legends of Superman"; script, Elliot S! Maggin; art, Joe Orlando. October 1984.*

Illustrating *Superman* No. 400's prologue about a classroom full of students, Joe Orlando drew himself into the sequence as the teacher. In the real world, Orlando — by that point, DC's Vice President / Executive Editor — was in fact serving as an instructor at Manhattan's School of Visual Arts.

HOUSE OF MYSTERY No. 201

Right: *Script layout, "The Demon Within"; story and art, John Albano.* Far right: *Interior, "The Demon Within"; plot, Joe Orlando; script, John Albano; pencils and inks, Jim Aparo. April 1972.*

Developed from a Joe Orlando plot, "The Demon Within" was one of writer — and able cartoonist, as evidenced in this penciled script layout — John Albano's most memorable efforts, earning a Shazam award for Best Short in 1972.

THE PHANTOM STRANGER No. 26

Above: Interior, "From Dust Thou Art"; script, Len Wein and Marv Wolfman; pencils and inks, Jim Aparo. August–September 1973.

After repeatedly lobbying Joe Orlando to revive *The Phantom Stranger*, Len Wein was dismayed when the editor finally listened in 1969…and assigned the script to Mike Friedrich. Wein finally got his chance in 1971 and crafted an atmospheric run with artist Jim Aparo that became the revival's high point.

THE WITCHING HOUR No. 12

Right: Interior, "Double Edge"; script, Steve Skeates; pencils and inks, Alex Toth. December 1970–January 1971.

One of Dick Giordano's great delights when editing *The Witching Hour* was its electrifying bridging sequences illustrated by Alex Toth. The editor also made a point of buying plenty of horror stories from Toth and others, subsequently sorting through them for a common theme and ordering enough bridge pages to balance each issue.

THE PHANTOM STRANGER No. 18

Above: Interior, "Home Is the Sailor"; script, Len Wein; pencils and inks, Tony DeZuniga, March–April 1972.

Filipino emigrant Tony DeZuniga was a masterful artist in his own right, but he also opened the door for DC to work with its first international studio, an atelier of illustrators in the Philippines, easing DC's budgets while improving artistic quality in the mystery titles.

THE WITCHING HOUR No. 10

Opposite: Interior, "A Warp in Time…Loses Everything"; script, unknown; pencils and inks, Gray Morrow. August–September 1970.

Dick Giordano's *Witching Hour* regularly showcased talent such as Gray Morrow, who made extensive use of ink wash and Craftint film. DC's production department rose to the reproduction challenges posed by such techniques to produce unusually striking images.

NOOOOO! PLEASE... NOOOOOO!

OH MY GOD... WHY ME? WHY MEEEEEEEE?

THE MIDNIGHT FLYER! I REMEMBER-- IT DISAPPEARED NEARLY SIXTY YEARS AGO WITHOUT A TRACE... OVER A HUNDRED PEOPLE... HERE!

CONTINUED ON 2ND PAGE FOLLOWING.

Len Wein

"In my heart, DC was home to me. I would come by at least once a week to have lunch with Julie Schwartz — even though I was running the other company, here I was picking up Julie for lunch! It's here I started. Home is the place that, when you go there, they have to take you in." —LEN WEIN

WEIN AND ABEL

Above: *Photo, Len Wein and Mark Hanerfeld, 1969.*

When the time came to create a companion to *House of Mystery*'s Cain, Joe Orlando looked no further than DC fan/insider Mark Hanerfeld as his model for Abel, host of DC's revived *House of Secrets*. During one of Tom Fagen's famed Halloween parties in Rutland, Vermont, fan-turned-pro Len Wein dressed as the fork-bearded host of *Mystery* and posed with Hanerfeld.

SWAMP THING No. 6

Above: *Interior, "A Clockwork Horror"; script, Len Wein; pencils and inks, Bernie Wrightson. September–October 1973.*

THE PHANTOM STRANGER No. 17

Opposite: *Cover art, Neal Adams, January–February 1972.*

ACTION COMICS No. 425

Left: *Interior, "The Short-Walk-to-Disaster Contract!"; script, Len Wein; pencils, Neal Adams; inks, Dick Giordano. July 1973.*

Initially a short-lived backup feature in *Action Comics* and other titles, Human Target's value to DC would not be realized for several decades. It inspired two separate TV shows: The first, starring rocker Rick Springfield, ran for only seven weeks on ABC in 1992, but the second, beginning on Fox in 2010, was more successful.

SPACE VOYAGERS

Deeper and deeper into the yawning abyss of space... the young SPACE VOYAGERS explore alien solar systems in their eternal quest to pierce the unknown! A strange sun lights their descent onto a cold, inhuman world...

"IT FEELS GOOD TO WALK ON SOLID GROUND AGAIN, BARTT... AND SEE SOMETHING OTHER THAN THE INSIDE OF OUR SHIP!"

"WE ALL NEEDED A CHANGE, MELONG!"

THE QUEEN ANT!

ART: ALEX NIÑO
STORY: ROBERT KANIGHER

SUPERMAN No. 355

Above: *Interior, "Momentus, Master of the Moon"; script, Cary Bates; pencils, Curt Swan; inks, Frank Chiaramonte. January 1981.*

Three years before he appeared here as "Asa Ezaak," science-fiction author Isaac Asimov was part of another fiction, this one perpetuated by Mort Weisinger. The editor asserted that Albert Einstein had once scoffed at the science behind Superman and that he'd recruited his good friend Asimov to deliver a rebuttal: "Professor Einstein's statement is based on theory. Superman's speed is based on fact." When asked about the incident, the famed writer offered only a tongue-in-cheek denial.

SPACE VOYAGERS

Opposite: *Interior,* Rima, The Jungle Girl *No. 5, "The Queen Ant"; script, Robert Kanigher; pencils and inks, Alex Niño. December 1974–January 1975.*

Alex Niño's "Space Voyagers" overflowed with bizarre alien imagery. Scripted first by Jack Oleck and then Robert Kanigher, the *Rima* backup feature ended with issue No. 5 after Niño briefly parted ways with DC.

TIME WARP No. 3

Above: *Cover art, Michael Kaluta, February–March 1980.*

The short-lived *Time Warp* comic book was conceived with grand plans of revitalizing the science-fiction comic book anthology. Budgetary restrictions prohibited such plans as adapting the work of authors like Ray Bradbury and Stephen King and the title ended after five issues.

FROM BEYOND THE UNKNOWN No. 6

Left: *Cover art, Neal Adams, August–September 1970.*

Months after retooling *Strange Adventures* as a comic book reprinting late 1950s/early 1960s science-fiction stories, DC released a companion title called *From Beyond the Unknown*. Aside from an inventory story meant for a licensed comic, the only new material in most issues were the new covers by the likes of Neal Adams, Murphy Anderson, Joe Kubert, and Nick Cardy.

FROM BEYOND THE UNKNOWN No. 17

Above: *Cover art, Murphy Anderson, June–July 1972.*

Richard Nixon appeared in ten DC stories during his presidency, along with this memorable cover.

THE HOT SPOT

Opposite: *Interior,* Rima, The Jungle Girl *No. 3; script, Robert Kanigher; pencils and inks, Alex Niño. August–September 1974.*

In the heightened Cold War climate of the early 1970s, tales of a nuclear-ravaged Earth flourished in DC titles and even spawned a recurring "The Day After Doomsday" feature primarily seen in *Weird War Tales*.

STRANGE ADVENTURES No. 223

Above: *Cover art, Murphy Anderson, March–April 1970.*

During their original 1960–1963 run in *Strange Adventures*, the post-apocalypse Atomic Knights appeared on the cover of the comic book only once. When the series was reprinted from 1969–1971, three episodes earned a cover spot…but the Knights were only physically seen on one of them.

WHO WILL TRIGGER WORLD WAR 3?

Right: *Cover art,* Strange Adventures *No. 226, Joe Kubert, October 1974.*

"MANY, MANY YEARS AGO... BEFORE YOU WERE BORN... WE LIVED ON *EARTH!*"

"BUT— CIVILIZATION HAD BECOME A *TIME-BOMB!*"

THE SEAS-- THE FORESTS-- THE SKIES-- EVEN THE *AIR* WAS *POLLUTED!*

THE PHANTOM STRANGER No. 14

Opposite: *Cover art, Neal Adams, July–August 1971.*

As in all Doctor Thirteen stories (as opposed to Phantom Stranger), the Swamp Thing shown here is a hoax, perpetrated by one Zachary Nail. Writer Len Wein would later acknowledge this prototype by introducing a different Zachary Nail in *Swamp Thing* No. 11.

TALES OF THE UNEXPECTED No. 20

Top right: *Cover art, Ruben Moreira, December 1957.*

FROM BEYOND THE UNKNOWN No. 22

Above: *Cover art, Murphy Anderson and Jack Adler (photo elements), April–May 1972.*

From Beyond the Unknown was a reprint title, but editor Julie Schwartz could still have fun taking inspiration from an old cover mixing the idea with new art and photography.

THE UNEXPECTED No. 221

Right: *Interior, "EM the Energy Monster"; script and pencils, Steve Ditko; inks, Gary Martin. April 1982.*

Along with his work on series characters like Stalker, the Creeper, Shade, and Starman, the legendary Spider-Man artist Steve Ditko had become a reliably off-beat presence in DC's supernatural and science-fiction books in the 1970s and early 1980s.

Bernie Wrightson

"Wrightson created a gothic atmosphere in his stories, and it's now apparent that he was one of the first people to successfully combine the best elements of the horror comics with the super heroes and give modern-day comics readers something fresh and original."
— JERRY WEIST

BERNIE WRIGHTSON

Above: *Photograph, ca. 1975*

A master of the short form, Wrightson only took on one series—Swamp Thing—during his five-year run at DC. "Gimme a good story that's just a few pages long," he said in a 1999 interview, "and I can really pour on the steam and do a real bang-up job." Indeed, amidst the citations for *Swamp Thing*, the artist's 1973 horror short "The Gourmet" with writer Steve Skeates in *Plop!* No. 1 received a Shazam Award for Best Humor Story. Conceding his difficulties in producing full-length stories by deadline, Wrightson actually declined an opportunity to draw DC's revival of the Shadow in 1973 during his tenure on *Swamp Thing*.

HOUSE OF MYSTERY No. 195

Left: *Cover art, Bernie Wrightson, October 1971.*

HOUSE OF SECRETS No. 92

Opposite: *Original cover art, Bernie Wrightson, June–July 1971.*

When Swamp Thing debuted in this issue of *House of Secrets* as a "one-shot," no one could have known it would lead to an enduring hit franchise, least of all its cover model, future comics writer Louise Simonson. Published almost continuously over four decades, it spawned one of DC's most prestigious series, two feature films, and two TV series, one live and one animated.

HOUSE OF MYSTERY No. 186

Right: *Interior, "The Secret of the Egyptian Cat"; script, Robert Kanigher; pencils and inks, Bernie Wrightson. May–June 1970.*

From his earliest DC work, such as the 1969 feature Nightmaster and numerous mystery shorts like this one, Wrightson's meticulously detailed and confidently slick rendering was in evidence. Here, some two years before Swamp Thing, we can see him experimenting with the "dripping" caption border that would become a hallmark of that series.

GIGANT No. 3

Above: *Cover art, Bernie Wrightson, 1983.*

Gigant was a Swedish reprint series that strayed further than the typical international license, which tended to be Superman- and Batman-centric throughout the 1970s.

SWAMP THING No. 9

Left: *Original cover art, Bernie Wrightson, March–April 1974.*

SWAMP THING No. 7

Opposite: *Cover art, Bernie Wrightson, November–December 1973.*

Today's readers take for granted being able to find a diverse array of Batman interpretations in comics and mass media. In 1973, however, seeing how Wrightson would depict the character was an eagerly awaited treat.

SWAMP THING No. 13

Right: *Original sketch, Carmine Infantino and Joe Orlando.* Far right: *Cover art, Nestor Redondo. November–December 1974.*

The strain of meeting deadlines with the painstakingly created art readers had come to expect finally took its toll on Wrightson, who left the book after No. 10. The search for his replacement led to the Filipino talent pool that was producing most of the mystery line's art — a studio now led by Nestor Redondo, a premier artist in that country. The cover sketch shows how an artist-editor like Orlando could take Infantino's pen composition and translate it with additional details to help an artist unfamiliar with Infantino's precise and almost abstract structures, which maximized drama. Notice how beautifully rendered, but less dynamically posed, Redondo's version becomes.

BATMAN FAMILY No. 17

Above: *Cover art, Michael Kaluta, April–May 1978.*

The expansion of *Batman Family* to an 80-page Dollar Comic left room for new stars like the Huntress. Bob Rozakis and Michael Golden's Man-Bat story in issue No. 17 featured a vivid revival of Jack Kirby's Demon, who was fast-tracked to return in his own backup series.

DETECTIVE COMICS No. 402

Opposite: *Cover art, Neal Adams, August 1970.*

Developing a darker Batman was helped by readers' increasing taste for horror. Writer Frank Robbins and artist Adams obliged with the tragic antihero Man-Bat—a scientist whose desire to emulate his hero led to monstrous consequences.

BATMAN No. 351

Above: *Interior, "What Stalks the Gotham Night?"; script, Gerry Conway; pencils, Gene Colan; inks, Tony DeZuniga. September 1982.*

Batman as bloodsucker was always a "natural," but vampirism was prohibited by the Code until 1971. Even then, restrictions on gore remained, making the theme tricky to execute until the early '80s. By then, further liberalizations had cleared the way for stories like this.

BATMAN FAMILY No. 20

Left: *Interior, "Private Eye Man-Bat"; script, Bob Rozakis; pencils, Michael Golden; inks, Joe Rubinstein. October–November 1978.*

A good-humored spin on the Man-Bat cast the winged avenger as a bounty hunter who depended on reward money to support himself and his pregnant wife. The series' light touch was well realized by a parade of fine artists like Marshall Rogers, Howard Chaykin, and Michael Golden.

THE SHADOW No. 5

Left: *Interior, "Night of Neptune's Death!"; script, Denny O'Neil; pencils and inks, Frank Robbins. June–July 1974.*

Frank Robbins stepped in to replace Michael Kaluta, and brought his stark sense of black-and-white cartooning to the series.

THE SHADOW No. 4

Above: *Cover art, M.W. Kaluta, April–May 1974.*

Nearly three decades after comics emerged from the world of pulp magazines, DC licensed the rights to the Shadow. Kaluta's Shadow stories were a career highlight for the legendary artist.

THE SHADOW No. 3

Right: *Interior, "The Kingdom of the Cobra"; script, Denny O'Neil; pencils and inks, Michael Kaluta and Bernie Wrightson. February–March 1974.*

Far behind on his deadline for *The Shadow* No. 3, Michael Kaluta was delighted when Bernie Wrightson offered to help him on the assignment. "It wasn't a 'pencilled by' or 'inked by' credit," Kaluta noted in 2005. "I would be pencilling pages, and he would be pencilling pages, and then we would hand them to each other and would start inking."

BATMAN No. 253

Opposite: *Cover art, Michael Kaluta, November 1973.*

A historic Shadow crossover acknowledged the debt that Batman owed to the pulp crime-fighter, both in the real world and the comic-book universe. Shaking the hand of the man he called his inspiration, the Dark Knight met the Shadow again in a 1974 sequel that contrasted their differences on the use of firearms.

DC COMICS PRESENTS No. 38

Above: Interior, "Whatever Happened to… the Crimson Avenger?"; script, Len Wein; pencils, Alex Saviuk; inks, Dennis Jensen. October 1981.

Nine years after reviving the Crimson Avenger in a Justice League story, Len Wein revisited the Golden Age hero for a final hurrah. Terminally ill, the Avenger performed one last act of heroism to save the city and died with no witnesses to record what he'd done.

ADVENTURE COMICS No. 425

Opposite: Cover art, Michael Kaluta, December 1972–January 1973.

After years of being subordinate to "head-lining" series Supergirl, the vintage *Adventure Comics* logo returned to full prominence in 1972 when editor Joe Orlando took the comic book in a new direction. The revamped anthology soon introduced characters like the Black Orchid and Captain Fear before striking a chord with a Spectre revival.

JUSTICE INC. No. 1

Above: Cover art, Joe Kubert, May–June 1975.

DC COMICS PRESENTS No. 47

Far left: Interior, "Whatever Happened to Sandy the Golden Boy?"; script, Mike W. Barr; pencils, Jose Delbo; inks, John Calnan. July 1982.

WONDER WOMAN No. 300

Left: Interior, "Beautiful Dreamer, Death Unto Thee"; script, Roy and Danette Thomas; pencils, Gene Colan; inks, Frank McLaughlin. February 1983.

Both the 1940s and 1970s versions of the Sandman were revisited as well in the early 1980s. The former received closure through a reunion with his old partner Sandy and effectively retired while the latter was initially revived as a would-be suitor of Wonder Woman before being folded into the new *Infinity, Inc.*

109

ADVENTURE COMICS No. 431

Opposite: *Cover art, Jim Aparo, January–February 1974.*

The mugging of editor Joe Orlando's wife inspired a tough take on crime. Michael Fleisher's version of the Golden Age's ghostly avenger, the Spectre, meted out poetic justice as shocking and grotesque as the Comics Code would permit, making for 10 issues of thrills readers would remember for decades.

ADVENTURE COMICS No. 432

Below: *Interior, "The Anguish of…the Spectre"; script, Michael Fleisher; pencils and inks, Jim Aparo. March–April 1974.*

The ghastly fare of the Spectre strip was sometimes at odds with *Adventure Comics*' more traditional backup strips. An issue touting the return of Aquaman — then starring in the *Super Friends* cartoon — appeared in the same issue where the Spectre transformed a killer into a block of wood and sawed him into pieces.

ADVENTURE COMICS No. 428

Above: *Interior, "The Ghosts on the Glasses"; script, Steve Skeates; pencils and inks, Tony DeZuniga. July–August 1973.*

Spinning off from the Phantom Stranger series, the Doctor Thirteen backup strip featured a character who didn't believe in ghosts and spent each case finding a logical explanation for the horrors he witnessed. When he finally met the Spectre in a 1980 story, the Ghost-Breaker's confidence was shaken.

Carson of Venus

"Into the Land of Noobol"
BASED ON *EDGAR RICE BURROUGHS'* "LOST ON VENUS"

OUT OF THE DOZEN *KLANGAN* THAT HAD STOLEN THE PRINCESS *DUARE*, ONLY ONE REMAINED ALIVE! WE WERE ATTEMPTING TO SIGNAL OUR WARSHIP WHEN WE WERE ATTACKED BY A BAND OF *THORIST WARRIORS*...

RATHER THAN HAVE DUARE CAPTURED, I ORDERED THE BIRDMAN TO FLY HER TO THE SHIP...

...AND AS THEY SOARED INTO THE CLOUD-HAUNTED SKY, I TURNED TO FACE MY GRIM ASSAILANTS!

"Edgar Rice Burroughs, wherever you are, my apologies. You wrote splendid action scenes and you created memorable people — huger than real life, purer, yet somehow believable — and best of all, you made whole worlds, exotic, filled with strange creatures and bizarre landscapes and a beauty I can't explain."

— DENNIS O'NEIL

WEIRD WORLDS No. 6

Above: *Cover art, Michael Kaluta, July–August 1973.*

A fan of the John Carter stories since childhood, Murphy Anderson was thrilled at the chance to draw the series when DC gained the rights. Premiering in *Tarzan*, the feature subsequently moved to *Weird Worlds* and Anderson reluctantly left the series to draw the higher-profile *Korak, Son of Tarzan*. John Carter's influence on Superman was readily apparent in these panels featuring the gravitationally augmented leaps that the hero took on Mars. Jerry Siegel often cited the hero as one of his inspirations.

CARSON OF VENUS

Opposite and left: *Interior,* Korak, Son of Tarzan *No. 54, "Into the Land of Noobol"; script, pencils, and inks, Michael Kaluta. October–November 1973.*

Given the opportunity to draw one of Edgar Rice Burroughs' features when DC acquired the license, Michael Kaluta initially asked for John Carter but learned that Murphy Anderson had already claimed it. Instead, Kaluta united with Len Wein on a serialized adaptation of Carson of Venus, eventually taking over the writing as well.

CAPTAIN FEAR

Left: *Interior, "Revolt and Revenge"; script, Steve Skeates; pencils and inks, Alex Niño. May–June 1974.*

Alex Niño recalled the short-lived Captain Fear episodes fondly "because that was a period strip, based in Colonial times, and it was fun to draw. It was a costume drama, very different from most of the scripts I received. Twists and turns — story short, but easy to understand."

THE BLACK PIRATE RETURNS

Opposite: *Interior, DC Comics Presents No. 48, "Whatever Happened to the Black Pirate and Son?"; script, Roy Thomas; pencils and inks, Alfredo Alcala. August 1982.*

Given the opportunity to conclude the Golden Age Black Pirate's story, Roy Thomas wrote a piece in which the Jon Valor's son Justin became a Puritan and sailed to the New World in search of religious freedom.

ADVENTURE COMICS No. 433

Right: *Interior, "Revolt and Revenge"; script, Steve Skeates; pencils and inks, Alex Niño. May–June 1974.*

"I was interested in the Caribbean and Haiti and I wanted to create an Indian hero," Joe Orlando said of slave-turned-pirate Captain Fear, "because you know that the Caribe Indians in the Dominican Republic were decimated through slavery." Ultimately the series disappointed, but Orlando said about Niño's contributions: "The art was beautiful."

WHATEVER HAPPENED TO THE BLACK Pirate AND SON?

Roy Thomas WRITER
Alfredo Alcala ARTIST/LETTERER

PROUDLY PRESENT THE STARTLING *FINAL CHAPTER* OF THE 1940s' MOST SWASHBUCKLING SERIES AIDED BY:

Julius Schwartz EDITOR & **Carl Gafford** COLORIST

"GIVE THE THIEVING DOGS A TASTE OF *GOOD ENGLISH STEEL*, LAD!"

"AYE, AND THAT *GLADLY*, FATHER!"

"*MADRE DE DIOS!* 'TIS THE SCOURGE OF ALL CORSAIRS-- *THE BLACK PIRATE!*"

SCALPHUNTER

Above: *Cover art*, Weird Western Tales *No. 53, George Evans and Luis Dominguez, March 1979.*

After Jonah Hex was spun off to his own title, Scalphunter—a white man raised by Kiowa Indians—became the new star of *Weird Western Tales*. Set during the Civil War, the series included an eight-part adventure in which Scalphunter came to Washington, D.C. and helped thwart a plot to kill President Abraham Lincoln.

WEIRD WESTERN TALES No. 14

Opposite: *Cover art, Tony DeZuniga, October–November 1972.*

EL DIABLO

Above: *Interior*, Jonah Hex *No. 57, "Desert Hell"; script, Gary Cohn; pencils and inks, Tony DeZuniga. February 1982.*

Before the ascension of Jonah Hex, the black-garbed El Diablo had been DC's foremost Weird Western hero. Despite atmospheric art by Gray Morrow and Neal Adams, the supernatural horsemen was never terribly successful as a leading man. He was revived at intervals into the 1980s, though, as a reliable backup feature.

JONAH HEX

Right: *Interior*, All Star Western *No. 10, "Welcome to Paradise"; script, John Albano; pencils and inks, Tony DeZuniga. February–March 1972.*

In response to a reader who pronounced Jonah Hex a "homicidal maniac" and asked for "clean-cut heroes," editor Joe Orlando declared that a reprint revival of 1950s Western heroes like Johnny Thunder had been "far less successful than our Weird Western characters.... Perhaps readers' tastes have changed."

Dick Giordano

"Growing up, my favorite hero was the Batman. Not so much because he looked cool, but because he had no superpowers... I believed he was real, and that if I wanted to I could become like him."

— DICK GIORDANO

TWO MASTER TEACHERS

Above: *Photograph, Harvey Kurtzman and Dick Giordano (foreground), Bob Layton and Joe Staton (background), ca. 1978.*

"I never knew I had so many brothers."
—Richard Giordano Jr., on hearing so many of his father's former associates describe Dick Giordano as a father figure at the DC memorial service, 2010

Both legendary for the their teaching skills, Kurtzman and Giordano developed a legion of talented protégés. Kurtzman wins peak moment (for simultaneously having Gloria Steinem, Terry Gilliam, and Rene Goscinny as assistant editors), but Giordano wins for largest group of talented assistants to subsequently solo in the comics field (particularly the generation of inkers who dominated the 1980s).

BATMAN No. 300

Opposite: *Cover art, Dick Giordano, June 1978.*

Anniversary issues and round hundred issue numbers are traditionally special moments for DC. For issue 300, Giordano got to illustrate a possible end to Batman's story.

THE BRAVE AND THE BOLD No. 143

Right: *Interior, "The Cat and the Canary Contract!"; script, Len Wein; pencils and inks, Dick Giordano. September–October 1978.*

Giordano inked the very first Human Target tale over Carmine Infantino's pencils, and went on to illustrate the series himself, in one of his longest runs at DC as penciller and inker.

DETECTIVE COMICS No. 457

Above: *Interior, "There Is No Hope in Crime Alley!"; script, Denny O'Neil; pencils and inks, Dick Giordano. March 1976.*

This touching retelling of Batman's origin adds the crucial detail of a compassionate social worker, based on *Catholic Worker* writer Dorothy Day. Leslie Thompkins brought her inspiration's pacifism to bear in subsequent stories as a quiet alternative to Batman's aggression.

I BURIED SAUL?

Left: *Cover art*, Batman *No. 222, Neal Adams, June 1970.*

The Beatles were frequent fodder for 1960s comics, and DC was no exception, inserting the Fab Four into cameos in *Girls' Romances*, *Metal Men*, and *Jimmy Olsen*, or having them send a fan letter to the *Teen Titans*. Playing off the 1969 hoax that Paul McCartney had died and been replaced by a look-alike, this 1970 story had Batman and Robin investigate similar accusations against the Oliver Twists. In this case, "Saul" was himself responsible for the hoax, to deflect attention from the fact that the rest of the quartet had died in a plane crash.

BATMAN FAMILY No. 17

Opposite: *Interior, "Scars"; script, Gerry Conway; pencils and inks, Jim Aparo. April–May 1978.*

Despite regularly drawing Batman team-ups in *The Brave and the Bold*, Jim Aparo rarely drew an interior story that united the Dark Knight with his original partner, Robin.

THE VILLAGE VILLAINS

Right: *Cover art*, Batman *No. 297, Jim Aparo, March 1978.*

After several years of stories primarily devoted to realistic adversaries, the Batman series began playing up super villains in nearly every issue beginning in 1977. Four issues were devoted to a cameo-laden "trial" involving the Dark Knight's death: the Joker and Penguin made multiple appearances, plus long-absent adversaries like Deadshot and the Mad Hatter returned.

BATMAN and ROBIN

GOTHAM CITY: ONE HOUR AFTER SUNSET...

ACTRESS MISSING

THREE DAYS AFTER THE DISAPPEARANCE OF SCREEN STARLET MARGO MULHARE, POLICE ARE STILL BAFFLED BY THE TOTAL LACK OF CLUES...

Jim Aparo

"Comics should still be for fun. Everybody gets too involved; there's too much of a hangup for authenticity… it's just entertainment. And the writers, the artists, the editors, we're just the guys who want to do just that — entertain people!" —JIM APARO

APARO AT WORK

Above: *Photo by Jack C. Harris, Jim Aparo in his Connecticut studio, February 1982.*

As illustrator on *Aquaman*, *The Phantom Stranger*, *The Brave and the Bold*, and more, Jim Aparo took pride in pencilling, inking, and lettering each page. By the early 1980s, the veteran artist's visualization of the pages he intended to draw was so strong that he lettered the pages in ink before pencilling the images around them.

PHANTOM STRANGER No. 39

Opposite: *Original cover art, Jim Aparo, October–November 1975.*

Although associated primarily with super heroes like Batman, the versatile Jim Aparo was adept at drawing horror as well. On the *Phantom Stranger*, the Spectre series, and in the occasional covers and stories for DC's supernatural titles, Aparo's crisp, attractive art drew readers into a given situation and added impact to the horror.

THE BRAVE AND THE BOLD No. 124

Above: *Cover art, Jim Aparo.* Right: *Interior, "Small War of the Super Rifles"; script, Bob Haney; pencils and inks, Jim Aparo. January 1976.*

Highly regarded for his early '70s run on *The Phantom Stranger*, Jim Aparo was assigned to draw the character's 1971 guest-appearance in *The Brave and The Bold* No. 98. Impressed with the results, editor Murray Boltinoff quickly installed Aparo as Batman permanent team-up artist by issue 100. Emerging as one the era's definitive Batman illustrators, Aparo maintained his association with the Dark Knight until his retirement in 2001. One of writer Bob Haney's most off-the-wall scripts was this meta-story in which terrorists attempted to force Aparo to redraw a Batman/Sgt. Rock story so that the villains would win.

123

THE JOKER'S LAST LAUGH

Above: *Cover art, Ross Andru and Vince Colletta, 1980.*

In 1979, DC partnered with General Mills to create quartets of mini-comics that were inserted into cereal boxes as premiums. Ross Andru pencilled the covers of each issue, while artists such as Don Newton, Kurt Schaffenberger, and Ric Estrada pencilled the interiors.

DETECTIVE COMICS No. 476

Opposite: *Cover art, Marshall Rogers and Terry Austin, March–April 1978.*

Arguably fans' best-loved version of Batman in the mid-1970s, writer Steve Englehart and penciller Rogers' *Detective* run featured an unambiguously homicidal Joker and resurrected such psychotic Golden Age villains as Hugo Strange, all in noirish, moodily rendered stories that evoked the classic Kane-Robinson era.

BATMAN No. 321

Above: *Interior, "Dreadful Birthday, Dear Joker"; script, Len Wein; pencils, Walter Simonson; inks, Dick Giordano. March 1980.*

By the end of the 1970s, the Joker was in danger of oversaturation. After two dozen appearances in eight years, his inevitable returns were scaled back going into the 1980s to ensure that they'd be more of an event.

UNTOLD LEGENDS OF THE BATMAN No. 1

Left: *Interior, "In the Beginning"; script, Len Wein; pencils, John Byrne; inks, Jim Aparo. July 1980.*

While the Joker's standing as Batman's foremost foe wasn't in dispute, there were always many more waiting in the wings, from the well-established Penguin, Riddler, and Two-Face to '70s creations like Rā's al Ghūl, Dr. Phosphorus, and a new Clayface.

DETECTIVE COMICS No. 500

Following pages: *Original cover art; José Luis García-López, Dick Giordano, Carmine Infantino & Bob Smith, Joe Kubert, Walter Simonson, and Tom Yeates (cover montage). March 1981.*

BOB LeROSE

Detective Comics

Proudly invites you to join in The 500th Anniversary Celebration of Detective Comics

NO. 500 MAR. $1.50

7 SPECIAL STORIES by WALTER GIBSON (Creator of THE SHADOW)

- Jim APARO
- mike BARR
- cary BATES
- alan BRENNERT
- dick GIORDANO
- carmine INFANTINO
- Joe KUBERT
- paul LEVITZ
- J.L. GARCIA LOPEZ
- walter SIMONSON
- bob SMITH
- len WEIN
- tom YEATES

DETECTIVE COMICS No. 475

Above: *Cover art, Marshall Rogers and Terry Austin, February 1978.*

While pencilling his two-part Joker story, Marshall Rogers recalled Jerry Robinson's visual inspiration for the Joker and kept a photo of actor Conrad Veidt (from 1928's *The Man Who Laughs*) above his drawing board. For his part, Steve Englehart strived to write the Joker as more insane than he'd ever been.

DC SPECIAL SERIES No. 15

Opposite: *Interior, "Death Strikes at Midnight and Three"; script, Denny O'Neil; pencils and inks, Marshall Rogers. Summer 1978.*

BATMAN No. 260

Above: *Interior, "This One'll Kill You, Batman"; script, Denny O'Neil; pencils, Irv Novick; inks, Dick Giordano. January–February 1975.*

In Denny O'Neil's second Joker story, he infected Batman with a slow-acting version of Joker Venom that threatened to make the Dark Knight die laughing.

DETECTIVE COMICS No. 468

Right: *Interior, "Battle of the Thinking Machines"; script, Bob Rozakis; pencils, Marshall Rogers; inks, Terry Austin. March–April 1977.*

After a publisher announced his intent to approach Batman about his memoirs, Bruce Wayne said, "You expect him to write a book for you?"

Later, Anthony Toombs would wonder if it was an hallucination, an illusion fomented by his immense fear and the startling, unexpected hope of salvation. Illusion or not, however, he would cherish those few moments of violence the rest of his days, would remain almost convinced that at twelve and three his personal darkness had been briefly lifted and he had seen:

The Batman, stark and implacable against the expanse of white, a grim figure congealing from the shadows.

"Looking for a target, gentlemen?" He asked pleasantly. "I volunteer."

Thomas and Malone jerked up their Colts and orange and blue flame gouted from the barrels. The screen shook and two holes puckered its gleaming surface, but The Batman remained untouched; as he had congealed, now he seemingly dissolved.

Unseen, he called, "Sloppy shooting."
Panicked, Thomas and Malone fired in every direction, again and again and again. A sprinkling of plaster dust fell from the ceiling.
The roar of gunfire faded, and there was silence.
"We got 'im," Gimp Malone said.

The blind man knew he was wrong. The blind man could see The Batman's fist pitch Malone into the aisle where he lay like refuse.
Then The Batman faced Boilerplate Thomas. Thomas started to raise the Colt.

"You could conceivably succeed," The Batman said. "If you're quick, and if your gun isn't empty, you might be able to nail me before I stuff it in your ear."
And the blind man saw Thomas extend the weapon to The Batman, butt first.

The familiar darkness gathered in his sight, and he was comforted.

Marshall Rogers

"Neal and Denny brought the character back to the darkness — absolutely what I always wanted to see — but not exactly how I wanted to see it. So I had a chance to do what I envisioned." —MARSHALL ROGERS

BACK TO THE DARKNESS

Above: *Photograph by Jackie Estrada, Marshall Rogers at San Diego Comic-Con, 1978.*

THE BATMAN PORTFOLIO

Opposite: *Portfolio, art, Marshall Rogers, 1981.*

The popularity of Rogers' Batman was so great that a licensed portfolio of new images was released in 1981. In 2005, the Englehart-Rogers-Austin team reunited for the six-issue *Batman: Dark Detective* miniseries.

DETECTIVE COMICS No. 472

Above: *Cover art, Marshall Rogers and Terry Austin, September 1977.*

After earning reader raves for a full-length Batman–Calculator story, Marshall Rogers and Terry Austin quickly became the official artists on *Detective Comics*.

THE SIGN OF THE JOKER

Right: *Interior, Detective Comics No. 476; script, Steve Englehart; pencils, Marshall Rogers; inks, Terry Austin. March–April 1978.*

The Joker's advance announcements about his upcoming murder victims in *Detective* Nos. 475–476 was an homage to his initial crime spree in 1940's *Batman* No. 1.

BATMAN No. 349

Above: *Interior, "The Man, the Bullet, the Cat: Part Two"; script, Bruce Jones; pencils, Trevor von Eeden; inks, Larry Mahlstedt. July 1982.*

BATMAN No. 355

Opposite: *Cover art, Ed Hannigan and Dick Giordano, January 1983.*

Although officially reformed, Catwoman wasn't above slipping into old patterns, as when she suffered a breakdown and attempted to kill Bruce Wayne's latest flame Vicki Vale. "I saw her as the ultimate bad-girl-trying-to-be-good," writer Gerry Conway remarked in 2010. "She was somewhat amoral, and slightly sociopathic."

DETECTIVE COMICS No. 475

Above: *Interior, "The Laughing Fish"; script, Steve Englehart; pencils, Marshall Rogers; inks, Terry Austin. February 1978.*

Bruce Wayne's girlfriend Silver St. Cloud was enormously popular with readers, so much so that she became the love interest in early drafts of the 1989 *Batman* movie.

BATMAN No. 350

Right: *Interior, "Those Lips, Those Eyes"; script, Bruce Jones; pencils and inks, Tony DeZuniga. August 1982.*

After decades as a villainess, the Catwoman reformed in 1978, initially becoming a love interest for Bruce Wayne in her alter ego of Selina Kyle. Inevitably, she resumed her costumed persona, now acting as a heroine and even appeared in a short-lived solo series in the back pages of *Batman*.

The daughter of Gotham's police commissioner, Barbara Gordon fights for justice on two fronts-- as a CONGRESSWOMAN and as the DOMINOED DAREDOLL named...

BATGIRL

In a city the size of GOTHAM, there are many HUMAN VULTURES who prey upon those WEAKER than themselves, and a scene like this is all too COMMON...

"YOU DON'T WANT TO PAY YOUR INSURANCE, HUH? NOT A SMART MOVE, MISTER! WHO KNOWS WHAT COULD HAPPEN TO YOU?"

"YEAH... LIKE MAYBE ALL YOUR STOCK COULD GET DESTROYED!"

But THIS scene is about to become very UNCOMMON... with the dramatic appearance of the DARKNIGHT DAMSEL--

"BATGIRL!"

BOSSMAN'S BANE!

CARY BURKETT — WRITER • JOSE DELBO & FRANK CHIARAMONTE — ARTISTS
BEN ODA — LETTERER • GENE D'ANGELO — COLORIST • PAUL LEVITZ — EDITOR

WORLD'S GREATEST SUPER-GALS!

Above: *Batgirl action figure, Mego, 1974.*

A companion to Mego's line of male heroes like Superman, Batman, and Robin, the Super-Gals action figures consisted of Batgirl, Supergirl, Wonder Woman, and Catwoman.

DETECTIVE COMICS No. 495

Opposite: *Interior, "Bossman's Bane!"; script, Cary Burkett; pencils, José Delbo; inks, Frank Chiaramonte. October 1980.*

At her peak in the 1970s, Batgirl seemed to have it all: Respect as an adult heroine and a successful career as a Washington, D.C. congresswoman in her Barbara Gordon identity. By the end of the decade, though, her fortunes shifted and she returned to Gotham City with a crisis of confidence that informed her characterization for the next decade.

BATGIRL GOES BOO!

Left: *Photograph, Jen (age 3) trick-or-treating in a Ben Cooper Halloween costume, 1974.*

BATMAN FAMILY No. 11

Above: *Interior, "Til Death Do Us Part"; script, Bob Rozakis; pencils, Curt Swan; inks, Vince Colletta. May–June 1970.*

After being retired in 1972, Batgirl was revived by writer Elliot S! Maggin in a pair of Superman team-ups that spurred the development of a *Batman Family* comic book. The title alternated Batgirl–Robin team-ups with solo stories featuring the two heroes.

135

BETMEN

Above: *Unauthorized Turkish film poster, 1973.*

Officially known as *Yarasa Adam—Betmen*, perhaps in an effort to avoid confusion with the Anatolian province of Batman (no known relation), this unauthorized Turkish movie was hilariously off-model. The Caped Crusader carried—and fired—guns, bedded many of the women he met, tossed Robin at the villains they fought, and wasn't particularly concerned about wearing a mask.

FIGHT BATMAN FIGHT!

Opposite: *Unauthorized Filipino film poster, 1973.*

LA MUJER MURCIELAGO

Above: *Film poster, Mexico, Cinematográfica Calderón S.A., 1968.*

DC worked hard to erase Batman's "camp" image, but not everyone—such as those who disregarded DC's ownership—cooperated.

BAT-MURAL

Right: *Photograph, Batman graffiti, location unknown, 1970s.*

FIGHT BATMAN FIGHT!

starring **VICTOR WOOD** as Batman

GLORIA ROMERO · ROSEMARIE GIL · LOTIS KEY · RODERICK PAULATE
Rossana Marquez · Rod Navarro · Ike Lozada · German Moreno Pinky

Cinematography by JUSTO PAULINO · Music by ERNANI CUENCO · Screenplay & Directed by ROMEO N. GALANG
EASTMANCOLOR

MUCH OF THE YEAR, **WAYNE MANOR** IS DARK, BUT NOT TONIGHT...

TONIGHT, LIGHTS BURN FOR *THIS* MAN...NDELE KSHUMBO, PRIME MINISTER OF THE NEW AFRICAN NATION *CONGOLA*, A LAND ONCE *ENSLAVED* BY MILITARY DICTATORSHIP...

NOW, AFTER LONG, BITTER FIGHTING, HE AND HIS PEOPLE ARE *FREE*...

CLICK

RACHET RACHET

SNAP

KLACK

WHOP! WHOP! WHOP!

TIMING! FOR THE ASSASSIN... *PERFECT!* FOR THE BATMAN...

...REAPPEARING AS BRUCE WAYNE...

...AWFUL!

NOW HE RACES FOR HIS BARELY ABANDONED CAPE AND COWL! NOW HE MOVES TOWARD THE *BEGINNING* OF A BLOODY TRAIL TO...

MANHUNTER'S MAKERS

Above: *Caricature, Archie Goodwin and Walter Simonson; art, Walter Simonson. 1984.*

"When the original strip was wrapping up," Walter Simonson recalled in 1999, "Archie and I joked that maybe we should retire, that this was about as good as it was liable to get."

DETECTIVE COMICS No. 443

Opposite: *Interior, "Gotterdammerung"; script, Archie Goodwin; pencils and inks, Walter Simonson. October–November 1974.*

With plans in place to leave DC, Archie Goodwin received permission to remain editor on *Detective Comics* long enough to bring the Manhunter story to a close in a 20-page team-up with Batman. "Manhunter is one of just several projects that I've worked on that I consider a highlight in my career," Goodwin said in 1998. "It is something that I may never be able to top in a lot of ways."

COLOR GUIDE

Above: *Original art, Walter Simonson, 1973.*

Part of the color scheme for Manhunter's costume was based on the blue and red that were part of Paul Kirk's outfit in the 1940s.

DETECTIVE COMICS No. 440

Left: *Interiors, "Rebellion"; script, Archie Goodwin; pencils and inks, Walter Simonson. April–May 1974.*

Archie Goodwin initially found Walter Simonson's samurai-style Manhunter costume to be unwieldy but the artist's redesigns struck the writer as too much like a conventional super hero. Goodwin not only came around to the original look but even acquiesced on the character's trademark Mauser despite concerns that it was somehow inappropriate. "As Manhunter's more or less mercenary background began to evolve," the writer recalled, "the gun seemed to fit."

DETECTIVE COMICS No. 442

Above: *Interior, "To Duel the Master"; script, Archie Goodwin; pencils and inks, Walter Simonson. August–September 1974.*

A panel from the groundbreaking Manhunter saga, told primarily as a series of backup stories in *Detective Comics*, featuring the early work of comics legend Walt Simonson.

DETECTIVE COMICS No. 437

Left: *Interior, "The Himalayan Incident"; script, Archie Goodwin; pencils and inks, Walter Simonson. October–November 1973.*

The Manhunter series created a sensation from the start, its first episode picking up a Shazam award from the Academy of Comic Book Arts as 1973's Best Short Story. Walter Simonson also claimed a trophy for Outstanding New Talent.

DETECTIVE COMICS No. 443

Right: *Interior, "Gotterdammerung"; script, Archie Goodwin; pencils and inks, Walter Simonson. October–November 1974.*

MANHUNTER No. 1

Opposite: *Cover art, Walter Simonson, May 1984.*

Within a decade of its original serialization, Goodwin and Simonson's celebrated saga had been collected in its entirety twice. Following a licensed black-and-white edition from Excalibur Enterprises in 1979, DC published a color version. The pair planned to produce a new epilogue for the 1999 re-edition, but after Goodwin's untimely death, Simonson completed the story without dialogue to honor his collaborator.

RICHARD DRAGON
KUNG-FU FIGHTER

THE DEADLIEST MAN ALIVE... THIS IS *RICHARD DRAGON*, MASTER OF ALL THE FIGHTING ARTS! YET HE HAS BEEN DEFEATED BY HIS SWORN ENEMY, THE *SWISS*... DEFEATED UNTIL *NOW!*

FOR WITH BOTH HIS *HONOR* AND THE LIFE OF A LOVELY *WOMAN* AT STAKE, HE KNOWS THAT THIS TIME HE *MUST* WIN--AT *ANY* COST!

YES, THIS TIME RICHARD DRAGON MUST *CRUSH* THE SWISS, FOR THIS IS--

A TIME TO BE A WHIRLWIND!

Adapted from JIM DENNIS' novel by
DENNY O'NEIL
writer
RIC ESTRADA & WALLY WOOD
artists

KARATE KID No. 1

Above: *Cover art, Mike Grell, March–April 1976.*

With a martial arts fad packing American movie houses and the Legion carrying the reformatted *Superboy* to new heights, spinning off this Legionnaire into his own series worked well for 15 issues. But later efforts to exploit the character were somewhat stymied by the 1984 film, which had no relation to this comic.

RICHARD DRAGON, KUNG FU FIGHTER No. 4

Opposite: *Interior, "A Time to Be a Whirlwind"; script, Denny O'Neil; pencils, Ric Estrada; inks, Wally Wood. October–November 1975.*

Created to take advantage of the martial arts craze in pop culture, *Richard Dragon, Kung Fu Fighter* ironically premiered just three months before ABC's hit TV series *Kung Fu* went off the air. The character had made his debut in the 1974 novel *Dragon's Fists*, written pseudonymously by Denny O'Neil and Jim Berry.

RICHARD DRAGON, KUNG FU FIGHTER No. 14

Above: *Cover art, Rich Buckler, March–April 1977.*

Three years after his death, Bruce Lee still loomed large as one of film's most iconic martial artists. A Richard Dragon story capitalized on his reputation in a story dealing with a supposed student of the late actor.

RICHARD DRAGON, KUNG FU FIGHTER No. 5

Left: *Interior, "The Arena of No Exit"; script, Denny O'Neil; pencils, Ric Estrada; inks, Wally Wood. December 1975–January 1976.*

Although Richard Dragon was the leading man, it was his companions who stood the test of time. Best friend Benjamin Turner became better known to 1980s readers as the Bronze Tiger while Lady Shiva took a turn toward the dark side and became one of DC's deadliest martial artists.

"I did a number of covers where I combined live action with drawings.... It wasn't my nature to sign them. I didn't think it was important, so I never bothered. All because it was just work; it was just my job."

— JACK ADLER

SUPERMAN No. 263

Opposite: *Cover art, Neal Adams (pencils), Murphy Anderson (inks), and Jack Adler (photo effects), April 1973.*

Cover dates on comics didn't match magazine dating norms, and by 1973 the competition's cover dates made them appear newer than DC's, so DC decided to skip using May 1973 and go straight to June. Maybe that's why Superman's in such a hurry on this April 1973 cover?

SUPERMAN No. 289

Left: *Cover art, Curt Swan (pencils), Bob Oksner (inks), and Jack Adler (photo effects including Bob Rozakis, Cary Bates, Jack C. Harris, and Carl Gafford as live models), July 1975.*

Photos for covers were created spontaneously, with photographer Adler recruiting whoever was available in the office when it was time to shoot — in this case, one writer, two assistant editors, and a production artist.

LIMITED COLLECTORS' EDITION No. C38

Above: *Cover art, Curt Swan and Bob Oksner, October–November 1975.*

GLOW-IN-THE-DARK KRYPTONITE

Above: *Advertising art, Heroes World, Joe Kubert School students, 1979.*

Two years after the creation of the Pet Rock, a glow-in-the-dark counterpart debuted in the form of Kryptonite Rocks. The Superman tie-ins were, of course, ordinary stones that were painted in Medina, Ohio.

SUPERMAN'S PAL, JIMMY OLSEN No. 126

Left: *Cover art, Curt Swan and Murphy Anderson, January 1970.*

Published just months after 1969's first moon landing, Jimmy Olsen imagined a worst case scenario: some of the moon rocks were actually lethal Kryptonite! Naturally, it was all a hoax.

IT'S A KILLER!

Right: *Cover art, The Best of DC No. 36; Ed Hannigan and Dick Giordano, May 1983.*

Less than seven years after kryptonite's expulsion from the Superman series, it returned in a big way during 1977. The new rain of glowing meteorites striking Earth was blamed on the explosion of a planet that was Krypton's twin and helped fuel a new version of Metallo, the man with the kryptonite heart.

SUPERMAN No. 317

Opposite: *Cover art, Neal Adams, November 1977.*

After creating a powerful image of Superman for a fanzine drawing, Neal Adams believed the piece was good enough for an official cover. Julius Schwartz agreed and added green tint and dialogue to fit an interior story.

UP, UP, AND AWAY

Above: *Photograph, assembly of Macy's Thanksgiving Day Parade Superman Balloon, 1980.*

ACTION COMICS No. 388

Opposite: *Cover art, Curt Swan and Murphy Anderson, May 1970.*

A deranged Superman cover overflowed with deliberate errors that were obvious to devoted fans. Among those details was the Man of Steel wearing Clark Kent's glasses, Perry White smoking a pipe rather than his trademark cigar, Brainiac wearing Mr. Mxyzptlk's costume, and Krypto the Superdog sporting the colors of Streaky the Supercat.

WORLD'S FINEST COMICS No. 241

Above: *Interior, "Make Way for a New World"; script, Bob Haney; pencils, Pablo Marcos; inks, John Calnan. October 1976.*

Macy's wasn't the only place Superman blew up like a balloon, though this wasn't one of his powers. Whether explained in the story or not, this sort of aberration was customary with writer Haney, whose disregard for established continuity was notorious among fans.

MAD MAGAZINE No. 208

Left: *Interior, "A Mad Look at Superman"; script, Don Edwing; pencils and inks, Don Martin. July 1979.*

Stranded on the set of *Superman: The Movie* on July 13, 1977, DC President Sol Harrison rushed to a pay phone and tried repeatedly to call his wife without success. As witnessed by DC proofreader Gerda Gattel, Harrison was using one of the movie's prop phones.

It is a very human, vulnerable person who drives a rented car through well-remembered streets of the village of SMALLVILLE...

THE PRIVATE LIFE OF CLARK KENT

...a man full of memories and all too full of sentiment on this very special afternoon in...

My childhood home... where MA and PA KENT raised me from infancy...

PETER ROSS ASSOCIATES GEOLOGICAL SURVEYORS

...and eased me through the pains of being a teen-ager!

I held onto the house as a kind of link with the past because I knew that you get awfully lonely when you spend your life hiding the fact that you're a SUPERMAN!

A geological survey has shown that the best possible place to run the new INTERSTATE HIGHWAY...

...is right through this piece of land!

So... I'll just have to adjust now to the fact that...

STORY: ELLIOT MAGGIN
ART: MURPHY ANDERSON

ACTION COMICS No. 454

Above: *Cover art, Bob Oksner, December 1975.*

DC's comic books were filled with businesses that seemed strangely similar to ones in the real world. MacTavish's—DC's parody of McDonald's—appeared in titles like *Action Comics*, *The Flash*, and *Infinity, Inc.*

SUPERMAN No. 270

Opposite: *Interior, "I Can't Go Home Again"; script, Elliot S! Maggin; pencils and inks, Murphy Anderson. December 1973.*

In this period, action-packed *Superman* lead stories were paired with lighter or more introspective shorts about the character's non-super dimensions. This was an early entry in a series that ran for many years.

ACTION COMICS No. 469

Above: *Cover art, José Luis García-López, March 1977.*

Although some readers laughed at the concept of a space-cowboy, Terra Man regularly reared his head in the Superman titles for more than a decade, with 18 appearances between 1972–1986.

SUPERMAN No. 225

Left: *Interior, "The Secret of the Superman Imposter"; script, Leo Dorfman; pencils, Curt Swan; inks, George Roussos. April 1970.*

Stories in which a hero met his double offered a surefire sales boost, but the gimmick was finally wearing thin by the time editor Mort Weisinger retired in 1970.

SHAZAM! No. 11

Opposite: Cover art, Bob Oksner, March 1974.

Original Captain Marvel artist C. C. Beck returned for DC's revival, but quickly came to disagree with the new writers and editor Julie Schwartz about the way to make the Big Red Cheese entertaining for a new generation. "I'm a firm believer in a little friction between editors and writers and artists," said Beck during their debates. But as 1974 began, he stepped away from the drawing board after 10 issues, returning to semiretirement. The slack was ably taken up by another original Captain Marvel artist, Kurt Schaffenberger, known to DC readers as Lois Lane's primary artist for more than 15 years, and the versatile Bob Oksner, equally adept at adventure and humor—a perfect fit for *Shazam!*

SUPERMAN No. 276

Above: *Cover art, Nick Cardy, June 1974.*

Fans who knew how Superman and Captain Marvel had figuratively battled, when DC and Fawcett fought over copyright infringement, often fantasized about an "actual" battle between the two heroes. Soon after *Shazam!* hit the stands, DC teased readers with such a battle by introducing Captain Thunder, an Earth-One version of the Big Red Cheese.

SHAZAM! No. 15

Right: *Interior, "Captain Marvel Meets… Lex Luthor"; script, Denny O'Neil; pencils, Bob Oksner; inks, Tex Blaisdell. November–December 1974.*

SHAZAM!

SPROING!

As Billy pronounces the magic word, the Suspendium watch, now no longer set correctly, blows itself to pieces!

BOOM

Instantly, magic lightning flashes and...

THE WORLD'S MIGHTIEST MORTAL IS ON THE JOB!..

BY FLYING AT **HALF** THE SPEED OF LIGHT I'LL BE ABLE TO FIND SIVANA IN ALMOST **NO** TIME AT ALL!

FOOOOOMM

Time is indeed strange! After a search that could have taken hours or days of normal time, Captain Marvel locates the mad scientist's hideout...

CRASH

HA! ONLY SECONDS HAVE PASSED!

SECOND, I'M GOING TO... WHA-?

SIVANA BROADCASTING SYSTEM

RIP BLAM

I'M A LITTLE LATE, BUT **BETTER LATE THAN NEVER**, EH, SIVANA?

OH, NO!

7

SHAZAM! No. 6

Opposite: *Interior, "Better Late than Never!"; script, Denny O'Neil; pencils and inks, C. C. Beck. October 1973.*

SHAZAM! No. 2

Above, left to right: *Cover mockup, black proof, and final proof; art, C. C. Beck and Jack Adler. April 1973.*

When developing the photo cover for *Shazam!*'s second issue, production manager Jack Adler used his grandson and two neighbor children as components in the shot. When another grandson expressed his jealousy, Adler was obligated to do a second photo cover for No. 6, and even used his son-in-law as a stand-in for the Captain Marvel figure that Beck drew for the published version.

PROUD GRANDPARENTS

Left: *Photograph, Jack Adler and publisher Carmine Infantino at the DC offices. July 1973.*

THE GUARDIAN MONSTER CONQUERED, THE TRIO ENTERS THE *KINGDOM OF THE DAMNED*...

SHAZAM! No. 35

Opposite: *Interior, "Backward, Turn Backward, O Time in Your Flight"; script, E. Nelson Bridwell; pencils, Don Newton; inks, Kurt Schaffenberger. May–June 1978.*

The arrival of penciller Don Newton opened opportunities for more serious stories in the *Shazam!* series, such as the Marvel Family's descent into Hell.

CAPTAIN MARVEL LIVES!

Below: *Cover, Limited Collectors' Edition No. C-35, Jackson Bostwick as Captain Marvel, April–May 1975.*

DC's photo cover of *Shazam!* star Jackson Bostwick appeared just four months after the debut of the TV series. Amidst vintage Golden Age reprints, the tabloid edition also included a photo feature that included the show's other stars Michael Gray (Billy Batson) and Les Tremayne (Mentor).

ISIS No. 1

Above: *Cover art, Kurt Schaffenberger, October–November 1976.*

Gods and goddesses of various cultures were thought to appeal to the sword and sorcery audience, hence this adaptation of *Isis*, Filmation's follow-up to the successful Saturday-morning live-action *Shazam!* series. Isis was a science teacher named Andrea Thomas who used an enchanted amulet and recitation to become a super heroine when necessary. Isis and Captain Marvel met three times apiece on their respective TV shows, while their comic book counterparts crossed paths only once, in a lead-in to the heroine's upcoming DC title.

SUPERMAN'S GIRL FRIEND, LOIS LANE No. 106

Left: *Cover art, Curt Swan and Murphy Anderson, November 1970.*

The assignment of the retiring editor Mort Weisinger's Superman line to new editors coincided with the social-issue trend. *Lois Lane*'s new team responded by having the newly "liberated" investigative reporter experience racism first-hand. The title is, oddly, a play on a pornographic Swedish film of the period, issued in the U.S. as *I Am Curious (Yellow)*.

DC COMICS PRESENTS No. 32

Right and opposite: *Interiors, "The Super-Prisoners of Love"; plot, Gerry Conway; script, Roy Thomas; pencils, Kurt Schaffenberger; inks, Vince Colletta. April 1981.*

The jealousy that characterized the Silver Age Lois Lane had given way to a more mature, level-headed persona as the 1970s wore on. By 1981, old-school conflict required machinations from the likes of the love god Eros, who created a fiery attraction between Superman and Wonder Woman… While never a serious consideration, a romance between Superman and Wonder Woman was often teased in stories. A 1971 issue of *World's Finest* even matched Clark Kent and Diana Prince through a computer dating service.

WONDER WOMAN! HAVE YOU GONE *MAD*? SOMEONE COULD'VE BEEN *KILLED* BY THAT *TIARA*, HURLED WITH YOUR *AMAZONIAN STRENGTH*!

FUNNY THAT YOU SHOULD MENTION *KILLING*, SUPERMAN-- BECAUSE THAT'S *JUST* WHAT I INTENDED TO *DO*--

--TO THIS *MAN-STEALING WITCH* WHO'S BEEN *PAWING* OVER YOU!

OHHHH--!

WAIT! YOU DON'T KNOW WHAT YOU ARE DOING!

SUPERMAN-- *HELP*!

I WAS JUST *USING* LOIS-- TO TRY TO *FORGET* ABOUT HOW I FEEL FOR *YOU*!

DON'T YOU *KNOW* THAT? BUT WHEN I GET THROUGH WITH HER, SHE WON'T BE MUCH USE--

--TO *ANYONE*!

EEEEEEEE

NO NEED FOR *HISTRIONICS*, LOIS! WONDER WOMAN'S JUST A LITTLE BIT...ER... *DISTRAUGHT* AT THIS PARTICULAR MOMENT--

--BUT I WON'T LET YOU COME TO *HARM*, EITHER AT *HER* HANDS--

--OR BENEATH THIS TRUCK'S *WHEELS*!

G-GLAD TO *HEAR* IT--!

SKREEEEETCH!

ADVENTURE COMICS No. 423

Above: *Cover art, Bob Oksner, September 1972.*

Supergirl's encounters with the Justice League were few and far between, but always eventful, as seen in this tale of "Treachery" by E. Nelson Bridwell.

ADVENTURE COMICS No. 420

Right: *Cover art, Bob Oksner, June 1972.*

After a succession of short-lived new costumes, Supergirl settled on a version created by fan John Sposato. With puffy sleeves, hot pants, and ample cleavage, the outfit endured for more than a decade until the impending Supergirl movie prompted an update.

CONTINUITY KEEPER

Above: *Photograph by Jack Adler, E. Nelson Bridwell, 1971.*

As caretaker of Superman's family, editor E. Nelson Bridwell was DC's first line of defense in maintaining a consistent history of the Man of Steel.

ADVENTURE COMICS No. 397

Opposite: *Cover art, Mike Sekowsky and Dick Giordano, September 1970.*

When Mike Sekowsky became Supergirl's custodian as writer-penciller-editor of *Adventure* in 1970, he borrowed the old *Katy Keene* gimmick of soliciting designs for the heroine's outfits from readers, beginning a series of new costume tryouts.

WONDER WOMAN No. 240

Right: *Cover art, José Luis García-López and Dick Giordano, February 1978.*

Lead times being what they were, the comic's story line continued to be set in the 1940s several months after the TV series switched to the present day in 1977.

WONDER WOMAN No. 189

Opposite: *Cover art, Mike Sekowsky and Dick Giordano, July–August 1970.*

Vietnam War protestors' flag burnings had equated "the red, white, and blue" with all things alienating to youth culture. Wonder Woman's costume became commercially unviable in that climate, so DC made her non-super for a time. The martial artist adventurer that resulted seemed more Diana Rigg (of '60s British TV's *The Avengers*) than Diana Prince.

A BOLD NEW DIRECTION

Left: *Interior, DC Comics Presents No. 41; script, Roy Thomas; pencils, Gene Colan; inks, Romeo Tanghal. January 1982.*

Wonder Woman's traditional golden eagle emblem was replaced with a "WW" in late 1981, providing a symbol that could be aggressively merchandised. Designed by Milton Glaser, the logo was also the symbol for the short-lived Wonder Woman Foundation.

SAFE KEEPING

Above: *Wonder Woman cookie jar, 1978.*

Thanks to Wonder Woman's prominence on TV in the 1970s, licensed products proliferated during the latter half of the decade. The Amazon Princess' likeness could be found on cookie jars, placemats, mirrors, sleeping bags, lamps, lunchboxes, and even a specially molded cake pan.

WONDER WOMAN No. 205

Above: *Cover art, Nick Cardy, March–April 1973.*

Following the 1947 death of Wonder Woman creator William Moulton Marston, Robert Kanigher almost exclusively wrote the Amazing Amazon's adventures for the next two decades.

WONDER WOMAN No. 204

Right: *Cover art, Don Heck and Dick Giordano, January–February 1973.*

Under pressure from *Ms.* founder Gloria Steinem, DC returned to the classic star-spangled version of Wonder Woman in late 1972. Writer Kanigher added a modern wrinkle, however, with the revelation that the Amazing Amazon had a black sister named Nubia who'd been abducted at birth.

WONDER WOMAN No. 207

Opposite: *Cover art, Ric Estrada and Vince Colletta, August–September 1973.*

After initially writing all-new plots, Kanigher looked to the past for inspiration. For five consecutive issues, *Wonder Woman* featured rewritten 1940s stories, marking time before editor Julius Schwartz stepped in to modernize the heroine.

WONDER WOMAN No. 269

Opposite: *Cover art, Ross Andru and Dick Giordano, July 1980.*

"I felt that Wonder Woman, like Superman, would have an outsider's point of view toward society," writer Gerry Conway remarked of his approach to the character. "Coming from the perfect, egalitarian world of the Amazons (where, in spite of the royal hierarchy, all women were treated as equal and worthy in their own right), she would be particularly offended by the small-mindedness and sexism of America (as it was in the 1940s especially). Given her unquestioned authority at home, as a dynastic princess, she would naturally feel that her view was essentially correct and proper, and she'd react with surprise, dismay, and contempt toward the unfairness and injustice she encountered in 'Man's World.'"

IT AIN'T ME BABE

Right: *Cover art, Trina Robbins, July 1970.*

A devoted fan of Wonder Woman and other female heroines in her youth, Trina Robbins became a pioneer in the underground comic movement and spearheaded *It Ain't Me Babe*, a comic book featuring nothing but female creators. In 1986, Robbins became the first female to draw a Wonder Woman solo story.

ENOUGH WITH THIS SECOND SEX BUSINESS, SUPERMAN!

Left: *Newspaper clipping,* Daily News; *art, José Luis García-López and Dan Adkins. January 20, 1978.*

A co-opted image from the recent *Superman vs. Wonder Woman* tabloid comic book illustrated its point about gender inequality among super heroes.

"I tried to make her real. From the start Wonder Woman wasn't just another TV character — I was living out a fantasy."
— LYNDA CARTER

CATHY LEE CROSBY

Above: *TV movie still,* Wonder Woman, *1974.*

LYNDA CARTER AS WONDER WOMAN

Opposite: *Promotional photo,* Wonder Woman *television show, ca. 1976.*

In 1976, ABC was the top-rated network on the strength of *Charlie's Angels* and the feminist-enraging programming fad called "jiggle." Beauty queen Lynda Carter was deemed perfect for the role. After one season of adventures set during World War II, whose budget ABC considered too high, the show was sold to CBS for two seasons of present-day action.

ENTER WONDER GIRL

Right: *Television still, "The Feminum Mystique," 1976.*

In the comics, Wonder Girl began as Princess Diana's younger self, then became the costumed persona of Donna Troy, of the Teen Titans. On TV, she was Wonder Woman's younger sister, Drusilla, seen in three episodes in the person of Debra Winger, making her professional acting debut.

WONDER WOMAN

Opposite: *Film still, Lynda Carter, 1975.*

Lynda Carter took her role as Wonder Woman seriously, resisting the temptation to adopt a camp approach. "I played the humor in a very human way, and it's sort of a dry way," she explained. "I tried to play her like a regular woman who just happened to have superhuman powers."

WONDER WOMAN No. 288

Right: *Interior, "Swan Song"; script, Roy Thomas; pencils, Gene Colan; inks, Romeo Tanghal. February 1982.*

WONDER WOMAN FOR THE '70s

Below: *Title card, 1977.*

Despite a successful series of broadcasts, ABC hesitated about renewing the Wonder Woman TV series and created an opening for CBS to pick up the show for the fall of 1977. At the network's request, *The New Adventures of Wonder Woman* was set in the present with the still youthful Amazon Princess now paired with the son of her wartime partner Steve Trevor (also played by Lyle Waggoner).

WONDER WOMAN No. 205

Right: *Interior, "Target Wonder Woman"; script, Robert Kanigher; pencils, Don Heck; inks, Bob Oksner. March–April 1973.*

After five years and 26 issues without a costumed star, *Wonder Woman*'s domestic sales were no better than they had been before DC decided that her star-spangled attire was a liability. Longtime writer-editor Bob Kanigher, returning to DC after an extended sabbatical, restored the Amazon's super-powered incarnation in stories like this one.

DC SAMPLER No. 3

Above: *Cover art, Fred Hembeck, 1984.*

The now-collectible *DC Sampler* series indicates how seriously DC was about taking the direct-sales market. These free pamphlets, available only in comic-book specialty shops, previewed DC's planned new product for the coming year.

THE UNEXPECTED No. 220

Opposite: *Cover art, Dave Manak (concept) and Joe Kubert, March 1982.*

In their twilight, DC's mystery/horror anthologies were as much a refuge for veteran comic-book creators as a training ground for newcomers. Writers like Robert Kanigher, Arnold Drake, and George Kashdan could reliably find a spot in their pages long after their presence in super hero titles had faded away.

PLOP! No. 22

Left: *Interior, "A Tale Before Sunrise"; script, Steve Skeates; pencils and inks, Vincent Alcazar. July–August 1976.*

Steve Skeates believed that *Plop!* "spoke more clearly than any other graphic publication to the heavy disillusionment, frustration, and cynicism that the good ol' U.S. of A. was caught up in at that particular moment." Its virtual credo, he continued, was "All institutions are corrupt; it's the innocent who get stepped on; only the cynical survive."

PLOP! No. 5

Above: *Interior, "Super Plops"; script, unknown; pencils and inks, Kurt Schaffenberger. January–February 1975.*

The Super Plops also reflected a sensibility from the Silver Age — or at least the camp Batman era — in their willingness to spoof the super heroes, as DC had with hero guest shots in titles like *Jerry Lewis*. In the next decade, fans would demand their heroes be treated in dead earnest.

PLOP! No. 1

Opposite: *Cover art, Basil Wolverton, October 1973.*

After finding success with *Weird Western* and *Weird War*, weird humor seemed like a logical next step—it certainly did to editor Joe Orlando, who had drawn for the EC horror comics, known for their occasional mix of mirth with the macabre, as well as *MAD*. For some time, Orlando had been buying tongue-in-cheek stories for the mystery line—such as "The Gourmet," the award-winning tale that ultimately ran in *Plop!* No. 1. In the search for new formats, a separate title to run them in seemed like a good idea. The stories were hosted by "cartoony" versions of the regular mystery hosts, such as Cain and Abel. With the humorously grotesque creatures of veteran cartoonist Basil Wolverton—whom *The New York Times* called "The Michelangelo of *MAD* magazine"—on most covers, *Plop!* delighted readers for 24 issues over three years—a respectable run for the time.

PLOP! No. 5

Above: *Interior, "Plop Celebrates"; script and art, Sergio Aragonés. May–June 1974.*

Celebrated *Mad* cartoonist Sergio Aragonés had been collaborating with Joe Orlando since the late 1960s, including humorous shorts in his mystery titles. Having long pressured his editor to publish a weird humor title, Aragonés became a fixture of *Plop!* with framing sequences starring hosts Cain, Abel, and Eve in each issue.

PLOP! No. 3

Right: *Back cover art, Basil Wolverton, January–February 1974.*

Did you ever dream of getting everything that you ever wanted? If so, read on, dear reader, for...

...A DATE WITH the DEVIL!

In his west side hotel room sits Orson Kane, comic book fan, mulling over the latest issue of his favorite magazine--

"This issue of Superman is really great! Boy, that Cary Bates is some writer!"

"But I wish I had more books!--"

"There are so many that I'm missing to complete my collection!"

"I'd do anything to get a complete collection! Why, I would sell my soul for a mint copy of Action Comics Number One!"

"Well, I might be able to arrange that!"

"What-t-t?"

"Who are you? What do you want?"

"You just said you wanted to make a deal! So, let's do it already!"

"I have a big waiting list that I have to take care of!"

TOM SCIACCA, WRITER
HOWARD BENDER, PENCILLER
ANDY MUSHYNSKY INKER
MILT SNAPINN, LETTERER
CARL GAFFORD COLORIST
DAVE MANAK, EDITOR

SECRETS OF HAUNTED HOUSE No. 42

Opposite: *Interior, "A Date with the Devil"; script, Tom Sciacca; pencils, Howard Bender; inks, Andy Mushynsky. November 1981.*

The potential for macabre humor in DC's mystery books made them a particularly good venue for references to comics and their creators. At various points, creators such as Paul Levitz, Paul Kupperberg, Jack C. Harris, Len Wein, and Karen Berger each became characters in the stories they were producing.

PLOP! No. 24

Above: *Interior, "Guido the Artist"; script, Steve Skeates and Cary Bates; pencils and inks, Ric Estrada. November–December 1976.*

Originally published without advertising like *Mad* magazine, *Plop!* eventually had to accept such revenue. It still wasn't enough to save the comic book, which ended after this issue.

"COMIC BOOK" McFIEND

Left: *Interior,* Plop! *No. 24; "The Collector"; script, Don Edwing; pencils and inks, Dave Manak. May–June 1975.*

Plop! was first conceived as more of a super hero–centric humor book called *Zany*, and material in that vein still filtered throughout its run. Using a Captain Marvel–style magic word in *Plop!*'s final issue, the 12-year-old owner of the world's largest comic-book collection transformed into a succession of DC heroes to fight a senator poised to stamp out comics. Her motivation was resentment: her parents never let her read them when she was a girl.

THE SECRET ORIGIN OF GROOBLE MAN

Above: *Interior,* Plop! *No. 10; plot, John Jacobson; script, Steve Skeates; pencils and inks, Sergio Aragonés. March–April 1975.*

Along with his major contributions to *Plop!*, the prolific Sergio Aragonés was also honored with a 1976 issue of *DC Super-Stars* devoted entirely to his stories and art.

PLOP! No. 2

Above: *Interior, "Hey, Skinny"; script, Steve Skeates; pencils and inks, Sergio Aragonés. November–December 1973.*

Charles Atlas' bodybuilding ads—with their "Insult That Made a Man Out of Mac" cartoons—were a ripe source for parody in the same comic books that once ubiquitously contained them.

FORBIDDEN TALES OF DARK MANSION No. 8

Opposite: *Interior, "The Blank Space"; script, Steve Skeates; pencils and inks, Alex Niño. November–December 1972.*

In a 2004 interview with Manuel Auad, artist Alex Niño declared that the hallucinogenic quality of his art owed nothing to drugs. "It's a natural high. Doing monsters, out-of-this-world scenes. Inside of a panel is a window for you to get high—who needs the other stuff? There's already a chemical in the brain to activate those mechanisms in your body that allow your mind to float like a joyous dream!"

SATURDAY NIGHT LIVE

Above: *Gilda Radner, Dan Aykroyd, Bill Murray, Margot Kidder, March 17, 1979.*

DC's sense of humor about itself also allowed the exposure of its characters to a wider audience: the Flash was not yet a TV star when he was included in this *SNL* sketch. DC even helped the show acquire accurate costumes for such spoofs on more than one occasion.

PLOP! No. 11

Right: *Interior, "Sssppprrrttttzzzzz"; script, Steve Skeates; pencils and inks, Alex Toth. April 1975.*

The Playboy lifestyle was beyond the typical comic-book artist but Haunted Tank illustrator Russ Heath notoriously spent months at the Chicago mansion before someone realized that the man with the drawing board didn't belong there.

"WALTER, WHERE ARE YOU *GOING*? YOU JUST CAN'T *WALK* OUT ON ME LIKE THIS!

IF YOU DON'T COME BACK HERE *THIS INSTANT*, I... I'LL... I'LL SPREAD A *NASTY RUMOR* ABOUT YOU ALL OVER SCHOOL!

I'LL *FIX* YOU!"

WORDS... A THREAT... THEY CAN ONLY PRODUCE AN EFFECT IF THEY'RE *HEARD*... AND WALTER DOES *NOT* HEAR THEM...

...AND AS THE NIGHTMARE COMES AGAIN... IN THE REAL WORLD, REAL TERROR IS IN THE OFFING...

WHEN YOU PATROL THE CITY DARKNESS, WHEN YOU STALK THOSE WHO WOULD PREY UPON OTHERS.. YOU ARE ALERT — PREPARED — FOR THE SOUNDS OF VIOLENCE — GUNFIRE! BUT GUNFIRE FROM THE TWIN VICKERS MACHINE GUNS OF A SPAD XIII — ?! FROM A GHOSTLY WHITE-BLEACHED RELIC OF A WAR ENDED OVER A HALF-CENTURY AGO ?! CAN ANYONE BE PREPARED FOR THIS NIGHT WHEN...

DEATH FLIES THE HAUNTED SKY

YET, PREPARED OR NOT FOR THE RELIC SPECTRE SUDDENLY BEFORE HIM, THIS MAN'S TRAINING — HIS VERY NATURE, IS TO **ACT!** FOR HE IS...

THE **BATMAN!**

FRIEND WRITER EDITOR: ARCHIE GOODWIN

ART: ALEX TOTH

WITH DUE HOMAGE TO: BOB KANE, JERRY ROBINSON, GEORGE ROUSSOS and NEAL ADAMS!

Alex Toth

"Batman is graphic fun, eye-candy, a delight of mysterioso makeup — needing no uglifying distortions or exaggerations to further dramatize it/him." — ALEX TOTH

THE ARTIST'S ARTIST

Above: *Photograph by Ken Steacy, Alex Toth (with Dave Stevens in the background), 1984.*

"Westerns, war, spy, crime, horror, mystery, sci-fi, space. All had their own disciplines to learn. Super heroes quite apart, too, freer swinging, anything goes, wild 'n' wooly, explosive bone-crunching non-stop action, etc. I've done my share of all. Historical tomes, too, demanding research to get it right, in its own context/timeframe/settings. I've had my share of flops in all of 'em, too, as anyone will find in a stack of my 50+ years at it. The worst bits always get reprinted, too, damn it!"
—Alex Toth

SUPERMAN ANNUAL No. 9

Left: *Interior, "Villain! Villain! Who's Got the Villain?"; script, Elliot S! Maggin; pencils, Alex Toth; inks, Terry Austin. 1983.*

DETECTIVE COMICS No. 442

Opposite: *Interior, "Death Flies the Haunted Sky"; script, Archie Goodwin; pencils and inks, Alex Toth. August–September 1974.*

With new approaches to Batman being sought, DC experimented with giving *Batman* and *Detective* to different editors. Alex got his first Batman job during the brief tenure of newspaper strip scripter and comics writer-editor Goodwin on *Detective*.

SUPER FRIENDS STORYBOARD

Right: *Alex Toth, 1973.*

This board explains Toth's reputation as a genius among traditional animators. Most comic artists are good enough storytellers to do "producible boards." Not all master — as did Toth — the minimalism required to craft animatable models that don't require simplification by others. Moreover, storyboards don't require on-model rendering, but Toth provided it, giving producers a more accurate sense of how the finished sequence would look.

SUPER HEROES ON SESAME STREET

Left: *House ad art, Carmine Infantino and Murphy Anderson, 1970.*

When the groundbreaking educational program *Sesame Street* premiered on November 10, 1969, its segments included Muppets and an ethnically diverse neighborhood. They were joined in 1970 by Superman, Batman, and Robin, who appeared in a handful of short sequences animated by Filmation that dealt with subjects like traffic safety — and the letter "S."

LIMITED COLLECTORS' EDITION No. C41

Opposite: *Back cover art, Alex Toth, December 1975–January 1976.*

"Many of our viewers haven't started reading comics yet — or started reading at all, for that matter — but they recognize Superman and Batman. I don't know exactly where or when such young kids learn about the characters; maybe they're just born knowing them."
—Joseph Barbera

CHALLENGE OF THE SUPER FRIENDS

Above: *Animated title sequence, Hanna-Barbera, 1977 and 1978.*

With the exception of the Wonder Twins, *Super Friends* evolved into a fairly faithful representation of the Justice League and its villainous counterparts.

SUPER FRIENDS MODEL SHEET

Left: *Superman art, Alex Toth, 1973.*

Toth returned to DC in the late '60s and refamiliarized himself with its super heroes. Among the characters he drew was the redesigned Green Arrow, in Black Canary features for *Adventure*. *Super Friends*' addition of JLA guest stars was handily facilitated by Toth, the ideal choice to contribute most of the series' models.

183

NO ORDINARY NEWSSTAND

Opposite: *Advertisement art, Dick Giordano, 1980.*

Elson's News and Gift Shops partnered with DC in the early 1980s to produce six 96-page issues filled with recent super hero stories.

SUPER B No. B2

Above: *Cover art, Kurt Schaffenberger, Curt Swan & George Klein, Joe Kubert, and Henry Scarpelli, 1977.*

During 1977 and 1978, DC partnered with Warner Educational Services to produce 16 comic books that could be distributed to schools as a reading tool. Composed of reprints from the 1950s to the 1970s, the stories were heavily re-edited in part to transform the mostly male and white characters of the originals into a cast that reflected girls and other races. Typical stories featured Spanish hero El Dragón in place of Robin or African American detectives Ted and Teri Trapper replacing the white Roy Raymond and Karen Conlin.

SUPER A No. 1

Above: *Cover art, Joe Kubert, Stan Goldberg, and Neal Adams, 1977.*

SILLY PUTTY MAN MEETS THE EGGOMEANY

Left: *Cover and interior; pencils, unknown; inks, Vince Colletta; 1979.*

One of the rarest DC comic books is this premium that was included with Silly Putty.

PREZ No. 2

Above: *Interior, "Invasion of the Chessmen"; script, Joe Simon; pencils and inks, Jerry Grandenetti. October–November 1973.*

Chess prodigy Bobby Fischer became a household name after beating the USSR's Boris Spassky in 1972's World Chess Championship. Inspired by the headlines, Joe Simon scripted a demented spin on the legendary chess tournament that pitted the U.S.'s Robbie Fishhead against the Soviet Union's Queen Errant in a grudge match.

PREZ No. 1 COVER ROUGH

Opposite: *Original art, Joe Simon, 1973.*

Prez had its roots in the 1968 film *Wild in the Streets*, wherein teenage rock singer Max Frost helped push the voting age back to 15… and then made a successful run for president. While Max and Prez each surrounded themselves with other young people, the latter wasn't audacious enough to throw everyone over 30 into re-education camps.

PREZ No. 3

Above: *Cover art, Jerry Grandenetti, December 1973–January 1974.*

PREZ No. 1

Right: *Interior, "Oh Say Does That Star Spangled Banner Yet Wave?"; script, Joe Simon; pencils and inks, Jerry Grandenetti. August–September 1973.*

In the wake of the 26th Amendment to the U.S. Constitution in 1971, which lowered the voting age to 18, came *Prez*, America's first teenage chief executive. Writer-editor Simon, who had worked on the Golden Age Boy Commandos, followed that comic's formula of appealing to juvenile male fantasies by improbably giving a boy a man's job. Perhaps too improbably for the era's increasingly politically savvy readership: *Prez* was impeached after only four issues.

TO SOME, **THIRTEEN** IS AN **UNLUCKY** NUMBER, BODING MISFORTUNE AND EVIL DESIGNS...

TO OTHERS, IT IS A **CHARM**, A SYMBOL TO BE CONJURED WITH...

PERHAPS IT IS **NEITHER**... PERHAPS IT IS **BOTH!** ON **THIS** BRIGHT NIGHT, IT MATTERS **LITTLE**, INDEED...

RUTLAND'S THIRTEENTH ANNUAL HALLOWEEN PARADE

FOR **THIS** IS THE NIGHT OF **RUTLAND'S THIRTEENTH ANNUAL HALLOWEEN PARADE**... AND ON ITS BUSTLING, CROWD-COVERED STREETS, THAT NUMBER STANDS FOR **EXCITEMENT!**

JUSTICE LEAGUE OF AMERICA No. 103

Opposite: *Interior, "A Stranger Walks Among Us"; script, Len Wein; pencils, Dick Dillin; inks, Dick Giordano. December 1972.*

With the rise of fans-turned-pros in the comic-book industry, parodies of familiar comic-book characters flowered. This Justice League story set during Halloween 1972 included characters costumed similarly to rival heroes, and avid fans soon discovered that similar events were taking place in issues of *Amazing Adventures* and *Thor*. The writers had conspired to write a stealth company crossover!

BATMAN No. 237

Left: *Interiors, "Night of the Reaper"; script, Denny O'Neil; pencils, Neal Adams; inks, Dick Giordano. December 1971.*

Characters based on Bernie Wrightson, Gerry Conway, and Alan Weiss joined Dick Grayson in a story set during Rutland, Vermont's famed Halloween parade.

DC COMICS PRESENTS No. 67

Above: *Interior, "'Twas the Fright Before Christmas"; plot, E. Nelson Bridwell; plot and script, Len Wein; pencils, Curt Swan; inks, Murphy Anderson. March 1984.*

Santa Claus—and his elves—met a number of DC characters over the years, not only Superman but Angel and the Ape, the Marvel Family, the Sandman, even Scooter.

THE NEW SCOOBY-DOO MOVIES

Above: *Animation cel, 1972.*

When the *Scooby-Doo* cartoon expanded to an hour in the fall of 1972, the format was revised to feature guest stars ranging from real-life celebrities to fictional characters like Batman and Robin. The Dynamic Duo appeared in two episodes of the series, fighting the Joker and the Penguin on each occasion. The team-ups were recalled in a 2011 episode of *Batman: The Brave and the Bold* that united Batman with Scooby and company once more, as well as the 2014 comic series *Scooby-Doo Team-Up*.

CAPTAIN CARROT AND HIS AMAZING ZOO CREW No. 14

Opposite: *"Crisis on Earth-C"; plot, E. Nelson Bridwell; script and pencils, Scott Shaw; inks, Al Gordon and Carol Lay. April 1983.*

When he first pitched a funny animal super hero comic book to DC, Roy Thomas wanted to do a Justice League parody called Just'a Lotta Animals. Although he ultimately developed the original characters of the Zoo Crew instead, Thomas held onto the idea, using the alternate JLA as a comic book within a comic book. With 1963's milestone first Justice League–Justice Society team-up as its template, a two-part story had the Zoo Crew meet Just'a Lotta Animals face-to-face.

LES SUPER JUNIORS NOËL A DISPARU

Above: *Interior, "The Isle of Forgotten Toys"; script, Tom DeFalco; pencils, Jerry Grandenetti; inks, Vince Squeglia; 1982.*

A mid-1970s line of dolls based on infant versions of DC's heroes eventually inspired a comic-book story. Produced for a late 1970s tabloid, this Super-Juniors Christmas story initially saw release only in French and Mexican editions until a 1984 digest in the United States.

THE OZ-WONDERLAND WAR No. 1

Right: *Interiors, "Slay It with Flowers"; plot, E. Nelson Bridwell; script, Joey Cavalieri; additional dialogue, pencils, and inks, Carol Lay. January 1986.*

A decade after DC and Marvel collaborated on an adaptation of MGM's *Wizard of Oz*, its writer Roy Thomas initiated a new trip, one that intersected with Captain Carrot's funny-animal world.

--I CALLED AN *EMERGENCY MEETING* OF THE *ENTIRE MEMBERSHIP* OF THE JLA-- THE *MIGHTIEST MENAGERIE* OF COSTUMED CRITTERS EVER ASSEMBLED:

RAT TORNADO!

THE MARTIAN ANTEATER!

ELONG-GATOR!

HAWKMOOSE!

ZAP-PANDA!

THE ITEM!

STACKED CANARY!

GREEN SPARROW!

FIRESTORK!

"WHAT'S ON THE OLD *AGENDA*, SUPER-SQUIRREL?"

"*PLEASE* DON'T TELL US IT'S ANOTHER ELECTION FOR JLA LEADER-- YOU *KNOW* YOU ALWAYS WIN!"

"*HARDLY*, HAWKMOOSE. THIS TIME, WE'RE *NOT* MONKEYING AROUND. TELL 'EM, G.L.--!"

"WHILE ON A MISSION IN *DEEP SPACE*, I RECEIVED WORD THAT AN *INTERSTELLAR ARMADA* IS BEING ASSEMBLED FOR THE PURPOSE OF *ATTACKING THE EARTH!*"

"ITS *HEAD HONCHO* IS NONE OTHER THAN OUR OLD FOE, *KANGAR-ROO!*"

6

SHE WAS BORN A PRINCESS -- DAUGHTER OF HIPPOLYTA, QUEEN OF THE AMAZONS -- BUT SHE LEFT THE TRANQUIL GROVES OF PARADISE ISLAND TO BATTLE EVIL IN A WORLD SHE NEVER MADE! SHE IS BEAUTIFUL AS APHRODITE... WISE AS ATHENA... STRONGER THAN HERCULES... SWIFTER THAN MERCURY!

SHE IS... **WONDER WOMAN**™

Beginning -- a special three-part **MINI-SERIES** *featuring the amazing Amazon -- and dynamic DC's mightiest, most magnificent super-heroines!*

JUDGMENT IN INFINITY!

PAUL LEVITZ / ROY THOMAS, plot / script
GENE COLAN, pencils
FRANK McLAUGHLIN, inks
JOHN COSTANZA, letterer
CARL GAFFORD, colorist
LEN WEIN, editor

CHAPTER 1
COMES THE **ADJUDICATOR!**

ACTION COMICS No. 395

Above: *Cover art, Carmine Infantino, Curt Swan, and Dick Giordano. December 1970.*

An occasional plot device found Superman meeting an alien super-woman and imagining that he'd found the perfect mate. Invariably, the pairing ran afoul, as when the Man of Steel discovered that his prospective wife was descended from birds, and thus part of a different species.

POWER GIRL

Right: *Cover art, Showcase No. 97, Joe Staton and Joe Orlando, February 1978.*

ALL-STAR COMICS No. 58

Left: *Interior, "All-Star Super Squad"; script, Gerry Conway; pencils, Ric Estrada; inks, Wally Wood. January–February 1976.*

The revived *All-Star* introduced Power Girl, conceived as Supergirl's Earth-Two counterpart. With Wallace Wood and his renowned skill at "cheesecake" determining the finished art, her breathtaking buxomness and "peek-a-boo" décolletage were perhaps inevitable. More due to a curious editorial restraint than formal protests from the Comics Code, however, the heroine was more modestly clad in her *Showcase* bid for stardom in her own feature.

WONDER WOMAN No. 291

Opposite: *Interior, "Comes the Adjudicator!"; plot, Paul Levitz; script, Roy Thomas; pencils, Gene Colan; inks, Frank McLaughlin. May 1982.*

A three-part 1982 story brought together many of DC's major heroines. While well-established characters like Wonder Woman, Black Canary, and Lois Lane were present, a striking number of the cast had been created only in the past decade. Among those relative newcomers were Raven, Starfire, Madame Xanadu, the Huntress, and Power Girl.

BLACK CANARY

Left and opposite: *Interiors,* Adventure Comics *No. 418; script, Denny O'Neil; pencils and inks, Alex Toth. April 1972.*

This was Toth at his best, only slightly more detailed than his animation models. How much of the writing was O'Neil's is not possible to know. Like Jim Aparo, Toth was a triple threat—penciller, inker, and letterer. Editors needed only to send him the script and back would come the finished art. He wrote, too…sometimes without being asked, meaning he was known to occasionally rewrite as he lettered. He was famously O'Neil's first choice to draw *The Shadow* until his unsolicited reworking of O'Neil's first script ended their collaboration.

BLACK ORCHID

Above right: *Cover art,* Adventure Comics *No. 428, Bob Oksner; July–August 1973.*

This series, set outside the DC Universe, was written by the legendary Sheldon Mayer. The Orchid led readers through several mysteries without ever solving the biggest mystery of all: her own identity. The enigmatic character was better received in a 1980s revival, in which she was reimagined as a humanoid plant by writer Neil Gaiman.

ADVENTURE COMICS No. 413

Right: *Interior, "Zatanna the Magician"; script, Len Wein; pencils and inks, Gray Morrow. December 1971.*

One of DC's most popular magical characters was Zatanna, introduced in the Silver Age Justice League. Like her father, the stage magician Zatara, who dated back to *Action Comics* No. 1, she, too, could work real magic with incantations spoken backward. But her main appeal was the "good girl art" her appearances occasioned, especially those by Morrow.

NNRRFFF **OOONNOOOWUK-KK**

HAW HAW HAW GOTCHA, LI'L OL' BIRDIE!

HOOFFF

GRRROOWWFFF **EEEEEOWWWFFF**

WANT TO TRY AGAIN?

NO NEED! THE JOB IS YOURS!

DC COMICS PRESENTS ANNUAL No. 2

Left: *Interiors, "The Last Secret Identity"; script, Elliot S! Maggin; pencils, Keith Pollard; inks, Mike DeCarlo. 1983.*

DC had used the Superwoman name periodically since the 1940s, sometimes applying it to Lois Lane and even using it for a villainess. In 1983, Elliot Maggin created a heroic Superwoman with her own distinct identity. Before she put on the costume, time-traveler Kristin Wells had previously been a major character in Maggin's 1981 prose novel *Superman: Miracle Monday*.

SUPERMAN No. 349

Opposite: *Cover art, Ross Andru and Dick Giordano.* Below: *Interior, "The Turnabout Trap!"; script, Martin Pasko; pencils, Curt Swan; inks, Frank Chiaramonte. July 1980.*

When Mr. Mxyzptlk reversed the genders of everyone on Earth, Supergirl's male counterpart still sported bare legs. The masculine Wonder Warrior, though, resisted the bare arms and legs that Wonder Woman showcased.

BATMAN FAMILY No. 9

Left: *Interior, "Startling Secret of the Devilish Daughters"; script, Bob Rozakis; pencils, Irv Novick; inks, Vince Colletta. January–February 1977.*

Robin's clash with a mysterious prankster called the Joker's Daughter was only the first of many encounters with the supposed female offspring of various Bat-villains. In reality, they were all one person: Two-Face's daughter. When readers pointed out that she'd be at least ten years younger than the teenage Robin, writer Bob Rozakis declared that she'd benefited from "selective aging."

SUPERBOY No. 223

Above: "We Can't Escape the Trap in Time"; script, Jim Shooter; pencils, Mike Grell; inks, Bob Wiacek. January 1977.

LEGION OF SUPER-HEROES No. 259

Opposite: Cover art, Dick Giordano, January 1980.

Since its inception, the Legion of Super-Heroes had only headlined with Superboy as a prominent front man. In late 1979, the series was finally allowed to succeed or fail on its own when the Boy of Steel left the team for a new solo title. After a shaky start, *Legion of Super-Heroes* became one of DC's most popular books of the 1980s.

LEGION OF SUPER-HEROES No. 2

Above: Cover art, Nick Cardy, March 1973.

The Legion of Super-Heroes' first shot at its own series was a four-issue run of 1960s reprints. Two months after it ended, the team became the official co-stars in Superboy.

DC SAMPLER No. 1

Right: Interiors, "What Kind of Sentient Being Devours Every Issue of Legion?"; script, Paul Levitz; pencils, Keith Giffen; inks, Larry Mahlstedt. 1983.

Direct-market content sometimes inspired an insider jokiness that would have been lost on casual readers. The captions enumerating the Legion's various attractions are the logos of other DC titles past and present—including the then obscure Quality title, *Police Comics*.

Paul Levitz

"Paul is one of a very few people who've been absolutely key in shaping the comics industry from what it was in the mid-'70s to what it is today. Staggering changes, built slowly over time, so that DC (and the companies that adopted DC's innovations) could build from strength to strength."

— KURT BUSIEK

PAUL LEVITZ

Above: *Photograph by Jack Adler, at the DC offices, mid-1970s.*

LEGION OF SUPER-HEROES No. 294

Following pages: *Interiors, "Darkseid"; plot and script, Paul Levitz; plot and pencils, Keith Giffen; inks, Larry Mahlstedt. December 1982.*

A decade after his creator Jack Kirby had left him behind, the evil Darkseid was no longer the imposing threat that he'd once been. Carefully reintroduced as a mysterious presence in the Legion of Super-Heroes' "Great Darkness Saga," the god of evil returned to the stage with maximum impact and a renewed sense of menace that kept him permanently in the top tier of DC's villainous threats.

LEGION OF SUPER-HEROES No. 1

Opposite: *Original interior art, "Here a Villain, There a Villain"; plot and script, Paul Levitz; plot and pencils, Keith Giffen; inks, Larry Mahlstedt. August 1984.*

In 1984, *Legion of Super-Heroes* was relaunched as a title sold exclusively from comic-book retailers although its content was reprinted on newsstands a year later. The story that spanned its first five issues harkened back to a 1966 Jim Shooter story, and featured the culmination of a feud between Nemesis Kid, Karate Kid, and Princess Projectra that began there.

SUPERBOY AND THE LEGION OF SUPER-HEROES No. 237

Above: *Interior, "No Price Too High"; script, Paul Levitz; pencils, Walt Simonson; inks, Jack Abel. March 1978.*

Often spurned by veteran artists as too difficult to draw (all those costumes!), the Legion's popularity among younger talent resulted in contributions from rising stars like Simonson.

HOUSE OF MYSTERY No. 251

Right: *Interior, "Tour of the Top Floor of the House of Mystery"; script, Jack C. Harris; pencils, John Calnan; inks, Jack Abel. March–April 1977.*

EEEYAAARGGH!

DARKSEID

"The minute Paul said, 'I want to use Darkseid,' I didn't even have to hear the story. It was like, 'I'm on board. Ab-so-lutely.' The idea of introducing that character into the Legion's mythos, I just thought it would be a great story, period, over and out." — KEITH GIFFEN

THE GREAT DARKNESS SAGA

Above: *Cover art,* Legion of Super-Heroes *No. 294, Keith Giffen and Larry Mahlstedt. Opposite: Interior, "Darkseid"; plot and script, Paul Levitz; plot and pencils, Keith Giffen; inks, Larry Mahlstedt. December 1982.*

That the Levitz–Giffen collaboration was a smash was confirmed by the "Great Darkness Saga" arc, still recognized by fans as one of DC's best stories, even decades later. Prior to 1982, DC had published all-new expanded editions of a few of their titles for anniversary issues but the saga's oversized conclusion was the first time it occurred in an issue unrelated to a milestone number.

LEGION OF SUBSTITUTE HEROES

Right: *Interior, "Darkseid"; plot and script, Paul Levitz; plot and pencils, Keith Giffen; inks, Larry Mahlstedt. December 1982.*

Even rarely seen teams like the Wanderers and the Heroes of Lallor turned out alongside the Legion of Substitute Heroes for the finale of "The Great Darkness Saga."

NO!

So... my powers have waned over the millenium! While they focused on you, they proved insufficient for other needs...

...and my hold on the billions of Daxamites has ended.

I have created an army of billions of super-beings... and your allies are leading them to me!

SUPERBOY No. 201

Above: *Interior, "The Silent Death"; script, Cary Bates; pencils and inks, Dave Cockrum. March–April 1974.*

Before the direct market, only the fan mail and gradual uptick in newsstand sales hinted that *Superboy*, as reformatted to showcase the Legion, had tapped a powerfully loyal fandom… or that artist Cockrum, with his "sexier" costume redesigns, might be a drawing card.

LEGION OF SUPER-HEROES No. 306

Opposite: *Cover art, Keith Giffen and Larry Mahlstedt, December 1983.*

Dave Cockrum updated Star Boy's look in 1973 with an eye-catching star costume. Keith Giffen tweaked the look further in 1982 by giving the hero a beard, something that was—the goateed Green Arrow aside—still a fashion anomaly among the super hero set.

LEGION OF SUPER-HEROES No. 283

Left: *Cover art, Jim Aparo, January 1982.*

Periodic spotlight issues on individual Legionnaires served a dual purpose. The stories fleshed out the cast for fans but they also provided an opportunity for guest artists to draw the stand-alone issues while the regular illustrators kept ahead of deadlines.

SUPERBOY No. 222

Above: *Interior, "This Legionnaire Is Condemned"; script, Cary Bates; pencils, Mike Grell; inks, Bob Wiacek. December 1976.*

After the lackluster art of the Legion's final *Action Comics* run in 1970, Cockrum was a step in the right direction. But the feature really kicked into high gear when drawn by instant fan favorite Mike Grell, beginning in 1974.

LEGIONNAIRES ASSEMBLED

Above: *Poster art, Keith Giffen and Larry Mahlstedt, 1983.*

LEGENDARY LEGION

Opposite bottom: *Poster legend, Arthur Lewandowski, 1989.*

Keith Giffen's decision to draw a poster featuring 275 distinct characters from the Legion of Super-Heroes' 25-year history was a massive undertaking. The time and research was so overwhelming, in fact, that the artist found himself burned out on the series afterward and quit the book. A fan-created key to the poster was later adapted into a six-page feature in a 1989 Legion trade paperback.

DC SAMPLER No. 1

Left: *Cover art, Ed Hannigan and Dick Giordano, 1983.*

In the mid-1980s, DC created several comic book–sized premiums that pitched upcoming series and were available at conventions and via comics retailers.

LEGION ALLIES

- Ornitho (Wanderer)
- Elvo (Wanderer)
- Gas Girl (Lallor)
- Dev-Em

- Antennae Lad (Subs)
- Comet Queen (Academy)
- Polar Boy (Subs)
- Comet (Pets)

- Proty II
- Laurel Kent (Academy)
- Porcupine Pete (Subs)
- Lamprey (Academy)

- Evolvo Lad (Lallor)
- Color Kid (Subs)
- Don Allen ⎤ Tornado
- Dawn Allen ⎦ Twins

- Duplicate Boy (Lallor)
- Beast Boy (Lallor)
- Fire Lad (Subs)
- Celebrand (Wanderer)

- Magnetic Lad (Academy)
- Krypto (Pets)
- Kid Psycho (Reserve)
- Elastic Lad (Jimmy Olsen)

- Stone Boy (Subs)
- Chlorophyll Kid (Subs)
- Beppo (Pets)

- Streaky (Pets)
- Pete Ross (Honorary)
- Insect Queen (Lana Lang)
- Nightwind (Academy)

- Quantum Queen (Wanderer)
- Command Kid
- Jed Rikane (Academy)
- Elastic Lad (Jimmy Olsen)

- Double Header (Subs)
- Night Girl (Subs)
- Crystal Kid (Academy)
- Urk (Academy)

- Dartalg (Wanderer)
- Life Lass (Lallor)
- Rond Vidor
- Shadow Kid (Academy)

- Psyche (Wanderer)
- Infectious Lass (Subs)

209

"My introduction to Eisner was many years ago, as a youngster, when I found his stunning Spirit stories. His unbelievable layouts inspired not only me but, I'm sure, three-quarters of the comic-book industry." —CARMINE INFANTINO

LEGION OF SUPER-HEROES No. 293

Opposite: *Cover art, Keith Giffen, November 1982.*

By what would have been *Superboy* No. 259, the title was changed to *The Legion of Super-Heroes,* and its sales were strong enough for it to be used as a showcase. This issue contained a special preview of DC's forthcoming *Masters of the Universe* miniseries.

SUPERMAN No. 400

Above: *Interior art, Will Eisner, October 1984.*

Among the signature devices of Will Eisner's 1940s Spirit Sections was the use of massive letters spelling out the hero's name as part of the landscape. A generation inspired by the groundbreaking cartoonist often repeated the effect in super-hero comic books as did Eisner himself in a special drawing for this landmark *Superman* issue.

WORLD'S FINEST COMICS No. 251

Left: *Interior, "The World's Finest"; script, Jack C. Harris; pencils, George Tuska; inks, Vince Colletta. June–July 1978.*

DC's late 1970s Dollar Comics often opened with creative introductions that united the stars of each issue's individual stories in a symbolic scene together.

"Infantino's eye for design was also apparent in his cover designs …his covers were so successful and popular that by 1967, Infantino was designing the covers for all of DC's titles. This integration of pop art sensibility and playful design continues to influence comic-book art — both covers and interiors — to this day." —PAUL R. JAISSLE

THE FLASH No. 202

Above: *Cover art, Dick Giordano, December 1970.*

THE FLASH No. 199

Right: *Cover art, Gil Kane, August 1970.*

DETECTIVE COMICS No. 431

Opposite: *Cover art, Michael Kaluta, January 1973.*

Although he officially stopped pencilling *The Flash* in 1967, Carmine Infantino was still a constant presence on its covers — and those of most of the DC line — as he laid out a never-ending stream of sketches and layouts that were fully developed by other artists.

THE FLASH No. 286

Left: Cover art, Don Heck and Dick Giordano, June 1980.

THE FLASH No. 310

Above: Interior, "Colonel Computron Strikes Back—with a Vengeance"; script, Cary Bates; pencils, Carmine Infantino; inks, Dennis Jensen. June 1982.

After leaving his executive post in 1976, Infantino pencilled for Marvel, taught art, and briefly worked in TV animation before being invited back to DC to draw many features including *The Flash*, on which he worked from 1981 to 1985.

DC SPECIAL SERIES No. 1

Right: Interior, "How to Prevent a Flash"; script, Cary Bates; pencils, Irv Novick; inks, Frank McLaughlin. September 1977.

Science-based fillers were a staple of Julius Schwartz's comic books of the 1950s and 1960s, including title-specific features like "Flash Facts" that appeared in *The Flash*. Those educational speed-based spots were long gone by the 1970s but writers like Cary Bates nostalgically integrated them into the occasional story.

SUPER TEAM FAMILY No. 15

Opposite: Interior, "Gulliver Effect"; script, Gerry Conway; pencils, Arvell Jones; inks, Romeo Tanghal. March–April 1978.

The Flash was a frequent guest star in other titles during the mid-1970s, joining forces with Superman, Batman, Hawkman, Supergirl, the Atom, and the New Gods. Even his rogues' gallery was branching out, with regular appearances in *The Secret Society of Super-Villains*.

NOW, AT LAST, FINAL BARRIER!

STRETCHING A BILLION MILES WIDE, A MILLION MILES HIGH, IT SEEMS LIKE A VAST CURTAIN OF ENERGY SEALING ONE PART OF THE UNIVERSE FROM THE OTHER...

...[AGA]INST THIS SHIMMERING [WAL]L, A HUMAN FORM IS [NOT]HING, AND LESS THAN [NOT]HING, AND WERE HE ANY [ONE] BUT THE MAN HE IS--

--THE SIGHT OF THIS MIGHT WELL DRIVE THE FLASH INSANE!

YET HE IS A SCIENTIST AS WELL AS A HERO, A HUMAN AS WELL AS A SUPERHUMAN, AND HE PROCEEDS...

THE FLASH No. 254

Above: *Cover art, Dick Dillin and Joe Rubinstein, October 1977.*

Schwartz had consciously deemphasized the Flash's colorful villains since the late 1960s, possibly thinking that readers would associate them with the campy *Batman* TV show. Under writer Cary Bates, the Rogues once again became a regular cover presence, even uniting for an annual convention.

THE FLASH No. 203

Opposite: *Cover art, Neal Adams and Jack Adler (photo effects), February 1971.*

Julius Schwartz was one of the first DC staff editors to embrace the use of photomontage that Jack Kirby had introduced. His many *Superman* and *Flash* covers that used the technique were facilitated by DC Production Manager Adler, an accomplished photographer who shot most of the images on the streets of Manhattan.

THE FLASH No. 268

Above: *Interior, "Riddle of the Runaway Comic"; script, Cary Bates; pencils, Irv Novick; inks, Frank McLaughlin. December 1978.*

The strangest aspect of the Earth-One–Earth-Two mythology was still being exploited in the late '70s. Writer Gardner Fox was said to have sensed Earth-Two's heroes while sleeping and believed he invented them in dreams, resulting in Earth-One comics that threatened the secrets of the "fictional" Earth-Two heroes.

THE FLASH No. 258

Left: *Interior, "The Day Flash Ran His Last Mile"; script, Cary Bates; pencils, Irv Novick; inks, Frank McLaughlin. February 1978.*

First introduced as an enemy of the Silver Age Green Lantern, Black Hand often broke the fourth wall to brag directly to the reader about the crimes he was planning. A 1970s Flash appearance maintained that trait...along with the villain's penchant for clichés.

AQUAMAN No. 50

Opposite: *Cover art, Nick Cardy, March–April 1970.*

The experimental nature of Steve Skeates, Jim Aparo, and Dick Giordano's *Aquaman* extended to an ambitious trilogy in which the lead story was complemented by a Neal Adams–produced Deadman backup that added key plot points and amplified others.

ADVENTURE COMICS No. 475

Right: *Cover art, Brian Bolland.* Below: *Interiors, "Scavenger Hunt"; script, J. M. DeMatteis; pencils and inks, Dick Giordano. September 1980.*

Adventure Comics helped catapult Aquaman back into his own comic book in the 1970s and twice became a haven for his solo series after the title was canceled in 1978.

HOSTESS TWINKIES AD

Left: *Interior, "Twinkies and Kelp"; script, unknown; pencils, Curt Swan; inks, Vince Colletta. October 1976.*

Bronze Age fortunes aside, Aquaman fared no worse than other heroes in the notoriously campy Hostess Twinkie ads, which used DC artists but were apparently written under impossible constraints from the advertiser. "Mother of pearl," indeed.

ACTION COMICS No. 538

Opposite: *Interior, "Mera, Mera, on the Wave — Who's the One You've Got to Save?"; script, Bob Rozakis; pencils, Alex Saviuk; inks, Frank McLaughlin. December 1982.*

The Bronze Age was not kind to Aquaman. His title was revived in 1977, but it lasted only a year. Thereafter he was relegated to ignominious backups like this one in *Action*, where he alternated with other also-rans like Air Wave.

SUPER DC GIANT No. S-26

Below: *Interiors, "Island of Fear"; script, Steve Skeates; pencils, Sal Amendola; inks, Dick Giordano. July–August 1971.*

This rarity appeared in a publication cover-dated four months after the first *Aquaman* series had been canceled. It is believed to have been conceived for that title, though in what form it was originally intended to be published is unknown. It was the only new material in what was otherwise a reprint. Writer Skeates had scripted the defunct series, but spot illustration artist Amendola was a hitherto rarely published protégé of *Aquaman* editor Giordano, who also supplied the inks.

THE SON OF A LIGHTHOUSE-KEEPER AND A WOMAN EXILED FROM SUNKEN ATLANTIS, *ARTHUR CURRY* GREW TO MANHOOD WITH THE POWER TO COMMAND ALL FORMS OF SEA-LIFE! TODAY HE IS THE KING OF THE SEVEN SEAS, THE MARINE MARVEL KNOWN AS...

AQUAMAN

BEGINNING WITH A NIGHTMARE OF HIS BELOVED WIFE MERA CALLING FOR HELP, IT BECAME A DREAM-COME-TRUE WHEN AQUAMAN DISCOVERED MERA BACK ON EARTH! BUT WHEN SHE HAD NO MEMORY OF BEING HIS WIFE, THE SEA KING SET OUT TO HELP HER REMEMBER -- ONLY TO HAVE IT TURN INTO A DEATHTRAP -- FOR HIM!

MERA -- YOUR BRAIN-WAVES HAVE FORMED *HARD WATER* AROUND ME...

...*WEAKENING* ME!

COLLECT YOUR THOUGHTS... BEAM THEM AT THE ATTACKING DOLPHINS... ORDER THEM *AWAY* FROM HERE!

I... I'M *TRYING*... BUT *NOTHING* IS HAPPENING!

"MERA, MERA, ON THE WAVE -- WHO'S THE ONE YOU'VE GOT TO SAVE?"

| BOB ROZAKIS WRITER | ALEX SAVIUK PENCILLER | FRANK McLAUGHLIN INKER | BEN ODA LETTERER | TATJANA COLORIST | JULIUS SCHWARTZ EDITOR |

EARTHQUAKE!

Above: *Film poster, 1974.*

Although comic books had what amounted to an unlimited special effects budget, the big screen spectacle of disaster movies like *Earthquake* was the exception rather than the rule going into the 1970s. Amidst the usual hero–villain battles, the scale of threats and destruction rose with a younger generation of writers over the ensuing decade.

AQUAMAN No. 53

Opposite: *Cover art, Nick Cardy, September–October 1970.*

DANGER: DINOSAURS AT LARGE!

Right: *Cover art, DC Special No. 27, Rich Buckler and Joe Rubinstein, April–May 1977.*

EARTH SHATTERING DISASTERS!

Far right: *Cover art, DC Special No. 28, Al Milgrom, June–July 1977.*

Originally a reprint title devoted to different themes, *DC Special* made the switch to all-new material at the direction of new publisher Jenette Kahn. The result was eclectic, merging concepts like dinosaurs or disasters that might appeal to the masses with the super heroes that fans loved.

AQUAMAN No. 56

Above: *Cover art, Nick Cardy, March–April 1971.*

Dynamic covers such as this one were not enough to save the Sea King, as this was the title's final issue. Perhaps stories set largely in an undersea realm seemed increasingly irrelevant to an aging readership immersed in a cultural revolution on the surface.

PLASTIC MAN

TOP SECRET

Gun on the dresser... secret documents flying around the room...

If I take a quick mental photo of Agent 260-Z's apartment...

ELLIOT S! MAGGIN WRITER

RAMONA FRADON and **MIKE ROYER** ARTISTS

GERRY CONWAY EDITOR

I'll be gone before anyone notices anything odd!

The National Bureau of Investigation's crack agent stakes out an enemy's New York headquarters... and so begins the weirdest love story ever, which we tenderly term...

MEAT BY-PRODUCT AND SLUDGE

Smell moving thing up here... warm...

...maybe food...?

PLASTIC MAN No. 14

Opposite: *Interior, "Meat By-Product and Sludge"; script, Elliot S! Maggin; pencils, Ramona Fradon; inks, Mike Royer. August–September 1976.*

DC's previous attempts at reviving Plastic Man were notable for having avoided the trademarks of its 1940s heyday under creator Jack Cole. For its mid-1970s incarnation, the series hewed closer to the source, complete with Plas' comical sidekick Woozy Winks. Ramona Fradon's rubbery artwork was a good fit as well but DC soon found out that audiences weren't terribly interested in a humorous super hero.

PLASTIC MAN LIVE

Below: *Film still, Mark C. Taylor as Plastic Man, ca. 1985.*

When the *Plastic Man* cartoon series was repackaged for syndication, enterprising producer Steve Whiting suggested framing the animation with sequences starring a live-action Plas. Model and stand-up comedian Mark C. Taylor played Plas, even making an appearance at the 1984 Democratic National Convention during his time in the role.

PLASTIC MAN No. 13

Above: *Interior, "If I Kill Me, Will I Die?"; script, Steve Skeates, Jane Aruns, and Mary Skrenes; pencils, Ramona Fradon; inks, Bob Smith. June–July 1976.*

DC had originally revived Plastic Man in 1966 as a persona of Robby Reed in the Dial "H" for Hero feature. By 1976, Robby's series was long gone so writer Steve Skeates brought him back in Plas' own book. Transforming into some of his wacky 1960s alter egos like the infant Mighty Moppet, this version of Robby was as demented as everyone else in the *Plastic Man* book.

PLASTIC MAN COMEDY ADVENTURE SHOW

Below: *Animation cel, 1979.*

The 1979–1981 *Plastic Man* cartoon largely departed from its comic-book source material and gave the Pliable Policeman a made-for-TV cast including girlfriend Penny and Polynesian pal Hula-Hula. By the second season, Plastic Man and Penny had married and the emphasis shifted to their offspring Baby Plas.

How a Comic Magazine Is Created

SCRIPT PAGE

PAGE 3

Box 1..CAP: A moment later...
Show Clark in process of nonchalantly falling thru open crack thru up to his waist.
CLARK(T): Can't think of a quicker way to DROP OUT OF SIGHT

Box 2-3-4-5
a full-length vertical cross-section shot, showing area between show multiple blurred images of falling Clark changing clothes in his Kent clothes into small flat packet, stuffing packet into pou water surface, swimming downward underwater, as Sman; the various into a continuous vertical motion; see sketch.
CLARK(T): Down here,
 Now no one...
"#2(T): ...Will see me slip out of these clothes...
"#3(T): At SUPER-SPEED...
"#4(T): ...And compress my suit into a tiny packet...
"#5(T): ...Which goes into a secret pouch in my cape!
-----------Sman underwater
"#6(T): NOW--
 And SUPERMAN is ready for action--!

LEGEND: From the fartherest reaches of outer space he came, acr
"#2: the beautiful cloud-fleeced sphere we call EARTH!
 Programmed to adapt any planet in the galaxy as his BATT
"#3: Trained for all possible forms of COMBAT!
 Brace yourself, reader, for the world will shake when...

story: CARY BATES, art: CURT SWAN and MURPHY ANDERSON;
edited by: JULIE SCHWARTZ.

PENCILLED PAGE

LETTERED PAGE

INKED AND COMPLETED PAGE

16

HOW A COMIC MAGAZINE IS CREATED

Opposite and right: *Interiors*, The Amazing World of Superman, Metropolis Edition; *Among those photographed are Carmine Infantino, Nick Cardy, Julius Schwartz, Denny O'Neil, Curt Swan, Murphy Anderson, Sol Harrison, Joe Letterese, Morris Waldinger, Gaspar Saladino, Lillian Mandel, Gerda Gattel, Alan Kupperberg, Glynis Wein, Jack Adler, and E. Nelson Bridwell.* 1972.

As it catered more to hardcore fans, DC realized that, even though its rival had been using "glimpses behind the scenes" as a promotional device for years, no one had really shown, in print, how a comic book was created. This was, in essence, a print version of the DC office tours that were regularly offered to the public in the 1960s.

ACTION COMICS No. 399

Far left and left: *Color plate and interior page, "Superman, You're Dead…Dead!"; script, Leo Dorfman; pencils, Curt Swan; inks, Murphy Anderson.* April 1971.

The Bronze Age marked the waning days of lithographic printing using metal plates. This involved four ink-transmitting color plates, each of which corresponded to one of the layers of the color separation. Over the next decade, before computerized desktop publishing revolutionized printing, many experiments to find more cost-effective methods would be undertaken, including the use of heavy-gauge plastic plates.

MISTER MIRACLE No. 16

Opposite: *Original interior color guide, "Shilo Norman, Super Trouble"; script and pencils, Jack Kirby; inks, Mike Royer. October–November 1973.*

Color guides were created with aniline dyes, and then marked up in a code for consistent interpretation within the limited spectrum available: RB2, for example, meant 100% red, 25% blue.

FIT TO PRINT

Right: *Photograph by Jack Adler, 1970s.*

THE DEMON No. 1 PROGRESSIVE PROOFS

Below, sequence: *Cover art, Jack Kirby (pencils), Mike Royer (inks), Jack Adler (colors), August–September 1972.*

Covers were important enough that a 3M technology for creating acetate proofs to assess colors early enough to make changes became common in the 1970s, eventually replacing the use of the small "proofing" press that had been the standard tool since the Golden Age.

AMAZING WORLD OF DC COMICS

Above left: *Cover art, No. 2, Kurt Schaffenberger, September–October 1974.* Above right: *Cover art, No. 10, Murphy Anderson and Jack Adler (photo elements), January 1976.*

Young staffers and paid interns dubbed themselves the "Junior Woodchucks" and were given the opportunity to create DC's own subscription-based fanzine…doing everything from writing and paste-up to stuffing copies in envelopes to mail after they'd hauled up the printed copies from the loading dock.

MURPHY ANDERSON

Right: *Photograph by Jack Adler, late 1960s.*

A fine artist in his own right, Anderson also endeared himself to a generation of fans through his polished inking of such pencillers as Carmine Infantino and Curt Swan. In 1973, the versatile cartoonist also founded Murphy Anderson Visual Concepts, which provided color separations and lettering.

DC STYLE GUIDE

Opposite: *Style guide interior page; Art, José Luis García-López, 1982.*

A student of the comics realism school typified by artists like Alex Raymond, Stan Drake, and Neal Adams, García-López became a popular addition to the DC lineup when he arrived in 1975, and quickly became associated with Superman. After working with Dick Giordano on the company's 1982 style guide, García-López found a sort of immortality as he began a long career creating images of the DC heroes that could be used for merchandising.

Swatch	Swatch	Swatch	Swatch	Swatch
25Y PANTONE 100	50Y PANTONE 101	100Y PROCESS YELLOW-2	100Y-25B PANTONE 374	100Y-50B PANTONE 375
25B PANTONE 304	50B PANTONE 305	100B PROCESS CYAN-2	50Y-25B PANTONE 358	50Y-50B PANTONE 345
25R PANTONE 196	50R PANTONE 210	100R PROCESS MAGENTA-2	25Y-25B PANTONE 337	25Y-50B PANTONE 338
100Y-25R PANTONE 130	100Y-50R PANTONE ORANGE 021	100Y-100R PANTONE RED 032	50Y-100B PANTONE 327	50Y-25R-100B PANTONE 329
100B-25R PANTONE 285	100B-50R PANTONE 286	100R-100B PANTONE 266	100Y-100B PANTONE 354	100Y-100B-25R PANTONE 336
25R-25B PANTONE 263	25R-50B PANTONE 278	100Y-25R-25B PANTONE 132	100Y-25R-50B PANTONE 385	100Y-100B-50R PANTONE 350
50R-25B PANTONE 257	50R-50B PANTONE 271	25Y-25R-50B PANTONE 429	50Y-25R-50B PANTONE 443	50Y-50R-50B PANTONE 437
100R-25B PANTONE 233	100R-50B PANTONE 241	25Y-50R PANTONE 183	50Y-50R PANTONE 177	50Y-100R PANTONE 833
50Y-25R PANTONE 156	50Y-25R-25B PANTONE 465	100Y-50R-50B PANTONE 470	100Y-50R-25B PANTONE 167	100Y-25B-100R PANTONE 484
25Y-25R PANTONE FLESH 162	25Y-25R-25B PANTONE 481	50Y-50R-25B PANTONE 479	100Y-50B-100R PANTONE 483	PROCESS BLACK

©DC Comics Inc. 1986

José Luis García-López

"When he started work at DC Comics in the '70s, José set the bar for dignity, graciousness, and mastery of his art, and gave everyone who followed something rare and fine to live up to. His line is beautiful — elegant, descriptive, and refined — with nothing more than exactly what is needed to define and reveal his characters."
— JENETTE KAHN

JOSÉ LUIS GARCÍA-LÓPEZ
Above: *Photograph, at the drawing board, 1977.*

ALL-NEW COLLECTORS' EDITION No. C-54

Opposite: *Cover art, José Luis Garcia-López and Dan Adkins.* Above: *Interior, "Superman Vs. Wonder Woman"; script, Gerry Conway; pencils, José Luis Garcia-López; inks, Dan Adkins. 1978.*

The discovery of García-López in 1975 gave DC a new interpreter of Superman. His action scenes were powerful, making him perfect for the tabloid-size specials, where he took full advantage of the widescreen double-page format for the two heroes' conflict over the use of the atomic bomb.

DC'S FIRST STYLE GUIDE

Right: *Cover art, José Luis García-López and Dick Giordano, 1982.*

"While he was working on the style guide, José drew two characters jumping out of a DC inkwell, smiles on their faces and bursting with life. And that's what truly distinguishes José's art — a joie de vivre, an optimism, an irrepressible élan."
—Jenette Kahn

ACTION COMICS No. 419

Opposite: *Cover art, Neal Adams, Murphy Anderson, and Jack Adler, December 1972.*

Editor Julius Schwartz's first issue of *Action Comics* opened with a bang thanks to a striking aerial photograph as its background courtesy of Jack Adler.

READ No. 10

Above: *Cover art, unknown, January 22, 1971.*

Air pollution was a popular subject for super heroes in the 1970s, figuring into stories involving the Justice League and Green Lantern/Green Arrow among others. A Murphy Anderson–illustrated cartoon for *Coronet* magazine even depicted Superman choking on toxic air while Wonder Woman mused, "What should I wear to the end of the world — a mini — or a midi?"

DYNAMIC COMICS MULTI-PACK

Above: *Cover art, Action Comics No. 479, Rich Buckler and Bob Oksner, January 1978.*

Despite being sold as non-returnable product to venues like department stores, DC's three-packs were often torn open by retailers and returned through magazine vendors for credit. That problem was circumvented in 1978 when the issues earmarked for multi-packs were printed with the logo of distributor Whitman rather than the DC bullet.

SUPERMAN SHELL COLLECTOR SERIES

Left: *Cover art, Ross Andru and Dick Giordano, ca. 1980.*

Conceived as a series of 12 comic books that would only be available at Shell gas stations, *Superman: The Shell Collector Series* never made it beyond an unpublished prototype. Dan Spiegle and Dick Giordano drew the interior story meant for the first issue.

"*This living diorama, this ant colony of real people, had great appeal for children, adding to the childlike nature of this era's Superman.... Kandor was every snowglobe and music box that stood for every bittersweet memory in every movie there would ever be.*" —GRANT MORRISON

SUPERMAN No. 338

Above and right: *Interior, "Let My People Grow"; script, Len Wein; pencils, Curt Swan; inks, Frank Chiaramonte. August 1979.*

Since its 1958 introduction, the Bottle City of Kandor had played a major part in Superman lore, one that allowed the Man of Steel to interact with his native culture. By 1977, Kandor's mythology had grown to the point that its native heroes Nightwing and Flamebird had their own series in *Superman Family*. Seeing Kandor's shrunken status as a loose end in need of tying off, Len Wein scripted a 1979 story in which the city's Kryptonian population was enlarged and relocated to a distant planet. Wein later regretted the decision, noting that he'd deprived future readers of experiencing the concept. "The idea of a bottle city of tiny people," he remarked, "is a much cooler idea than what I left it as."

SUPERMAN No. 307

Opposite: *Cover art, Neal Adams, January 1977.*

SUPERMAN NO. 408

Above: *Cover art, Ed Hannigan and Al Williamson, June 1985.*

With tensions running high between the United States and Soviet Union during the last years of the Cold War, a 1985 story found the Man of Steel haunted by nightmares of a global nuclear war. Although he considered disarming the world's nuclear arsenal, Superman ultimately decided that he couldn't mother hen the human race.

SUPERMAN No. 393

Below: *Cover art, Ed Hannigan and Murphy Anderson, March 1984.*

SUPERMAN No. 248

Above: *Original cover art, Carmine Infantino and Murphy Anderson, February 1972.*

Even as he revived Superman's genius adversary Lex Luthor, writer Len Wein was creating a complementary physical threat who added much-needed raw power to the Man of Steel's rogues' gallery. Supercharged by the stars, the Galactic Golem was a formidable match for Superman, so much so that no writer other than Wein could figure out how to bring him back until Kurt Busiek in 2008's *Superman* No. 675.

SUPERMAN No. 294

Opposite: *Cover art, Ernie Chan, December 1975.*

When DC cast about for a mid-1980s reboot of the Superman series, writer Cary Bates proposed a miniseries in which the Man of Steel died. Like Klaatu (Michael Rennie) in the 1951 Cold War thriller *The Day the Earth Stood Still*, Superman would have been resurrected but left weaker and psychologically scarred.

"Ever stop to think that on this Earth, Superman is probably as much a part of high school history courses as Jefferson and FDR? He is a symbol of all that is good and right, and silly Red-K spells aside, has never been otherwise.... Feet of clay are for lesser heroes — Superman, in his context, is still the Greatest Hero of Them All."

— MARK WAID

SUPERMAN No. 240

Opposite: *Cover art, Neal Adams, July 1971.*

The fickle nature of public acclaim was a recurring theme during the Superman stories of the 1960s. That didn't stop in the following decade, as the Man of Steel learned during the ongoing serial in which his powers were progressively weakened.

SUPERMAN No. 296

Above: *Cover art, Bob Oksner, February 1976.*

A memorable four-part story dug into the nature of Superman's two identities by contriving to force him to choose between them. Without the need to downplay his normally confident nature, Clark Kent stood up to his abusive boss Morgan Edge and had a passionate fling with Lois Lane.

THE NEW ADVENTURES OF SUPERBOY No. 40

Left: *Cover art, Howard Bender and Dick Giordano, April 1983.*

As hipper teenage heroes like the New Teen Titans stole the spotlight in the 1980s, Superboy struggled to stay relevant with fans. One lengthy subplot followed Clark Kent's high school romance with classmate Lisa Davis, who preferred the bookish teenager to his flashy alter ego.

THE GREAT SUPERMAN MOVIE CONTEST

Right: *Promotional flyer, 1977.*

Encompassing comics published in May and June of 1977, DC's first Superman Movie Contest required readers to clip special coupons from various letter columns that, when assembled, would spell "Superman," "Kal-El," or "Clark." In order to get the word out, DC had 10,000 stickers and window-streamers printed for distributors to hand out to various outlets. The contest was such a hit with retailers that DC had to do a few more print runs of the flyers, with the last several thousand available only on plain white stock after the yellow stock ran out.

SUPER MAILMAN

Above: *Photograph, Bob Rozakis, 1977.*

DC's 1978 Superman Movie Contest required readers to submit answers to 25 trivia questions. It was Bob Rozakis' task to grade the mountain of postcards that arrived in order to determine who qualified to win the prizes.

SUPERMARKETING FOR SUPERMAN

Right: *Newspaper clipping,* Cleveland Press, *September 6, 1976.*

Before Superman was officially cast, A-list Hollywood names like Burt Reynolds and Robert Redford were touted for the role.

ACTION COMICS No. 569

Opposite: *Cover art, Howard Bender and Bob Oksner, July 1985.*

"I was brought up on Superman, and I believe this myth. There is a little bit of God Bless America in it. There is a purity and a fantasy in it that is right for our times."

— RICHARD DONNER

BEHIND THE SCENES

Right: *Photograph, from left, Christopher Reeve, director Richard Donner, screenwriter Mario Puzo, and producer Pierre Spengler on the set of Superman, 1977.*

MILLION DOLLAR MINUTE

Above: *Film still, Marlon Brando as Jor-El and Susannah York as Lara, Superman, 1978.*

Accounts of Brando's $3.7 million salary for about 10 minutes of screen time as Superman's father Jor-El failed to mention that the actor also shot scenes for *Superman II*. His footage for that film ended on the cutting room floor.

SPECIAL EFFECTS

Opposite: *Photograph, Christopher Reeve and director Richard Donner on the set of Superman II, 1978.*

Here, Reeve is seen on the boom used in special effects designer Zoran Perisic's "Zoptic" process. It created the never-before-seen effect of Superman flying into the camera.

244

"SUPERMAN II" — "TOO CLOSE FOR COMFORT" — "AMERICAN JOKES" FROM POLAND — DAVE BERG — DON MARTI[N]

...and the usual gang of idiots are all in this issue of...

MAD

No. 226 Oct. '81

OUR PRICE 90¢ CHEA[P]

OPTICAL ILLUSION: STARE AT THIS PATTERN FOR 10 SECONDS!

NOW LOOK AWAY! YOU'LL THINK YOU SEE IT ON EVERYTHING!

MAD No. 226

Opposite: *Cover art, Jack Ricard, October 1981.*

In its first parody of the Man of Steel in 1953, *Mad* dubbed him Superduperman. Mort Drucker illustrated take-offs of the first three films in the late 1970s and early 1980s, by which time he'd been rechristened Stuporman.

SUPERMAN IN JAPAN

Right: *Poster, artist unknown, 1981.*

International audiences sometimes saw more differences in the U.S. Superman films than just the translated dialogue. Europe's home video version of *Supergirl* actually ran 20 minutes longer than the U.S. incarnation, and was available on Japanese laserdisc.

SUPERMAN II

Below: *Film still,* Superman II, *1980*

Superman II's success clinched it: Adult audiences really were ready to take a super hero, previously thought to be strictly kids' stuff, as seriously as they did any Clint Eastwood character.

THE DAILY PLANET

Above: *Movie prop, facsimile newspaper,* Superman III, *1983.*

The movie's *Daily Planet* as shown here bore no physical resemblance to the real-life paper "playing" it: many scenes were filmed in front of the offices and in the lobby of the tabloid *New York Daily News*.

POLISH SUPERMAN III POSTER

Opposite: *Art, Waldemar Swierzy, 1983.*

Superman III tried to broaden the film's appeal by co-starring comedian Richard Pryor, but an entirely different tactic was taken in this Polish movie poster.

NEARLY EXPOSED

Above: *Film still, Reeve and Aaron Smolinski,* Superman III, *1983.*

To moviegoers, this little boy was just another uncredited extra, but to the producers of the Superman series, he was an old colleague who had been with them from the beginning. Five years earlier, Aaron Smolinski had played Baby Kal-El in the first film.

HE IS SUPERMAN!

Right: *Film still, Christopher Reeve, 1978.*

Following the release of *Superman: The Movie*, the once-unknown Christopher Reeve was now mobbed by fans wherever he went. Following an early 1979 visit to the DC offices, Reeve was smuggled out of the building via a freight elevator with the help of Bob Rozakis. An indignant woman subsequently insisted that the actor couldn't have left the premises because she'd never taken her eyes off the regular elevator. "Well, ma'am," Rozakis quipped, "he *is* Superman."

DC IN THE EIGHTIES

Above: *Photo, ca. 1982.*

Following the 1981 retirements of Jack Adler and Sol Harrison, much of DC's editorial staff came together at an all-company retreat. Seated in the center of the front row, Warner Books' Bill Sarnoff was flanked by Joe Orlando and Jenette Kahn on the left and Dick Giordano and Paul Levitz on the right.

THE NEW DC IS ON THE MOVE!

Opposite top: *Moving announcement; art, José Luis García-López, 1982.*

In anticipation of DC's move from 75 Rockefeller Plaza, Neal Pozner designed an inventive fold-out announcement that proclaimed the company would be based at 666 Fifth Avenue as of December 3, 1982.

JENETTE KAHN BY NEAL ADAMS

Right: *Spot illustration for publisher's feature,* Superman *No. 309; art, Neal Adams. March 1977.*

Immediately upon her arrival, Kahn began experimenting to find her version of "Stan's Soap Box," the chatty, ingratiating promotional page that Marvel's chief editor, Stan Lee, had been writing for years. A prototype for what became the "Publishorial" introduced her to DC readers with a mock internal memo critiquing Adams' portrait.

SUPERMAN'S BOSSES

Left: *Photograph, Jenette Kahn and Paul Levitz,* Savvy *magazine, January 1984.*

"I was the positive one and he was the skeptic," Jenette Kahn said of Paul Levitz in a 2012 interview. "Paul always said I saw around corners. But Paul loved detail and understood how to make things happen. If I saw something around the corner, Paul knew how to implement it. We were a wonderful team…I cherish that relationship to this day as I do the relationship I had with Dick [Giordano] and Joe [Orlando]."

251

CAN YOU SPOT THE CELEBRITIES WATCHING THE GREATEST FIGHT OF ALL TIME-AND-SPACE? (See inside cover

SUPERMAN vs. MUHAMMAD ALI

THE FIGHT TO SAVE EARTH FROM STAR-WARRIORS

$2.50
C-56
32180

ALL NEW COLLECTOR EDITION

SUPERMAN vs. MUHAMMAD ALI

Script based on an original story by: Denny O'Neil
Adapted By: Neal Adams
Penciller: Neal Adams

Inkers: Dick Giordano & Terry Austin
Letterer: Gaspar Saladino
Colorist: Cory Adams
Editor: Julius Schwartz

CODE

A. SHOW-BIZ PERSONALITIES
B. CELEBRITIES:
 B1. POLITICS
 B2. SPORTS
 B3. LITERATURE AND THE ARTS
C. DC STAFFERS
D. WARNER COMMUNICATIONS EXECUTIVES
E. NEAL ADAMS' CONTINUITY ASSOCIATES
F. MUHAMMAD ALI CORNERMEN
G. EDITORS/WRITERS/ARTISTS
H. DC CHARACTERS

1. Berni Wrightson (G)
2. Boston (Deadman) Brand (H)
3. Wallace Wood (G)
4. Ed Davis (G)
5. Flo Steinberg (G)
6. Gil Kane (G)
7. Tex Blaisdell (G)
8,9,10,11,12. The Jacksons (A)
13. Sergio Aragones (G)
14. Howard Chaykin (G)
15. Archie Goodwin (G)
16. Walt Simonson (G)
17. Alan Weiss (G)
18. Rac Shade (H)
19. Sol Himmelman (D)
20. Caesar Kimmel (D)
21. Joseph P. Grant (D)
22. Bert Wasserman (D)
23. Byron Preiss (G)
24. Ms. Mystic (H)
25. Frank Herrera (D)
26. Albert Sarnoff (D)
27. Dick Giordano (G)
28. Joel Adams
29. Neal Adams (E) (G)
30. Jason Adams
31. Kristine Adams
32. Zeea Adams
33. Joe Orlando (C)
34. Arthur Gutowitz (C)
35. Allen Milgrom (C)
36. Jay Emmett (D)
37. David Horowitz (D)
38. Steven J. Ross (D)
39. Noel Neill (A)
40. Kirk Alyn (A)
41. Joe Shuster (G)
42. Jerry Siegel (G)
43. Emanuel Gerard (D)
44. William Sarnoff (D)
45. Kenneth S. Rosen (D)
46. Ron Palillo (A)
47. Robert Heyges (A)
48. Jack Larson (A)
49. Joe Namath (B2)
50. William Conrad (A)
51. Pele (B2)
52. Andy Warhol (B3)
53. Cher (A)
54. Donny Osmond (A)
55. Marie Osmond (A)
56. Joe Kubert (C)
57. Tony Orlando (A)
58. Kurt Vonnegut Jr. (B3)
59. Jill Krementz (A)
60. Wolfman Jack (A)
61. Frank Sinatra (A)
62. Jenette Kahn (C) (D)
63. Ron Howard (A)
64. Gerald R. Ford (B1)
65. Charles Lomax (F)
66. Herbert Muhammad (F)
67. Bundini Brown (F)
68. Angelo Dundee (F)
69. Red Ryan (H)
70. Ace Morgan (H)
71. Prof Haley (H)
72. Rocky Davis (H)
73. Plastic Man (H)
74. Mary (Mary Marvel) Batson (H)
75. Freddy (Captain Marvel Jr.) Freeman (H)
76. Doc Magnus & the Metal Men (H)
77. Bob LeRose (G)
78. Bob Layton (G)
79. Billy (Captain Marvel) Batson (H)
80. J'onn J'onzz (H)
81. Julius Schwartz (C)
82. Denny O'Neil (G)
83. Carol Fein (C)
84. Dan Goldstein (D)
85. Morris Waldinger (C)
86. Carter (Hawkman) Hall (H)
87. Shiera (Hawkgirl) Hall (H)
88. Paul Kupperberg (G)
89. Anthony Tollin (G)
90. Milton Snapinn (C)
91. Carol Ferris (H)
92. Hal (Green Lantern) Jordan (H)
93. Oliver (Green Arrow) Queen (H)
94. Ray (Atom) Palmer (H)
95. Alfred (Wayne Butler) Pennyworth (H)
96. Arthur (Aquaman) Curry (H)
97. Morgan Edge (H)
98. Dick (Robin) Grayson (H)
99. Dinah (Black Canary) Lance (H)
100. Perry White (H)
101. Jimmy Olsen (H)
102. Lois Lane (H)
103. Barry (Flash) Allen (H)
104. Iris Allen (H)
105. Roy (Speedy) Harper (H)
106. Aqualad (H)
107. Wally (Kid Flash) West (H)
108. Betty Ford (B1)
109. Jack Adler (C)
110. Jim Bouton (B2)
111. Lillian Mandel (C)
112. Steve Mitchell (G)
113. Vince Colletta (G)
114. Paul Levitz (C)
115. John Workman (G)
116. Donna (Wonder Girl) Troy (H)
117. Paul Kirchner (G)
118. Jack C. Harris (G)
119. Murray Boltinoff (C)
120. Sol Harrison (C) (D)
121. Bob Rozakis (C)
122. Mrs. Sol Harrison
123. Midge Bregman (C)
124. William M. (MAD) Gaines (B3)
125. Raquel Welch (A)
126. Vicente Alcazar (G)
127. Wayne Rogers (A)
128. Joe Letterese (C)
129. Alfred E. Neuman (B3)
130. Don King (F)
131. Lex Luthor (H)
132. Barbara (Batgirl) Gordon (H)
133. Steve Trevor (H)
134. Diana (Wonder Woman) Prince (H)
135. Pat Rooney (G)
136. Pat Bastine (E)
137. Ralph Reese (G)
138. Larry Hama (C)
139. Trevor Von Eeden (E) (G)
140. Mark Alexander (E)
141. Joe DiEsposito (E) (G)
142. Jack Abel (E) (G)
143. Joe Rubinstein (G)
144. Joe Barney (E) (G)
145. Marshall Rogers (E) (G)
146. Bob Wiacek (E) (G)
147. John Fuller (E) (G)
148. Liberace (A)
149. Frieda Sacco (C)
150. Bruce Patterson (G)
151. Frank Cirocco (G)
152. Cary Burkett (C)
153. Bill Morse (G)
154. E. Nelson Bridwell (C)
155. Shelley Eiber (G)
156. Bob McLeod (G)
157. Mike Nasser (E) (G)
158. Joe Brozowsky (E) (G)
159. Carl Potts (E) (G)
160. Terry Austin (G)
161. Cary Bates (E) (G)
162. Tom Sciacca (G)
163. Johnny Carson (A)
164. Christopher Reeve (A)
165. Greg Theakston (G)
166. Lucille Ball (A)
167. Rick Bryant (G)
168. The Batman (H)
169. Sonny Bono (A)
170. Jimmy Carter (B1)
171. Rosalynn Carter (B1)
172. Mike Gold (C)

ALL NEW COLLECTORS' EDITION, Vol. 7, No. C-56, 1978. Published quarterly by DC COMICS INC., 75 Rockefeller Plaza, New York, N.Y. 10019. Copyright © 1978 by DC Comics Inc. All Rights Reserved. The stories, and incidents mentioned in this magazine are entirely fictional. Printed in U.S.A.

This periodical may not be sold except by authorized dealers and is sold subject to the conditions that it shall not be sold or distributed with any part of its cover or markings removed, nor in a mutilated condition, nor affixed to, nor as part of any advertising, literary or pictorial matter whatsoever.

Jenette Kahn, Publisher
Joe Orlando, Managing Editor
Julius Schwartz, Editor
E. Nelson Bridwell, Associate Editor
Jack Adler, Vice-Pres. Production
Vince Colletta, Art Director
Paul Levitz, Editorial Coordinator
Sol Harrison, President

SUPERMAN VS. MUHAMMAD ALI

Previous pages: *Cover art, Neal Adams, 1978.*

THE FIGHT OF THE CENTURY!

Above: *House ad art, Neal Adams and Dick Giordano, 1977.*

In early 1976, shortly after the release of *Superman vs. the Amazing Spider-Man*, a bemused Julius Schwartz noted that the world's heavyweight boxing champion was in town. "Superman vs. Ali," he laughed. "Now that's a good one." The joke was on Schwartz when new publisher Jenette Kahn fell in love with the idea, convincing Ali's camp to agree to the tabloid-sized comic book and recruiting Neal Adams as the key talent on the project.

SUPERMAN VS. ALI

Above: *Unused cover art, Joe Kubert. Published in* Amazing World of DC Comics *No. 12, July 1976.*

War comics great and DC editor Joe Kubert was the company's first choice to illustrate the Ali project, but likenesses were not his strong suit. He was replaced by Adams, whose rendering of the heavyweight champ met with the athlete's approval.

THE GREATEST

Left: *Photograph, left to right, Don King, Herbert Muhammad, and Muhammad Ali at a press conference with Sol Harrison, 1977.*

"Superman don't need no seat belt."
—Muhammad Ali
"Superman didn't need no airplane neither."
—Unidentified stewardess

RINGSIDE WHO'S WHO

Opposite: *Interior, key to Neal Adams' wraparound cover, 1978.*

Not all 172 likenesses were nationally known celebrities. Many were comics industry figures known only to fans, who delighted in finding their faces.

WORLD'S FINEST COMICS No. 247

Above: *Cover art, José Luis García-López and Dick Giordano, October–November 1977.*

SUPERMAN No. 321

Opposite: *Cover art, José Luis García-López and Dick Giordano, March 1978.*

1970's less-powerful Superman was abandoned by 1975, and finding suitable challenges for him again became daunting. The occasional solution was turning his own powers—such as super-hearing—against him.

ACTION COMICS No. 541

Left: *Cover art, Gil Kane, March 1983.*

Throughout the first half of the '80s—before John Byrne was brought in to reinvent Superman—DC made an ongoing effort to sustain the sales momentum generated by the character's greater exposure in films. One strategy was letting veteran DC artists who had not previously handled the Man of Steel offer their takes. Some of the most interesting results were provided by Silver Age *Green Lantern* artist Gil Kane, creating striking covers like this one.

ACTION COMICS No. 480

Above: *Cover art, José Luis García-López and Dick Giordano, February 1978.*

Some things look worse than they are. That was certainly the case with this cover in which Superman was pressed against a meteor that was about to strike downtown Metropolis. In the story itself, the touchdown took place harmlessly in the Pacific Ocean.

257

ACTION COMICS No. 508

Above: *Interior, "The Secret World of Jonathan Kent"; script, Cary Bates; pencils, Curt Swan; inks, Frank Chiaramonte. June 1980.*

One of Cary Bates' best-remembered Superman stories found the hero's foster father Jonathan Kent mysteriously resurrected and sharing a life with his adult son — an imaginary story, in Clark Kent's reality, it sadly never happened.

SUPERMAN ANNUAL No. 9

Opposite: *Interior, "I Flew with Superman"; plot, Cary Bates; script, Elliot S! Maggin; pencils and inks, Curt Swan. 1983.*

"Woke up this morning, what do I see?
Robbery, violence, insanity…
Superman, Superman…
I want to fly like Superman."

—The Kinks, "(Wish I Could Fly Like) Superman," 1979

THE GOSPEL ACCORDING TO SUPERMAN

Right: *Book cover art, Curt Swan; A. J. Holman Co.; 1973.*

While later filmmakers drew parallels between Superman and Jesus, author John Galloway Jr. cautioned against such parallels. "Superman bears striking resemblance to the god of popular religion," he remarked, but not to the Biblical Christ.

SUPERMAN
Created by Jerry Siegel & Joe Shuster

"IT WAS THURSDAY, BUT WEDNESDAY WASN'T FAR BEHIND. I DIDN'T MISS IT. I'D BEEN WORKING DAY AND NIGHT FOR A WEEK THAT FELT LIKE A MONTH..."

"MY EYES FELT LIKE A SWAMP, MY DRAWING HAND FELT LIKE A CLAW AND MY HEAD FELT LIKE THE NAVY MARCHING BAND WAS USING IT FOR A PARADE GROUND!"

"MY NAME'S CURT SWAN. I'M AN ARTIST..."

"...AND WHEN MY TEACHERS TOLD ME YEARS AGO THAT I SHOULD LIVE THROUGH MY ART I NEVER KNEW THAT SOMEDAY I WOULD BE ABLE TO SAY..."

I FLEW WITH SUPERMAN!

ARTIST/STORYTELLER: CURT SWAN • AS TOLD TO: CARY BATES (PLOT) • ELLIOT MAGGIN (COPY) and JULIUS SCHWARTZ (EDITING)
JOHN COSTANZA, LETTERING • ANTHONY TOLLIN, COLORING

MAY CO PRESENTS SUPERMAN

GREAT CAESAR'S GHOST! IT'S CHRISTMAS PRESENT! JUST IN THE NICK OF TIME, THE MAY COMPANY SAVES THE DAY WITH SPECTACULAR OUT OF THIS WORLD "SUPERMAN" STUFF FOR ALL THE LITTLE HEROES ON YOUR CHRISTMAS LIST!!!

"SUPERMAN" DRAWING! REGISTER NOV. 30 THRU DEC. 15 FOR A COLOSSAL CONTEST WITH A GALAXY OF "SUPERMAN" STUFF PRIZES INCLUDING TICKETS TO THE NEWLY RELEASED "SUPERMAN" MOVIE, "SUPERMAN" CLOTHING, BEDDING AND OTHER PARAPHERNALIA DEPICTING THE CAPED KRYPTONITE PLUS DAILY PLANET PRESS CARDS (WHILE THEY LAST) TO ALL WHO REGISTER!!!

GRAND PRIZE: Lunch with a Cleveland Press editor, a tour of the plant, movie tickets and a chance to be a cub reporter in the Press Mini-Section. Register in the Children's Dept. at all stores, or mail your name/address/phone number to "Superman", c/o Special Events, May Co., 158 Euclid Ave., Cleveland, Ohio 44114.

THE SHIRT RIGHT OFF OUR HERO'S BACK.
A special "Superman the Movie" sweat shirt for young heroes disguised as "mild-mannered" junior boys. Sizes 8-14, assorted colors, $8. Jr. Boys (31)—all stores. (P.S. They also fit junior girls!)

THE SUPERMAN SCOOPS
Now the whole story of "Superman" is told in this book: The Great Superman Book, $8.95. And keep up to date with the "Superman the Movie" 1979 calendar with scenes from the movie, $4.95. Books (26)—all stores.

"SUPERMAN" BAGS ANOTHER ONE
It's in the bag with Superbags™ Canvas take-alongs in many sizes. Shown, "Superlunch", $4. Other Superbags, $3 to $8. Children's World (66)—all stores.

"SUPERMAN" GETS 'EM BY HOOK OR COOKIE!
The "Superman" Cookie Jar. A ceramic cookie jar featuring the smartest cookie of them all and his famous quick-change telephone booth. $20. Cook's Pantry (6)—all stores.

THE BEDTIME BEDAZZLERS

"SUPERMAN" SHEETS
Kids "leap into bed in a single bound" to sleep on "Superman" sheets! Flat and fitted, twin size, each $7.99. Cases, each $3.99. Domestics (15)—all stores.

"SUPERMAN" SLEEPERS
Dreams are heroic for kids who take off for Z-land in the "Superman" blanket sleeper. In cuddly red and blue. Sizes 1 to 7, $10.50. Children's World (70) all stores.

"IT'S A BIRD, IT'S A PLANE, IT'S SUPERMAN" SWEAT SHIRTS.
A cosmic delight! "Superman" sweat shirts for kids, sizes 6 to 14, in assorted colors and transfers, $6. Shown, glitter "S". Children's World (66)—all stores.

the store is may company

TM indicates trademark of DC Comics, Inc. ©DC Comics, inc 1978

SHOP DOWNTOWN TONIGHT TIL 9, BRANCHES TIL 10. WE GIVE AND REDEEM EAGLE STAMPS.

SIEGEL AND SHUSTER

Above: *Photograph by Steve Schapiro, 1979.*

Given a hero's welcome at the world premiere of *Superman: The Movie*, Jerry Siegel and Joe Shuster channel their inner heroes in this fanciful photo shoot.

MAY CO. PRESENTS SUPERMAN

Opposite: *Advertising art, unknown, 1979.*

The release of *Superman: The Movie* was a licensing bonanza that generated countless books, toys, and other products. For Michael Fleisher, whose *Encyclopedia of Comic Book Heroes* had stalled after editions devoted to Batman and Wonder Woman, it was an opportunity to get his Superman volume into print, rebranded as *The Great Superman Book*.

SUPERMAN DAY IN METROPOLIS

Left: *Photograph, January 1972.*

As part of the promotion for Metropolis, Illinois', first Superman Day on January 21, 1971, local artist Ken Moeckel painted a massive image of the Man of Steel—based on a classic Wayne Boring image—that was mounted on the community's water tower.

SHOWTIME—THE RETURN OF SUPERMAN

Above: *Cover art*, The Press; *José Luis García-López and Dick Giordano; Thursday, November 30, 1978.*

When it reprinted 1939's *Superman* No. 1 in 1978, DC also commissioned companion pieces to its original cover that—rendered by García-López and Giordano—depicted the Man of Steel in the present and the future.

261

THE COMIC BOOK PRICE GUIDE No. 1

Above: *Cover, 1970.*

The fact that collectors might pay big money for old comic books took the news media by storm in 1965, but there was rampant inconsistency in the budding market on specifics like condition and price. Robert M. Overstreet's annually published *Comic Book Price Guide* was instrumental in creating uniform guidelines for comic book buyers and sellers as well as serving as a basic resource on the contents of those issues.

LET'S MAKE A DEAL

Opposite: *Photograph by Alan Kamuda, Dream-Con chairman Mike Shiner,* Detroit Free Press. *August 9, 1975.*

Organized by 15-year-old Mike Shiner and held at Detroit's Notre Dame High, 1975's three-day Dream-Con boasted such guests as Will Eisner, Dick Giordano, Marie Severin, Rich Buckler, and Mike Vosburg.

SUPER DC CON '76

Above: *Convention program cover art, Curt Swan, 1976.*

For a 1976 convention, Sol Harrison asked DC advertiser Hostess Bakeries if they'd be willing to donate product for door prizes. Harrison and company ended up with so many Twinkies that they began handing out entire cases—eventually as many as could be carried—to every fan in attendance.

AND THE WINNER IS . . .

Right: *Photograph by Jack Adler, costume contest at a comics convention, early 1970s.*

As comics conventions proliferated, fans increasingly dressed as favorites ranging from the mainstream Superman to cult classic Deadman.

THE SUPERHERO BOOK No. 2

Above: *Cover art, Joe Kubert, April 1977.*

Seeing the potential in the plethora of 1970s super-hero toys and books, Ivan Snyder began producing nationally distributed comic book–size catalogs for his Heroes World business. After a few issues, the catalog art was produced by the students of the Joe Kubert School with Kubert himself editing and drawing each cover.

CONVENTION BOOTH

Opposite: *Photograph, collector Michael Carbonaro's comics and memorabilia booth at a Star Trek convention, New York City, January 16, 1976.*

TRUTH, JUSTICE, AND . . . SALES

Left: *Print advertisement for Mego toys, Licensing Corporation of America, from Playthings magazine, February 1975.*

In the '70s, DC's sister company LCA licensed out its super heroes to Mego, whose "World's Greatest Super-Heroes" line transformed the small toy company into a major player. The company has been defunct since 1983, however, with the result that today its action figures and play sets are prized collectibles worth thousands.

THE COMICMOBILE

Above: *Advertising flyer, Summer 1973.*

Conceived by Sol Harrison, the Comicmobile drove along the New Jersey coast and Long Island in the summer of 1973, with Michael Uslan and Bob Rozakis dispensing comic books to kids. The short-lived experiment was aimed at seeing if this venue was a viable alternative to the shrinking magazine retailers, but sales dwindled once the new school year began.

SUPER HALLOWEEN!

Above: *Advertising art, unknown, October 1976.*

While rival publishers' product was often intermixed in Ivan Snyder's Heroes World catalogs, he also produced publisher-specific ads to run in each of their own comic books. An ad for Halloween costumes was also able to plug DC's 1974 tabloid edition of *Ghosts*.

UNDERWEAR THAT'S FUN TO WEAR

Right: *Advertisement, Underoos, ca. 1978.*

Underoos was first conceived by Larry Weiss, who acquired licenses to the major characters of DC and other publishers. After early rejections, the concept was embraced by Fruit of the Loom and became an enormous success in the 1970s. Perhaps inevitably, Underoos were revived in adult sizes by the Hot Topic chain in 2014.

TRICK OR TREAT

Above: *Photograph, Josh Baker, age 5, wearing a custom-made-by-mom Superman costume, October 1979.*

ACTION COMICS No. 425

Opposite: *Cover art, Nick Cardy, July 1973.*

"With my covers, I wanted them to be simple and powerful," Nick Cardy explained. "If you're at a newsstand and you have rows and rows of comic books, you want your cover to have a two-second impact that catches the reader. And if you have a lot of confusing covers, the people are not looking at the drawings, they're just looking at the titles."

OFFICIAL METROPOLIS EDITION

$2.

AMAZING WORLD OF SUPERMAN

Special BONUS! GIANT POSTER "MAP of KRYPTON"

THE AMAZING WORLD OF SUPERMAN, METROPOLIS EDITION

Opposite: *Cover art, Curt Swan and Murphy Anderson, 1973.*

In 1972, Metropolis, Illinois, hoped to capitalize on its name by transforming itself into a destination spot for Superman fans with a massive theme park and statue. In support of the project, DC produced a tabloid-sized souvenir edition that included a definitive retelling of the Man of Steel's origin. Although Metropolis' ambitious theme park plans went unrealized, the community still plays host to an annual Superman Celebration each summer.

SUPERMAN TASCHENBUCH No. 70

Left: *Cover art, Frank Miller, 1985.*

One of Germany's major sources for Superman stories from 1976 to 1987 was *Superman Taschenbuch*. Each album reprinted multiple U.S. adventures and, at 100 pages per issue, could collect multi-part stories as virtual graphic novels. This issue, for instance, reprinted *Superman: The Secret Years* 1–4, including Frank Miller's cover for issue 2.

SUPERMAN ALBUM No. 1

Above: *Cover art, Adrian Gonzales and Joe Orlando, 1982.*

When German publisher Ehapa's demand for Superman content exceeded the United States' supply, editor Julius Schwartz began producing a series of extra-long stories primarily for that overseas market. The first edition was released in an album format for German, British, and U.S. audiences…but most of the eventual 25 stories between 1982 and 1985 were never published in English.

BUGS BUNNY MEETS THE SUPER-HEROES

Above: *Poster, Summer 1978.*

For four years, the Looney Tunes cartoon characters united with DC's super heroes in a live-action stage musical produced by Roger Hess. The theme of the show varied from year to year—ranging from space travel to sports—as the actors toured throughout the United States and United Kingdom.

SUPER HEROES AT SEA WORLD

Opposite: *Showbook cover, 1976.*

The DC Super Heroes aquatic spectacle was a pricey enterprise. The costuming expense of the 1976 Sea World production came to $40,000. To the producers' horror, the elastic in the spandex and foam outfits melted after going through a clothes dryer. A special drying room was subsequently built to avoid similar disasters.

COME SEE US AT SEA WORLD

Above: *Advertising art; pencils, unknown; inks, Vince Colletta. 1977.*

Opening at the Aurora, Ohio, Sea World in the spring of 1976, "The Salute to the DC Super Heroes" expanded to the Orlando, Florida branch of the theme park and began a four-year run. Some 23 water-skiers portrayed DC heroes and villains in the 45-minute extravaganza.

BUGS MEETS THE SUPER-HEROES CAST

Right: *Photograph, Cate Fowler as Wonder Woman and friends, summer 1978.*

Along with Wonder Woman, DC characters in the Bugs Bunny stage production came from the Batman mythos with Commissioner Gordon, Catwoman, the Joker, the Penguin, and the Riddler also featured throughout.

THE AMAZING WORLD OF SUPERMAN

Left and opposite *Proposed theme park concept renderings; art, Neal Adams; ca. 1973.*

The concept for the sprawling park was heavily influenced by a story in *Action Comics* No. 210, "Superman in Superman Land," presumably inspired by the sensational opening of Disneyland that year. Adams' renderings updated some attractions conceived in that story, such as a Voyage to Krypton ride and a Smallville "Main Street," while adding others based on then-current Superman stories such as a walk-in Bottle City of Kandor and a Bizarro playground where everything worked backward. While the ambitious project was abandoned in the recession of the mid-1970s, today Metropolis houses a Superman museum.

THE AMAZING WORLD OF SUPERMAN CONCEPT SKETCH

Opposite and right: *Proposed theme park art, Neal Adams, ca. 1973.*

Since 1972, Metropolis, Illinois, has been a major Midwestern tourist attraction, having proclaimed itself the "Hometown of Superman." DC and private developers proposed that Metropolis could become the site of a Superman theme park, as envisioned in designs it commissioned from Adams.

THE SUPER DICTIONARY

Opposite: *Book cover art, Joe Kubert.* Above: *Interior; script, unknown; art, Alex Toth, Nick Cardy, Joe Kubert, and Dick Dillin & Dick Giordano. 1978.*

Using DC heroes to help define words, *The Super Dictionary* also incorporated several ethnically diverse characters also used in other Warner Educational projects.

SUPER HEALTHY COOKBOOK

Left and above: *Book cover and interior, 1981.*

The original cover for a DC-themed cookbook was rejected as too abstract. "It was a sunny yellow wraparound with fruits in super-hero regalia on the front," Jenette Kahn recalled. "On the back, all that was left of the fruit were the cores, the super-hero costumes scattered on the ground."

POST CEREALS PROMOTION

Left: *Advertising art, Dick Giordano, 1980.*

DC's late 1970s partnership with Post Cereals included mini-comic premiums in boxes of Fruity Pebbles (1979) and Super Sugar Crisp (1980) as well as posters.

LET US START WORKING FOR YOU!

Below: *Promotional brochure art, José Luis García-López and Dick Giordano, 1979.*

Hoping to attract clients for company specific promotional comics, DC produced a handsome eight-page brochure filled with testimonials and colorful artwork.

CO-OP ADVERTISING PROGRAM

Right: *Advertising binder; art, José Luis Garcia-López and Kevin Maguire & Terry Austin. 1987.*

Working with retailers, DC produced a co-op advertising program that included print ads and merchandising tips.

50% of this same group say more people read their promotional comics than any other of their marketing material.*

67% of these companies believe comics are educational...70% say comics are effective in changing customer attitudes.*

Sources:
* "Study of Comics as PR Tool in Communications."
—Marvin J. Migdol

** "Study of DC Comics Readers" —Mark Clements Research, Inc.

DETECTIVE COMICS No. 463

Above: *Interior, "Crimes by Calculation"; script, Bob Rozakis; pencils, Mike Grell; inks, Terry Austin. September 1976.*

First commercially available at a steep $300–400 price tag in 1971, the pocket calculator went mainstream in the mid-1970s as the cost plunged. The now ubiquitous device inspired an eponymous villain who fought members of the Justice League in a six-part serial culminating with a confrontation with Batman. Bob Rozakis revived the villain a few times in the 1980s but the Calculator wouldn't become prominent again until 2004's *Identity Crisis*.

COMPUTER WHIZ-KIDS

Opposite: *Interior, "The Computer Masters of Metropolis"; script, Paul Kupperberg; pencils, Curt Swan; inks, Frank Chiaramonte. 1982.*

DC partnered with Radio Shack to produce an annual series of giveaway comic books that simultaneously educated readers about computers while pitching the TRS-80 unit. Superman starred in the 1980–1982 editions—but "whiz kids" Alec and Shanna were the representative reader stand-ins in each story. After production of the giveaways left DC, the two youngsters became the stars of the series, continuing into the early 1990s.

DETECTIVE COMICS No. 489

Above: *Interior, "Computer Crisis"; script, Bob Rozakis; pencils, Alex Saviuk; inks, Vince Colletta. April 1980.*

Even taking the Atom's six-inch size into perspective, computers in 1960s and 1970s comic books were massive units. A 1975 Superman story anticipated the day that computers would control buildings' basic function. This particular unit was also imprinted with Clark Kent's brain patterns and, by extension, his alter ego, becoming "The Computer with a Secret Identity."

WONDER WOMAN No. 294

Right: *Interior, "Rampage"; plot, Roy Thomas; script, Marv Wolfman; pencils, Gene Colan; inks, Frank McLaughlin. August 1982.*

The rise of computer games was reflected in DC stories of the early 1980s. A Wonder Woman adventure involved players who were brainwashed when they played the game "Commander Video," while a Flash episode made the Scarlet Speedster a pixelated part of the computer screen.

"AND CAN ANYONE TELL ME WHAT *THIS* IS?"

"CAN I?! IT'S A TRS-80 MODEL III COMPUTER -- JUST LIKE THE ONE MY FOLKS RECENTLY BOUGHT FOR OUR HOME... EXCEPT THIS ONE IS ALMOST AS BIG AS OUR HOME!"

"YOU *SAID* IT! AND THE *KEYBOARD* I'M STANDING ON IS A SOURCE OF *INPUT* FOR THE COMPUTER!"

"AND THE *VIDEO SCREEN* DISPLAYS THE *OUTPUT*!"

"COLOSSAL!"

ALL-STAR SQUADRON No. 25

Above: *Interior, "The Infinity Syndrome"; script, Roy Thomas; pencils, Jerry Ordway; inks, Mike Machlan. September 1983.*

Reflecting a different age, a group of second-generation super heroes literally went into business as Infinity, Inc. with regular paychecks to cover their service in Los Angeles. Noting that policemen and firemen were also paid, co-creator Roy Thomas declared, "There is nothing inherently disgraceful in trying to make money out of having super-powers."

FULL TILT

Opposite: *Superman pinball game, Atari, 1979.*

The resurgence of pinball in the 1980s resulted from the development of solid-state electronic games, which were made possible by the microchip. Atari was briefly a major player in the field, and its Superman game was one of the most popular. One holiday week saw the DC staff furiously competing in a tournament on the newly installed machine in the office.

DIRECT CURRENTS HOT-LINE!

Left: *House ad art, Kurt Schaffenberger, 1976.*

From November 1976 to July 1977, readers could call a toll-free phone number and hear pros like Martin Pasko and Bob Rozakis announce forthcoming DC projects in recorded messages. Near its end, the number was averaging 100,000 calls per week and taxed the system to such a degree that the Direct Currents Hot-Line had to be shut down.

THE MYSTERIOUS DISCO QUEEN

Above: *Advertising postcard,* The World's Greatest Superheroes *newspaper strip; art, George Tuska and Vince Colletta, Fall 1978.*

Most newspaper story strips typically provided subscribing papers with an ad promoting each new story line, and *The World's Greatest Superheroes* was no exception. A story involving abductions of young male disco dancers overlapped with the 1978 release of *Superman: The Movie* and segued into the Man of Steel's takeover of the strip in 1979.

DC EXPLOSION FLYER

Opposite: *Art, Jim Aparo and unknown, 1978.*

A pamphlet for magazine distributors repurposed Jim Aparo's art for the cover of *World's Finest* No. 250 with other images to tout the expansion of the DC line in the summer of 1978.

HOUSE OF SECRETS No. 140

Above: *Cover art, Ernie Chan, February–March 1976.*

When reports suggested a spike in sales on *Swamp Thing*, DC quickly readied a spin-off series featuring the Patchwork Man. Just as suddenly, the initial sales reports proved premature and the tie-in feature was canceled after only a single episode was published.

GIGANT No. 3

Left: *Interiors, "Night of the Rat"; script, Gerry Conway; pencils and inks, Nestor Redondo. 1983.*

A second Patchwork Man story sat in DC's files until a Swedish publisher inquired about running the first episode. To their surprise, they also received its unseen sequel and published it for the first time.

RAGMAN No. 1

Above: *Cover art, Joe Kubert, August–September 1976.*

Another "mysterioso" was Ragman, the super hero written by Bob Kanigher and drawn by Joe Kubert, his longtime collaborator on Sgt. Rock. Imbued with the physical prowess of four dead men, Ragman avenged his father—a murdered junk dealer from whose rags he fashioned his costume.

JASON'S QUEST

Left: *Cover art, Showcase No. 88, Mike Sekowsky and Dick Giordano, February 1970.*

A blond teenage boy—equipped with a guitar and a motorcycle—set off in search of his missing twin sister in a three-issue trial run that never received a series callback. Produced and developed by Mike Sekowsky, *Jason's Quest* was identified by Carmine Infantino as a concept that he'd first developed as a proposed newspaper strip.

SOUL LOVE

Opposite: *Unpublished, partially inked cover art, Jack Kirby, 1971.*

Jack Kirby's prospective 1971 line of adult black-and-white magazines included the uncompleted *Soul Love*, which was allegedly killed by fear of protests from Southern retailers. It grew out of a story about a black couple breaking up, prepared for another proposed Kirby vehicle, *True Divorce Cases*.

LADY COP

Above left: *Cover art, 1st Issue Special No. 4, John Rosenberger and Dick Giordano, July 1975.*

Was it true that, with romance comics extinct, no girls read DC titles? *1st Issue Special* was another *Showcase*, in which "pilot" issues for potential series were tried out. *Wonder Woman*'s Bob Kanigher—writer for Black Canary, Poison Ivy, and scores of other femmes fatales—contributed this concept. Readers, however, seemed indifferent.

THE OUTSIDERS

Right: *Cover art, 1st Issue Special No. 10, Ernie Chan, January 1976.*

Inspired by Tod Browning's 1932 cult classic film *Freaks*, Joe Simon's bizarre Super Freaks—rechristened the Outsiders before their debut—were a stark contrast from typical fashion-model heroes. From the Amazing Ronnie (a four-armed cyclops) to the partly amphibious Mighty Mary, these misfits were almost too much for DC. The original cover by Jerry Grandenetti was replaced by this ghastly teaser. The theme would be returned to in Vertigo's *American Freak* miniseries in 1994.

SOUL LOVE

DC SUPERCOMIC

The first and best of its kind!

PEOPLE OF SENSITIVITY, HUMANITY AND DEEP PASSIONS STRUGGLE WITH LIFE — AND THE SWEET PERILS OF SOUL LOVE

Read:

THE MODEL! Her problem wasn't as glamorous as her work!!!

THE TEACHER! When school was out — she went to the wrong man!!!

DEDICATED NURSE!! The patient would die — but not before he saved her!

"GO-GO GIRL" and other gripping man-woman relationships!

SUPER-HEROES BATTLE SUPER-GORILLAS No. 1

Above: *Cover art, Ernie Chan and Vince Colletta, Winter 1976.*

In the 1970s, the sight of a gorilla behaving like a human being was no longer the surefire cover gimmick it had been in decades past. Nonetheless, a pair of reprint giants devoted to super heroes vs. super-gorillas inspired new stories featuring the likes of Titano the Super-Ape and the Gorilla Boss of Gotham City.

GORILLA CITY

Right: *Unpublished interior page, "The Simian Connection"; script, Cary Bates and Elliot S! Maggin; pencils, Joe Barney and Carl Potts; inks, Terry Austin and Bob Wiacek. 1976.*

With a flood of competitors' titles threatening to bury them on the newsstand, DC released a plethora of new titles in 1975 to maintain visibility. By the time a Gorilla Grodd spin-off series was produced, the over-production had taken its toll and multiple titles—new and unreleased—were shut down.

SUPER TEAM FAMILY No. 3

Above: *Interior, "Gorilla My Dreams!"; script, Steve Skeates; pencils, Ric Estrada; inks, Wally Wood. February–March 1976.*

Although he began as a regular enemy of the Flash, Gorilla Grodd branched out in the 1970s to fight heroes such as Superman, Hawkman, and the Atom when he wasn't serving with the Secret Society of Super-Villains.

SUPERBOY AND THE LEGION OF SUPER-HEROES No. 240

Opposite: *Interior, "Dawnstar Rising"; plot, Paul Levitz; script, Paul Kupperberg; pencils, James Sherman; inks, Bob McLeod. June 1978.*

THE *FORMER* IS THE UNIVERSE'S MOST *POWERFUL* PRIMATE. LIKE A LATTER DAY *KING KONG*, IT NOW WALKS AMONG MANKIND -- A LIVING KILLING MACHINE!

THE *LATTER* IS THE DEADLIEST CREATURE KNOWN TO MAN. ITS EYES PROJECT FORCE-RAYS OF DEVASTATING POWER...

AND AS YOUNG *DAWNSTAR* SWOOPS DOWN ON HER *PREY*, SHE HEFTS A NEARBY STORAGE CONTAINER AS A *SHIELD* AGAINST THE DEADLY RAYS...

...WHICH *SHATTERS* AT THE IMPACT!

THONK

CANCELLED COMIC CAVALCADE No. 2

Above: *Cover art, Alex Saviuk, 1978.*

The abrupt corporate reversal of DC's line-wide expansion in the summer of 1978 left multiple ready-to-be-published comic books in limbo. Photocopying the pages for many of those withdrawn stories along with other unused material, DC produced 35 copies of the two-volume *Cancelled Comic Cavalcade* for contributors. The rarity became a prized commodity among DC collectors.

CANCELLED COMIC CAVALCADE No. 1

Opposite: *Cover art, Al Milgrom, Summer 1978.*

These compilations of eleventh-hour cancellations that resulted from the notorious "DC Implosion" are now valuable collectibles—some of the few copies available to collectors have even been anonymously hand-colored. A lot of the material saw print elsewhere, but some—such as the Western feature "The Deserter"—has yet to see the light of day.

DC SPECIAL No. 10

Above: *Cover art, Nick Cardy, January–February 1971.*

Repurposing episodic police stories from the 1950s series *Gang Busters*, this early 1970s reprint giant also included Fireman Farrell and Manhunters stories from *Showcase* in 1956.

THE VIXEN

Right: *House ad art, Bob Oksner and Vince Colletta, 1978.*

The decision to kill DC's line expansion in mid-1978 resulted in the cancellation of many titles that had already been advertised as going on sale. Many of those stories were printed only in a pair of photocopied *Cancelled Comic Cavalcade* sets, while others were shoehorned into surviving titles. For the Vixen, an African American heroine, this ad was her sole appearance until a 1981 debut in *Action Comics*.

Cancelled Comic Cavalcade

ALL NEW DC

STILL 10¢ — NO ADS! NO. 1

SECRETS OF HAUNTED HOUSE No. 11

Opposite: *Cover art, Michael Kaluta, April–May 1978.*

SHADE, THE CHANGING MAN No. 4

Above: *Interior, "To Rescue My Destroyer"; plot, pencils, and inks, Steve Ditko; script, Michael Fleisher. December 1977–January 1978.*

Steve Ditko's *Shade, the Changing Man* was one of DC's most eclectic titles in early comic-book retail outlets. "Heralded for its fast pace, multiple plotlines and vigorous employment of flashbacks," *American Comic Book Chronicles: The 1970s* reported, "the innovative series garnered a devoted following who placed it in the same rarified space as earlier critical favorites like Goodwin and Simonson's Manhunter."

TIME WARP No. 3

Left: *Interior, "The Dimensions of Greed"; script, J. M. DeMatteis; pencils and inks, Steve Ditko. February–March 1980.*

Time Warp was DC's final attempt at a science-fiction anthology in the spirit of classic titles like *Strange Adventures*. It often paired seasoned veterans like *Spider-Man*'s Steve Ditko with promising newcomers like J. M. DeMatteis. For all its energy and innovation, it lasted only five issues.

SHADE, THE CHANGING MAN No. 1

Above: *Cover art, Steve Ditko, July 1976.*

"While the complex story line of Shade, the Changing Man made it a difficult book to keep up with," Ed Via remarked in a 1979 *Comics Journal* review, "it also made it one of the most riveting and strangely intriguing comics ever published."

The Case For Rating Comics by Jan Strnad – page 87

The Comics Journal

No. 85
$2.50
$2.95 in Canada

The Magazine of News & Criticism

Robert Kanigher

"Bob's stories turned and moved on the emotional aspects of the characters involved. That, then, caused the artist to plumb the depths of his concentration to create a graphic response to his text. I always felt I had a great deal of freedom in illustrating Bob's stories, and he constantly pushed me to test myself, in terms of design, storytelling, and character identification." —JOE KUBERT

ROBERT KANIGHER

Above: *Photograph by Jack Adler, 1960s.*

"I wanted characters as human as I could conceive them," Robert Kanigher wrote of his war comics. "Their emotion and characterization would be the motor that drove the plot. War provided the background of action. But true character dictated the action. I felt that if I were concerned, even worried, about whether characters lived or died, the readers would be too."

FROM ONE OF THE GUYS

Opposite: *Cover art*, The Comics Journal No. 85, Joe Kubert, October 1983.

MAKE WAR NO MORE

Above: *Logo*, Our Army at War No. 233, June 1971.

A fixture at the end of DC war stories during the early 1970s, the phrase "Make War No More" first appeared at the end of a Sgt. Rock story. Although set during World War Two, the plot was analogous to the infamous 1968 My Lai massacre, which led to media attention for the Rock story.

STAR SPANGLED WAR STORIES No. 164

Right: *Interior, "White Devil...Yellow Devil"; script, Robert Kanigher; pencils and inks, Alex Toth. August–September 1972.*

"Two run-throughs of Bob's scripts," Alex Toth recalled, "and I was in synch with his intentions for pacing and key scenes because he made me feel the underlying emotion per particular scenes of his stories — without a lot of fuss 'n' feathers asides to the cartoonist."

TOUGH ACTION SOLDIER

Above: *Toy package, Remco, 1982.*

Sgt. Rock was licensed for a Remco toy line in the early 1980s, but they largely squandered the opportunity. Rather than the familiar Easy Co. crew that accompanied Rock for decades, the toy Sarge was surrounded by generic soldiers and fought "The Bad Guys: The Ultimate Enemy."

SGT. ROCK No. 384

Above: *Cover art, Joe Kubert, January 1984.*

Although he continued to draw every *Sgt. Rock* cover, by the 1980s Joe Kubert rarely drew an interior story for the series. Frank Redondo was the primary artist on the book through the mid-1980s before Kubert's son Andy stepped in to draw the final years of the Rock comic book.

SGT. ROCK No. 370

Right: *Cover art, Joe Kubert, November 1982.*

Robert Kanigher sometimes recycled story hooks in *Sgt. Rock*, as in his 1982 "Surrender Ticket." He'd previously used that title and premise in 1964's *Our Army at War* No. 149. Kubert, who drew the original Sgt. Rock episode, made the old chestnut feel fresh with his intricate cover rendering.

OUR ARMY AT WAR No. 220

Opposite: *Cover art, Joe Kubert, June 1970.*

Joe Kubert's 1950s hero Tor was never far from his thoughts. A 1970 story written and drawn by the cartoonist merged the caveman with his signature character Sgt. Rock, playing up the parallels between the primitive fight for survival with modern warfare.

STAR SPANGLED WAR STORIES No. 159

Opposite: *Cover art, Joe Kubert, January–February 1976.*

Joe Kubert's Unknown Soldier brought a fresh perspective to DC's group of combat series, pulling its focus away from the front lines and into wartime intelligence operations and intrigue. The series' darker tone was a good fit for the era, particular when subsequent writers like David Michelinie emphasized the Soldier's cynicism and hatred of war.

STAR SPANGLED WAR STORIES No. 158

Below: *Cover art, Joe Kubert. August–September 1971.*

Succeeding Joe Kubert as writer on the new Unknown Soldier series, Bob Haney recalled it as "one war comic I particularly liked. […] One nice touch we used was real photos of war statted into the montage to give it a more mature flavor. The Soldier was a more complex and mature concept and his attitudes toward war and himself had a bit of psychic depth."

BLITZKRIEG No. 1

Above: *Cover art, Joe Kubert, January–February 1976.*

In *Blitzkrieg*, writer Robert Kanigher revisited the concept of a war series from the German perspective, albeit without the sympathetic slant he'd employed in *Enemy Ace*. Following a trio of Nazi soldiers named Franz, Hugo, and Ludwig, the series featured often grisly images of the atrocities of World War Two.

BLAM

CRUMP!

G. I. COMBAT No. 148

Opposite: Interior, "The Gold-Plated General"; script, Robert Kanigher; pencils and inks, Russ Heath. June–July 1971.

Although it wasn't evident in his impeccably rendered pages, artist Russ Heath admitted to being bored during his long run on the Haunted Tank feature. He held his tongue, though, remarking, "You don't know what it does if the writer hears that, and he doesn't want to write for you anymore."

MEN OF WAR No. 8

Above and left: Interiors, "Death-Stroke"; script, Roger McKenzie; pencils, Dick Ayers; inks, Romeo Tanghal. August 1978.

Although DC had previously introduced black soldiers Jackie Johnson and Gus Gray in the respective Sgt. Rock and Haunted Tank features, Gravedigger—debuting in 1977's *Men of War* No. 1—was the first to be a leading man. Restricted to graveyard detail due to racism, World War Two soldier Ulysses Hazard believed his talents were being wasted and he convinced officials to make him "a one-man commando unit." Along with debuting Gravedigger in 1977, writer David Michelinie also unveiled black villain Pulsar the same year as well as retroactively revealing that decade-old Aquaman villain Black Manta was African American.

299

SGT. ROCK No. 364

Above: *Interior, "No-Hitter"; script, Jack C. Harris; pencils and inks, Ron Randall. May 1982.*

As he helped train a new generation of artists at the Joe Kubert School, the facility's namesake opened the back pages of *Sgt. Rock* to short stories where newcomers like Ron Randall, Stephen Bissette, Timothy Truman, Rick Veitch, and others could get a chance in the spotlight.

OUR ARMY AT WAR No. 257

Opposite: *Interior, "The Castaway"; script, Robert Kanigher; pencils and inks, Russ Heath. June 1973.*

DC SPECIAL SERIES No. 21

Above: *Interior, "The Longest Night"; script, Robert Kanigher; pencils, Dick Ayers; inks, Romeo Tanghal. Spring 1980.*

Although he was a regular presence in DC's war comics during the late 1970s and 1980s, veteran artist Dick Ayers rarely pencilled the Sgt. Rock feature itself. Ironically, Ayers had regularly pencilled Sgt. Fury—the competition's war hero—during the 1960s.

OUR ARMY AT WAR No. 247

Right: *Interiors, "Color Me Brave"; script, pencils, and inks, Sam Glanzman. July 1972.*

Sam Glanzman's favorite episode of his heartfelt U.S.S. Stevens series told the story of sailor Mac Stringer's rescue of his shipmates during harbor…and the subsequent failure by the Navy to recognize his heroics. "Color Me Brave" was staged to withhold the revelation that Stringer was black until the final panel. Glanzman dedicated the story to reader Paul LeBlanc, who'd asked why no African Americans had ever appeared in the feature.

CRACK!

BAM BAM BAM BAM BAM BAM BAM

BATTLE ALBUM!

DRESDEN!

If **WAR** represents the **WORST** in man... **DRESDEN** represents the **WORST** in war! Spring, 1945 -- only weeks before Germany's **SURRENDER** -- this ancient port on the Elbe is hit by the most **SAVAGE** bombing of World War II!

1300 **FLYING FORTRESSES** pummel the city... and **FIRESTORMS** shriek through the streets like tornadoes--sucking in hapless victims!

FIRESTORM!

This ghastly phenomenon is created when many small fires super-heat the atmosphere causing **HOT AIR** to **RISE**! **COOL AIR** rushes in to take its place and the result is a **FLAMING TYPHOON** of **BLAST FURNACE TEMPERATURES**!

HOT AIR
COOL AIR
COOL AIR

1800°F

Dresden burned for a week...

Its charred ruins yet **ANOTHER** monument to **WAR!**

SCRIPT: BILL KELLEY
ART: RICK VEITCH

SGT. ROCK No. 359

Opposite: *Interior, "Dresden"; script, Bill Kelley; pencils and inks, Rick Veitch. December 1981.*

After three years of drawing primarily short stories for DC, Kubert School graduate Rick Veitch was ready for bigger things. Along with the development of this own creations like *The One* and *Bratpack*, the cartoonist was also a prominent contributor to *Swamp Thing*.

WEIRD WAR TALES No. 93

Above: *Interior, "Ultimate Weapon"; script, George Kashdan; pencils, Denys Cowan; inks, John Celardo. November 1980.*

Anthologies like *Weird War* were good venues to try out new talent like J. M. DeMatteis, Denys Cowan, and Frank Miller, but they were also a vital outlet for industry veterans such as John Celardo, George Kashdan, and Jack Oleck.

OUR ARMY AT WAR No. 262

Below: *Interior, "The Return"; script, Robert Kanigher; pencils and inks, Russ Heath. November 1973.*

Russ Heath's "draftsmanship was unequaled," Robert Kanigher raved. "He could draw the parting of the Red Sea and have room left over for Marc Antony's address to the Roman citizens."

OUR ARMY AT WAR No. 257

Above: *Interior, "The Sea Is Calm, the Sky Is Bright"; script, pencils, and inks, Sam Glanzman. June 1973.*

A memorable episode of U.S.S. Stevens dealt with a sailor attempting to send a letter to his mother without upsetting her. After composing a "thought letter" of the horrors he experienced, the young man put pen to paper and wrote his official note home: "Dear Mom, I'm fine. The sea is calm…the sky is bright."

THE CREATURE COMMANDOS

Above: *Cover art, Weird War Tales No. 93, Joe Kubert, November 1980.*

Developed by J. M. DeMatteis and Len Wein, the Creature Commandos imagined the horror archetypes of a vampire, werewolf, and a monster as World War Two soldiers. The first stories invigorated the long-running *Weird War* title and the Commandos were soon promoted to series regulars.

WEIRD WAR TALES No. 61

Opposite: *Interior; script, Paul Levitz; pencils and inks, Howard Chaykin. March 1978.*

Before his *American Flagg* catapulted him into the first rank of American comics creators in the '80s, Howard Chaykin found a showcase for his art in DC's genre anthologies.

WEIRD WAR TALES No. 13

Left: *Interior, "Old Samurai Never Die"; script, Arnold Drake; pencils and inks, Alex Niño. April 1973.*

As editor, Joe Orlando introduced a "host," as he'd done in his other horror titles. The skeletal figure of Death was a humorous touch, often costumed to suit the stories he introduced.

WEIRD WAR TALES No. 68

Above: *Interior, "Rotirra — The Monster-Weapon"; script, Bob Rozakis; pencils and inks, Gerry Talaoc. October 1978.*

Given the stand-alone nature of their stories, DC's anthologies were prone to having a backlog of inventory. On succeeding Orlando as editor, Paul Levitz was faced with a mountain of such material. When he finally exhausted the supply in 1978, Levitz proudly announced in the letter column that he could finally solicit new stories.

OUR ARMY AT WAR No. 241

This page and opposite: *Interiors, "Dirty Job"; script, Bob Haney; pencils and inks, Alex Toth. February 1972.*

Gifted with what was once described as "an almost transcendent understanding of the power of art as a visual story component," Alex Toth had largely abandoned the monthly grind of comic books by the early 1970s in favor of animation. The challenges of sequential storytelling were in Toth's blood, though, and his periodic return visits to comics were often groundbreaking. That was never truer than his collaboration with Bob Haney on "Dirty Job." In contrast to Toth, the journeyman Haney was a prolific contributor to multiple DC titles through the end of the 1970s. Readers who'd begun to take the writer for granted were set on their heels by his novel perspective on the crucifixion of Christ and the story was later hailed as his "true masterpiece." Discussing the classic, Mark Waid observed, 'DC's war comics had a well-deserved reputation for being more emotional and hard-hitting than its super-hero fare, and nowhere is this more evident; 'Dirty Job' shows DC's courage in addressing themes and moments in history that other publishers would shy away from, citing them as 'inappropriate' or 'too intense.' Years later, when assembling its first 'Best of DC Comics' collection, DC re-presented this powerful four-pager unapologetically."

-- JUST A "DIRTY JOB"-- THAT THE WHOLE WORLD CAN NEVER FORGET...!

MAKE WAR NO MORE

"I did very detailed breakdowns because there was minimal contact. At the time, Nestor was still living on the Islands. He had a whole crew working with him; they were recommended. He normally worked with a whole bunch of guys but, without telling me, I recognized immediately that he did it all himself. He did a magnificent job! It was obvious that he poured everything he had into it." —JOE KUBERT

LIMITED COLLECTORS' EDITION No. C36

Above: *Cover art, Joe Kubert.* Right and opposite: *Interiors, "The Creation"; script, Sheldon Mayer; pencils and inks, Nestor Redondo. June–July 1975.*

This curio was one of the last projects written by Sheldon Mayer, who had begun to focus on scripting after failing eyesight curtailed his ability to draw. Certainly Mayer must have been remembering *Picture Stories from the Bible*, the pride and joy of his old mentor, M.C. Gaines, and sought to re-create that 1940s title's charms for a new generation. The meticulously researched *Bible* met with indifference despite Redondo's beautiful art, and several other projects slated to follow in 1976—King Arthur and the Knights of the Round Table, the Story of Jesus, and Rudolph's Easter Parade—reached varying levels of completion but never saw print.

Then... from the dust of the earth... he made a **MAN** in his own image. And he gave man dominion over the earth and all its living creatures. And, so... God created **ADAM**.

On the seventh day, God rested... and he blessed that day, and made it holy.

SIXTH DAY

the VIKING PRINCE

SCRIPT: ROBERT KANIGHER
ART: JOE KUBERT

"The VIKING AND THE MERMAID!"

JON, THE VIKING PRINCE, SCANS THE RAIN-STREAKED FACE OF HIS VOICELESS COMPANION... AND ASKS...

WHY... WHY DO THE GODS TORMENT ME?

BUT-- YOU CAN-NOT SPEAK, MUTE BARD! YOUR TONGUE HAS BEEN REMOVED!

I... I CANNOT LOSE THE STRANGE VISION THAT PURSUES ME! I SEE... AS IF IN A DREAM... A BEAUTIFUL MAIDEN... LYING IN A TREASURE CHEST! BELOW THE SURFACE... ON THE OCEAN'S BED!

FROM: THE BRAVE AND THE BOLD #16 (FEB.-MAR., 1958).

Joe Kubert

"Teaching was easier than sitting at a drawing board and solving tough story problems. All I was doing — and I told the classes right off the bat — was telling them the things I'd done, and how I did them.... Because I'd made my living doing that kind of work for so many years, they knew that the way I handled assignments worked." —JOE KUBERT

JOE KUBERT

Above: *Photograph by Jack Adler, 1972.*

"[Becoming an editor] has only allowed me to exercise ideas and judgments I've had all along. When you're working for an editor, you must provide the kind of work that he will accept. If I'm going to accept the responsibility of an editor, then the credits or criticisms will be for my mistakes, not for somebody else's. Being an editor now allows me to apply those thoughts more than I would or could have done working for somebody else." —Joe Kubert

THE KUBERT SCHOOL

Below: *Advertisement, The Joe Kubert School of Cartoon and Graphic Art; script and art, Joe Kubert. June 1984.*

STAR SPANGLED WAR STORIES No. 151

Above: *Cover art, Joe Kubert, June–July 1970.*

Kubert's replacement of the fan-favorite Enemy Ace series with the Unknown Soldier earned an angry response from many readers. The editor candidly responded that "all the acclamation via letters and cards did not make up for the lack of market sales.... The fact that sales have steadily risen since the appearance of the Unknown Soldier forces me to assume that the present direction is the correct one."

DC SPECIAL No. 12

Opposite: *Interior, "The Viking and the Mermaid!"; script, Bob Haney; pencils and inks, Joe Kubert. May–June 1971.*

Kubert's growth as an artist was apparent in this new splash page drawn in 1971, in contrast with the comparatively restrained 1958 reprint that followed it.

TARZAN OF THE APES

Left: *Book cover; art, Fred J. Arting; A.C. McClurg & Co. 1914.*

The earliest images of Tarzan appeared as covers on Edgar Rice Burroughs' first stories of the ape man in the 1910s. Clinton Pettee painted the cover for Tarzan's debut in the October 1912 edition of *The All-Story* while Fred J. Arting's silhouette of the character adorned the story's first hardcover edition.

TARZAN No. 222

Below: *Interiors, "The City of Gold" Part 4; story, pencils, and inks by Joe Kubert. August 1973.*

Edgar Rice Burroughs' creation had been brought to life by many great cartoonists, from School of Visual Arts co-founder Burne Hogarth to Russ Manning, but Kubert's lavish adaptations for DC are perhaps the most raw and powerful.

TOR No. 1

Opposite: *Cover art, Joe Kubert, May–June 1975.*

Kubert revived his Tarzan-inspired caveman Tor in 1975 but only wrote and drew a new story for its first issue.

THE JUNGLE IS STARTLED BY THE CRACK OF A RIFLE!

LIKE A MANTEL OF A THOUSAND WINGS, THE BIRDS OF THE JUNGLE DRAPE THEMSELVES OVER THE FIGURES LYING INERT ON THE EMERALD-GREEN GRASS...

ONLY TO WING AWAY IN TERROR AT THE APPROACHING HUNTERS...

"YOU GOT HER, HINTON!"

"WINGED THE JUNGLE GIRL JUST ENOUGH TO PUT HER OUT!"

RIMA, THE JUNGLE GIRL No. 6

Opposite: *Interior, "Safari of Death"; script, Robert Kanigher; pencils and inks, Nestor Redondo. February–March 1975.*

W. H. Hudson's 1904 novel *Green Mansions* provided a heroine to serve as a counterpart to *Tarzan*. Rima's title lasted only seven issues and was canceled two years before *Tarzan*, but, ironically, she ultimately became more of a star for the company: Between 1977 and 1980, she made guest appearances in several episodes of the *All-New Super Friends Hour* animated TV series, and a slightly different version appeared in the 2010 limited series *First Wave*.

KONG, THE UNTAMED No. 1

Left: *Cover art, Bernie Wrightson, June–July 1975.*

Primitive, scantily clad heroes—whether barbarians or jungle lords—made a brief resurgence in the 1970s although most fell quickly to oversaturation.

RIMA, THE JUNGLE GIRL No. 4

Above: *Interior, "The Flaming Forest"; script, Robert Kanigher; layouts, Joe Kubert; finished art, Nestor Redondo. October–November 1974.*

Two decades before he became involved with the Rima comic book, Nestor Redondo drew the adventures of the jungle girl Diwani for *Hiwaga Komiks* in his native Philippines.

"As the twain eyed each other challengingly through the torchlit fog, they were already dimly aware that they were two long-sundered matching fragments of a greater hero and that each had found a comrade who would outlast a thousand quests and a lifetime of adventuring." —FRITZ LEIBER, "TWO SOUGHT ADVENTURE," 1939

NIGHTMASTER

Above: *Cover art,* Showcase *No. 82, Joe Kubert, May 1969.*

Nightmaster, comics' first cover-featured sword and sorcery hero, premiered in a three-issue run a year before Conan made his four-color debut.

SWORD OF SORCERY No. 2

Opposite: *Cover art, Howard Chaykin and Bernie Wrightson. April–May 1973.*

In the Bronze Age, comics had a brief flirtation with sword and sorcery, a term coined in 1961 by writer Fritz Leiber to describe the swashbuckling adventures of strong, though not necessarily super, men on personal quests, usually requiring the vanquishing of a magical foe. The fad was a response to Roy Thomas' great success in adapting Robert E. Howard's *Conan the Barbarian*. DC purchased the rights to Leiber's fan-favorite Fafhrd and the Gray Mouser for a short-lived run in *Sword of Sorcery*. Howard Chaykin drew the feature, even as he struggled with dissatisfaction over his work. At the outset, the artist redrew the first issue's splash page six times before he could move on.

SWORD OF SORCERY No. 5

Right: *Interior, "The Sunken Land"; plot, Fritz Leiber; script, Denny O'Neil; pencils, Walter Simonson; inks, Al Milgrom. December 1973.*

Despite tepid sales, *Sword of Sorcery* was a way station for several young cartoonists destined to be major comics industry figures: Walter Simonson, Jim Starlin, and Al Milgrom.

HERCULES UNBOUND No. 5

Opposite: *Cover art, José Luis García-López, June–July 1976.*

INTRODUCING ATLAS

Above: *Cover art, 1st Issue Special No. 1, Jack Kirby and D. Bruce Berry, April 1975.*

Though they usually inhabited their own "lost worlds" with names like Cimmeria or Pellucidar, sword and sorcery heroes like Conan were usually shirtless muscle men who recalled the Italian movies of the early '60s, in which body builders like Steve Reeves played Hercules in ancient Rome. Thus, at DC at least, the genre became conflated with classical mythology, and for his own entry into the genre, Jack Kirby borrowed the legend of Atlas, adding his typical idiosyncratic flourishes. As with most features introduced in this title, its first issue was also its last.

UNKNOWN SOLDIER No. 219

Above: *Interior, "The Edge of History"; script, Elliot S! Maggin; pencils, Frank Miller; inks, Danny Bulanadi. September 1978.*

Like many future stars, Frank Miller cut his artistic teeth drawing stories for the back of DC's anthologies. In the wake of DC's 1978 Implosion, Miller found his stride at Marvel, returning to DC in the 1980s to create milestones *Ronin* and *Batman: The Dark Knight*.

HERCULES UNBOUND No. 12

Left: *Interior, "Chaos Among the Gods"; script, Cary Bates; pencils and inks, Walter Simonson. August–September 1977.*

The post-apocalyptic *Hercules Unbound* had struggled since originators Gerry Conway and José Luis García-López left the series, and the decision was made to end the series with issue 11. Bates and Simonson requested another issue to properly end the series, and management agreed to the deal. In the final stories, Simonson rendered the mythological gods in a photo-negative effect, evoking the art of classical antiquity to distinguish them from typical super-heroic depictions.

ARAK, SON OF THUNDER No. 14

Above, sequence: Interiors, "Heritage of Blood"; script, Roy Thomas; pencils and inks, Alfredo Alcala. October 1982.

As writer of the *Conan the Barbarian* comic book for the past decade, Roy Thomas was seen by many as the central architect of the '70s sword and sorcery comics boom. When he arrived at DC in 1981, Thomas was naturally prevailed upon to create a new S&S series—his main request was to set the series in the past of the real world rather than some fictional land. "I was tired of poring over detailed maps with magnifying glasses," he joked, "trying to read fabricated names even William F. Buckley couldn't pronounce." Instead, he conceived the story of an American Indian named Arak who was found adrift at sea by Vikings and had adventures throughout 9th-century Europe with comrades such as Valda the Iron Maiden.

THE COMIC READER No. 94

Opposite bottom: *Cover art, Howard Chaykin, February 1973.*

The preeminent fanzines of the 1970s not only had access to news from comic-book publishers but black-and-white stats of upcoming covers. As editor of *The Comic Reader* and a frequent visitor to DC's offices, Paul Levitz was able to secure original covers featuring the likes of Howard Chaykin's space-faring Ironwolf.

STALKER No. 1

Right: *Cover art, Steve Ditko and Wally Wood, June–July 1975.*

The greatest concentration of star power in the burgeoning S&S genre could be found in the Paul Levitz–scripted *Stalker*, where legends Ditko and Wally Wood joined forces on the artwork. With opportunities drying up in the 1970s, DC offered a refuge to the cartoonists who'd helped lay the foundation for the comic-book industry.

THE FLASH No. 313

Above: *Interior, "Crimson Testament"; script, Steve Gerber and Martin Pasko; pencils, Keith Giffen; inks, Larry Mahlstedt. September 1982.*

One of penciller Keith Giffen's innovations on Dr. Fate was the use of color-holds, images that were produced without a black outline surrounding them.

DOCTOR FATE RETURNS

Opposite: *The Flash No. 305; house ad art, Keith Giffen and Larry Mahlstedt. January 1982.*

Backups rarely got house ads, but fan favorite Giffen's eerie art and Martin Pasko's revamped Fate characterization—a discarnate entity who possessed the hero's body—seemed special enough for a promotional push.

DC SPECIAL SERIES No. 10

Above: *Interior, "This Immortal Destiny"; script, Paul Levitz; pencils, Joe Staton; inks, Michael Netzer. 1978.*

Paul Levitz's retelling of the 1941 origin of Doctor Fate incorporated details that Martin Pasko had added to the story in a 1975 one-shot. In the revision, the mystic Nabu was part of the cosmic Lords of Order and his spirit possessed acolyte Kent Nelson when he became Doctor Fate.

THE FLASH No. 310

Right: *Interior, "American Gothic"; script, Steve Gerber and Martin Pasko; pencils, Keith Giffen; inks, Larry Mahlstedt. June 1982.*

The decision to replace *The Flash*'s Firestorm backup feature with Doctor Fate originated with editor Mike W. Barr. Viewing the Flash and Firestorm series as conceptually similar, Barr believed that the occult Fate feature would attract additional readers who hadn't been interested in more conventional heroics.

WHEN EVIL STRIKES, WHEN CHAOS IS UNLEASHED UPON THE MULTIVERSE, AND ALL WHO LIVE BY ORDER SCREAM IN ANGUISH--ONE MAN ALONE IS EQUAL TO THE CHALLENGE

Dr. Fate

A NEW MONTHLY SERIES PREMIERING IN FLASH #306, ON SALE NOVEMBER 12TH

BROUGHT TO YOU BY MARTIN PASKO KEITH GIFFEN LARRY MAHLSTEDT

OUT OF THE TIMELESS MISTS OF A TIMELESS WORLD IT COMES... AN ENIGMA IN A WORLD OF MYSTERY... A REMINDER THAT IN THE LOST WORLD OF SKARTARIS ONE MUST ALWAYS *EXPECT* THE UNEXPECTED!

THE WARLORD

Above: *Cover art,* 1st Issue Special *No. 8; pencils and inks, Mike Grell, November 1975.*

THE WARLORD No. 11

Opposite: *Interior, "Flashback"; script, pencils, and inks, Mike Grell. February–March 1978.*

DC's own quest—for a homegrown Conan —led Carmine Infantino to publish *The Warlord,* written and illustrated by rising *Legion of Super-Heroes* star Mike Grell.

STARFIRE No. 2

Above: *Interior, "The Siege of Lortnan Manor"; script, David Michelinie; pencils, Mike Vosburg; inks, Vince Colletta. October–November 1976.*

Editor Joe Orlando wanted a DC version of Red Sonja but writer David Michelinie rejected the idea in favor of a more original character. The half-Caucasian/half-Asian Starfire still carried a sword but she wielded it in a science-fiction setting against the alien slavers known as the Mygorg.

THE WARLORD No. 56

Left: *Cover art, Mike Grell, April 1982.*

When he completed art duties on *Warlord* with issue 50, creator Mike Grell agreed to stay on as author. Beneath the continuing Grell covers, however, he only plotted the stories while his wife Sharon did uncredited scripting, including a fan-favorite serial involving court intrigue and the hero's lost son.

JUSTICE LEAGUE OF AMERICA No. 190

Above: *Cover art, Brian Bolland, May 1981.*

Super teams were as popular as ever, and not just the teen variety. *Justice League*'s continuing success was enriched by a new stable of cover artists, among them fan-favorite-in-the-making Bolland, of *Camelot 3000* fame.

JUSTICE LEAGUE OF AMERICA No. 213

Opposite: *Cover art, George Pérez, April 1983.*

By 1983, *Teen Titans* was consuming so much of Pérez's time that covers like this were all but impossible for him to fit in, even as just the penciller, much less inking. His last cover for *JLA* would appear on No. 220.

JUSTICE LEAGUE OF AMERICA No. 151

Above: *Cover art, Al Milgrom and Joe Orlando, February 1978.*

Having artists working in the office made it easy for editors to find new cover talent quickly, and occasionally resulted in some rarely seen pairings: both penciller Milgrom and inker Orlando were on staff as editors.

JUSTICE LEAGUE OF AMERICA No. 81

Right: *Interiors, "Plague of the Cosmic Jest-Master"; script, Denny O'Neil; pencils, Dick Dillin; inks, Joe Giella. June 1970.*

The dawn of the Bronze Age changed the look and feel of *JLA*, as writer Gardner Fox's successor, O'Neil, was joined by longtime Blackhawk artist Dillin, who took over for Mike Sekowsky.

JUSTICE LEAGUE OF AMERICA No. 210

Above: *Cover art, Rich Buckler and Mike DeCarlo, January 1983.*

A 72-page JLA story, originally intended for publication in an oversize tabloid edition in 1978, sat in limbo for five years until it was finally serialized over three issues of the regular comic book, beginning with this one.

JUSTICE LEAGUE OF AMERICA No. 184

Opposite: *Interior, "Crisis Between Two Earths, or Apokolips Now"; script, Gerry Conway; pencils, George Pérez; inks, Frank McLaughlin. November 1980.*

The innovative composition and painstakingly detailed rendering seen here were the hallmarks of Pérez's work, which helped make *The New Teen Titans* a success. He had also hoped to draw for JLA but acquired the assignment under tragic circumstances when the title's regular penciller, Dick Dillin, unexpectedly died.

ALLSTAR SQUADRON No. 20

Above: *Cover art, Jerry Ordway, April 1983.*

Roy Thomas' secret weapon on *All-Star Squadron* had been Jerry Ordway, whose detailed, realistic inking style maintained visual continuity of separate pencillers—Rich Buckler and Adrian Gonzales—as well as reconstructing an unused story by Don Heck. Ordway ultimately became full penciller and inker on the book to draw one of its most memorable runs.

JUSTICE LEAGUE OF AMERICA No. 214

Left: *Interior, "The Siren Sisterhood"; script, Gerry Conway; pencils, Don Heck; inks, Romeo Tanghal. May 1983.*

Following George Pérez's run, veteran Don Heck became the title's new penciller. While not the superstar fan-favorite that Pérez was, Heck brought stability and solid storytelling to *JLA*, resulting in an increase in sales during his first year on the book.

ALLSTAR COMICS No. 64

Opposite: *Cover art, Wally Wood, January–February 1977.*

All-Star's revival is fondly remembered as one of several DC titles of the 1970s that published the last mainstream comics work of the legendary Wallace Wood, of EC fame, who died in 1981. This issue was particularly noteworthy because Wood (and his assistants) illustrated it in its entirety, rather than working over others' layouts, and the story reflected Wood's request to writer Paul Levitz to include Superman and knights in armor.

ADVENTURE COMICS No. 466

Above: *Interior, "The Defeat of the Justice Society"; script, Paul Levitz; pencils and inks, Joe Staton. November–December 1979.*

As much as Senate hearings were blamed for homogenizing 1950s' comics books via the Comics Code Authority, a Justice Society flashback credited the same politicians with putting the team out of business. Accused of Communist affiliations, the JSA was ordered to unmask and prove themselves as "good Americans." The sequence—and the group's icy response—struck a chord with readers and pros alike and was revisited and expanded on often into the 21st century.

ALLSTAR SQUADRON No. 7

Left: *Interior, "Carnage for Christmas"; script, Roy Thomas; pencils, Adrian Gonzales; inks, Jerry Ordway. March 1982.*

Part of the richness of *All-Star Squadron* came from its scrupulous integration of real-world history and characters into a universe populated by super heroes. President Franklin D. Roosevelt became a regular in the series, endearing himself so much to readers that he was sometimes nominated as Favorite Supporting Character in fan-voted contests.

THE UNTOLD ORIGIN OF THE JSA

Above: *Cover art, DC Special No. 29, Neal Adams, August–September 1977.*

The Justice Society of America premiered as a fully-formed club of heroes in late 1940 without any explanation as to how they got together in the first place. In the real world, Adolf Hitler had opted against a Nazi invasion of England during the same time frame. Using that historical fact as his hook, Paul Levitz conceived a scenario where the future JSA members were first united to thwart the invasion of England…and save the life of President Roosevelt.

DC SUPER-STARS No. 17

Above: *Cover art, Joe Orlando (layout), Joe Staton, and Bob Layton, November–December 1977.*

Levitz and Staton's Huntress was the costumed persona of Helena Wayne, daughter of the Earth-Two Batman and his wife, the former Catwoman.

HUNTRESS IN THE FLESH

Far right: *Film still, Barbara Joyce, 1979.*

Although NBC's campy 1979 pair of *Legends of the Superheroes* specials horrified fans, the broadcasts nonetheless represented the first live-action appearances of many DC characters. The Huntress had other opportunities in the 21st century, notably a featured role (played by Ashley Scott) on 2002's *Birds of Prey* TV series and guest appearances on *Arrow* (portrayed by Jessica De Gouw) beginning in 2012.

ADVENTURE COMICS No. 462

Opposite: *Interior, "Only Legends Live Forever!"; script, Paul Levitz; pencils, Joe Staton; inks, Dick Giordano. March–April 1979.*

The adult Robin and the Huntress became joint heirs to the Batman legacy when the aged Dark Knight of Earth-Two was killed in action. Originally intended for a 1978 issue of *All-Star Comics*, the story was ultimately serialized in *Adventure Comics* with the canceled book's cover used as a splash page.

EARTH-TWO -- A WORLD MUCH LIKE OUR OWN, YET *SLIGHTLY DIFFERENT*. A WORLD WHERE YOUNG AND OLD HEROES HAVE *JOINED FORCES* TO BATTLE EVIL AS THE...

JUSTICE SOCIETY

Concluding the JSA's most epic adventure!

ONLY LEGENDS LIVE FOREVER!

PAUL LEVITZ, WRITER
JOE STATON, ARTIST
BEN ODA, LETTERER
ADRIENNE ROY, COLORIST
JOE ORLANDO, GUEST EDITOR

STATON & GIORDANO

ALL-STAR SQUADRON No. 7

Opposite: *Cover art, Joe Kubert, March 1982.*

The 1976 attempt at a Justice Society title—reviving *All-Star Comics*—lasted only 17 issues, but the growing direct-sales market allowed a second try to fare better. Fans were especially pleased to see Joe Kubert return to the heroes he drew in the 1940s in frequent cover illustrations.

FREEDOM FIGHTERS No. 1

Above: *Cover art, Ernie Chan, March–April 1976.*

First revived in Justice League of America, a sextet of heroes once published by Quality Comics joined forces as the Freedom Fighters. Framed for crimes they didn't commit, the team spent 15 issues trying to prove their innocence.

ALL-STAR SQUADRON No. 29

Above: *Cover art, Jerry Ordway, January 1984.*

Created in 1941, the Seven Soldiers of Victory never reached the heights of their Justice Society forerunners. Nonetheless, the group saw occasional revivals, including their initial return in 1972's *Justice League of America* Nos. 100–102, a newly illustrated serial in *Adventure Comics* that had been written in the 1940s, and spotlights in *All-Star Squadron*.

ALL-STARS ON THE MOVE

Left: *Interior,* All-Star Squadron *No. 1; "The World on Fire!" script, Roy Thomas; pencils, Rich Buckler; inks, Jerry Ordway. September 1981.*

METAL MEN No. 47

Above: *Cover art, Walter Simonson, August–September 1976.*

A powerful one-shot *Metal Men* revival by Steve Gerber and Walter Simonson was so well-received by Carmine Infantino that he put an ongoing series back on the schedule. Joined by writers Gerry Conway and Martin Pasko, Simonson drew six total issues before passing the artistic torch to Joe Staton.

BLACKHAWK No. 259

Opposite: *Cover art, Howard Chaykin, June 1983.*

HAWKMAN

Above: *Interior, Detective Comics No. 500, "The Strange Death of Doctor Erdel"; script, Paul Levitz; pencils and inks, Joe Kubert. March 1981.*

Since the 1960s, Hawkman only appeared sporadically outside the *Justice League of America*. Amidst occasional solo stories in *Detective* and *World's Finest*, the Winged Wonder also flew in a 1978 *Showcase* tryout. Some of the most memorable stories reunited Hawkman with a pair of his Silver Age artists: Joe Kubert and Murphy Anderson.

NOVEL CONCEPT

Right: *Book cover,* Challengers of the Unknown; *art, Enrique Torres; author, Ron Goulart; Dell Publishing. 1977. Far right: Book cover,* Blackhawk; *art, Romas Kukalis; author, William Rotsler. 1982.*

During the late 1970s, DC explored the possibility of spinning its characters into novels. These eclectic titles appeared alongside two Superman books by Elliot S! Maggin. Announced Batman (by Denny O'Neil) and Wonder Woman (by Jane Lynch) volumes never appeared.

GREEN LANTERN No. 165

Left: *Cover art, Gil Kane, June 1983.*

GREEN LANTERN No. 123

Above: *Cover art, Gil Kane, December 1979.*

GREEN ARROW RELAUNCHED

Opposite: *House ad art, Trevor von Eeden and Dick Giordano, May 1983.*

Although he'd been kicking around the DC line for more than 40 years, Green Arrow never had a comic book to call his own until 1983. Trevor von Eeden, who had sporadically illustrated GA's solo feature in *World's Finest* for five years, pencilled the four-issue mini-series while Mike W. Barr provided the script. It would take another miniseries in 1987—Mike Grell's *The Longbow Hunters*—to clinch Green Arrow's ability to carry a title. A long-running GA title premiered in 1988.

GREEN LANTERN No. 90

Right: *Interior, "Those Who Worship Evil's Might"; script, Denny O'Neil; pencils and inks, Mike Grell. August–September 1976.*

In the 1976 revival of *Green Lantern/Green Arrow*, Mike Grell included a sight gag featuring a Green Lantern who resembled *Star Trek*'s Spock, complete with his "live long and prosper" hand gesture. During the same time, Grell was also drawing the space-craft of the Legion of Super-Heroes, which —as designed by Dave Cockrum—bore a striking resemblance to Trek's Enterprise.

Green Arrow

"IT'S FIFTY OF *THEM* AGAINST ONE OF *ME!*"

"I'VE GOT 'EM *OUTNUMBERED!*"

HARD-HITTING, HIGH-SPIRITED ADVENTURE BY MIKE W. BARR, TREVOR VON EEDEN, & DICK GIORDANO! COLLECT THE WHOLE MINI-SERIES! FIRST ISSUE ON SALE FEB. 24th! THE NEW DC IS ON THE MOVE!

I'VE BEEN ASSUMING IT WOULD BE JUST *ONE* THING WHICH WOULD SOMEHOW DESTROY MY FORTRESS--AND THE *WORLD*.

AT THE *MOST*, I THOUGHT IT MIGHT BE *TWO* OR *THREE* THINGS-- A VERY *LIMITED* CHAIN OF EVENTS-- WHICH WOULD CAUSE THAT EARTH-DESTROYING *EXPLOSION*.

BUT--IT MIGHT *NOT* BE THAT WAY AT *ALL!*

WHAT IF THE ANSWER REALLY INVOLVES *SEVERAL* OBJECTS WITHIN THE FORTRESS-- OR *MANY* OF THEM--EVEN *MOST* OF THEM--

--SOME KIND OF *FREAK ACCIDENT* THAT WOULDN'T HAPPEN MORE THAN *ONCE IN A MILLION LIFETIMES*-- BUT IS STILL A *REMOTE POSSIBILITY*--

--LIKE THE *LIGHTNING BOLT* THAT EVERY *ODDSMAKER* IN THE UNIVERSE WOULD BET *WON'T* STRIKE YOU--BUT STILL *MIGHT!*

MAYBE SOME *COMBINATION* OF THINGS--OF *EVENTS*-- IS ABOUT TO CAUSE THE *FINAL BLOW-UP* I SAW!

DC SPECIAL SERIES No. 26

Opposite: *Interior, "Fortress of Fear"; script, Roy Thomas; pencils, Ross Andru; inks, Romeo Tanghal. Summer 1981.*

Among Roy Thomas' first assignments upon joining DC was a research-heavy project that drew on old Superman stories to create a history of the Fortress of Solitude. The tabloid-sized tie-in to the *Superman II* film included a through-line in which the Man of Steel had to stop a dire chain of events that would trigger an atomic reaction within the Fortress that would destroy the Earth.

FAMOUS FIRST EDITION No. C26

Above: *Cover art, Joe Shuster, 1974.*

Months after a copy of *Action Comics* No. 1 made headlines by selling for an unprecedented $1,801.25, DC published an oversized replica edition. By detaching the cardboard outer cover, some unscrupulous sellers pitched the reprint to gullible buyers as the 1938 real thing. Licensed hardcover editions of all DC's Famous First Editions were also published with an eye toward collectors and libraries who wanted to place the classics on their bookshelves.

ACTION COMICS No. 484

Above: *Cover art, José Luis García-López and Dick Giordano, June 1978.*

Forty years after they debuted in *Action Comics* No. 1, Clark Kent and Lois Lane were married. This was not the modern 1978 couple, though, but rather the older characters from the parallel world of Earth-Two, who had wed in the early 1950s.

SUPERMAN IN THE FUNNY PAGES

Left: *Newspaper strip art, George Tuska and Vince Colletta, 1980.*

Initially a showcase for the Justice League, *World's Greatest Superheroes* shifted its focus to Superman after the 1978 movie premiered. The title box of the Sunday strips evolved accordingly, with the iteration shown here debuting on December 14, 1980.

DC COMICS PRESENTS No. 59

Above and opposite: *Interior, "Ambush Bug II"; script and layouts, Keith Giffen; additional dialogue, Paul Levitz; finished art, Kurt Schaffenberger. July 1983.*

First created by Keith Giffen as a one-shot villain for a Superman–Doom Patrol team-up, the teleporting bandit was so popular that he was soon revived for a second, overtly comical adventure. The escalating fan reaction inspired more returns for Ambush Bug and increasingly self-referential miniseries and specials.

"I've always thought that comic books are much poorer for having kicked out the humor.... After all, they're called comic books, not drama books. But with the Subs, it was just a place for me to have fun, not trying to do anything of import, not trying to get my message off, but have big, goofy fun." —Keith Giffen

THE LEGION OF SUBSTITUTE HEROES

Above: *Cover art, DC Comics Presents No. 59, Keith Giffen and Mike DeCarlo, July 1983.*

Created in the 1960s as a group whose powers weren't up to Legion standards, the Substitute Heroes were commonly portrayed as noble underdogs. That changed when Keith Giffen needed foils for his second Ambush Bug story. Playing up the Subs' drawbacks, the cartoonist created a sensation and the perspective on the characters was revisited in a 1985 special.

AND THE AUXILIARY TEAM

Right: *Interior, "Ambush Bug II"; script and layouts, Keith Giffen; additional dialogue, Paul Levitz; finished art, Kurt Schaffenberger. July 1983.*

Gags in this tale included appearances by other Legion rejects like Porcupine Pete, and the introduction of an auxiliary team who weren't good enough to join the Subs. Double-Header's "power," for instance, was that he had two heads.

"*Superman stories are not about power. They're about moral and ethical choices. Each one asks the question: 'What does a good person do in a situation if he's got all the power in the world?'...Every 'superman' in every culture — Zeus and Odin; John Henry and Paul Bunyan; Beowulf and Arthur — gets to decide the answer, in his own context, to that question.*"

— ELLIOT S! MAGGIN

SUPERMAN PIN-UPS

Opposite, left, and above: *Pin-up art by Bill Sienkiewicz, Jim Steranko, and Moebius, October 1984.*

It seemed fitting to mark this publishing milestone by appealing to the comics-literate fans' curiosity about how Superman would be interpreted by the medium's masters. In addition to the industry giants seen here, *Superman* No. 400 featured art by Howard Chaykin, *MAD*'s Jack Davis, M. W. Kaluta, Jack Kirby, Frank Miller, Jerry Robinson, Marshall Rogers, Walt Simonson, Leonard Starr, Al Williamson, and Bernie Wrightson, among others.

Marv Wolfman & George Pérez

"From the Titans, we are working from the inside out. We know the characters as individuals; we have a lot of ourselves in there. So we work from what the gut feeling is, to their reaction, and then the character develops." — GEORGE PÉREZ

THE NEW TEEN TITANS No. 20

Opposite: *Cover art, George Pérez, June 1982.*

With a hot writer–artist team and a mixture of high adventure with teen angst, *The New Teen Titans* had a transformative effect on DC's fortunes. With a bona fide fan favorite hit under its belt, the company built on the moment with a succession of fresh new titles that attracted lapsed readers back into the fold.

MARV WOLFMAN & GEORGE PÉREZ

Above: *Photograph, 1980s.*

"The best characters have strong, traumatic origins that you can constantly revisit and find new wrinkles to play with. Superman's origin echoed the biblical story of Moses. Doomed to die, an infant was sent by his parents on a journey to another land where he grew up to become a great hero. Batman watched as his parents died. Spider-Man let a burglar kill his favorite uncle and from that day on, his guilt motivated him to combat crime. These heroes were born of tragedy, and the trauma that created them continued to motivate them throughout their adventures. Psychologically speaking, we are what we were." — Marv Wolfman

MEANWHILE, ON EARTH-PRIME...

Left: *Interior,* The New Teen Titans *No. 20, "A Titanic Tale of Titans' Tomfoolery"; script, Marv Wolfman; layouts, George Pérez; finished art, Romeo Tanghal. June 1982.*

A comical 1982 short featured the *New Teen Titans* creative team. Featured in the first panel are Managing Editor Dick Giordano, writer-plotter Marv Wolfman, inker Romeo Tanghal, plotter-artist George Pérez, editor Len Wein, and letterer Ben Oda. Colorist Adrienne Roy and editor Karen Berger also made cameos later in the story.

"FIVE MONTHS I WAS IN THAT HOSPITAL! FIVE MONTHS FEELIN' LIKE SOME KINDA *FREAK!* EVERYTHIN' I ONCE KNEW I HADDA *RELEARN.* YOU IMAGINE WHAT I FELT LIKE HAVING TO FIGGER OUT HOW TO WALK AGAIN?

"YOU KNOW WHAT IT'S LIKE NOT EVEN BEIN' ABLE TO HOLD SOMETHIN' WITHOUT CRUSHIN' IT?

"I USEDTA RUN A MILE IN FOUR MINUTES, TWENTY. BUT NOW I COULDN'T EVEN *WALK.*

"I DIDN'T KNOW HOW TO ADJUST TO MY NEW STRENGTH.

"EVERYTHING WAS LIKE A LIVING HELL TO ME. RELEARNIN', READJUSTIN', STARTIN' FROM SCRATCH.

"FIVE MONTHS IT TOOK. FIVE LONG, LONELY MONTHS BEFORE I COULD HOLD AN EGG IN MY HAND AGAIN.

"FIVE MONTHS SPENDIN' EVERY HOUR WITH THE MAN I *HATED* MORE THAN ANYONE ELSE IN THE WORLD...

"...THE MAN WHO *FORCED* ME TO LEARN TO BE A *PERSON* ONCE AGAIN.

18

THE NEW TEEN TITANS No. 1

Above: *Interior, "The New Teen Titans"; script, Marv Wolfman; pencils, George Pérez; inks, Romeo Tanghal. November 1980.*

When brainstorming the cast of the revamped Titans, Wolfman thought in terms of characters who would complement and contrast one another. Raven, for instance, would be as tightly wound and private as Starfire was exuberant and open. Conscious of the fact that Raven would not be the action hero that her teammates were, George Pérez designed a flowing dress and cape for the heroine that wouldn't have been practical for a more physical character.

TALES OF THE NEW TEEN TITANS No. 1

Opposite: *Interior, "Cyborg"; plot and script, Marv Wolfman; plot and pencils, George Pérez; inks, Brett Breeding. June 1982.*

Not to be confused with the later *Tales of the Teen Titans*, this was the first of a four-issue miniseries, each of which spotlighted the new additions to the team introduced in the reboot. The others were the super-sorceress Raven, the superpowered alien princess Starfire, and Changeling, previously known as Beast Boy.

TALES OF THE NEW TEEN TITANS No. 4

Above: *Interior, "Starfire"; plot and script, Marv Wolfman; plot and layouts, George Pérez; finished art, Ernie Colón. September 1982.*

The miniseries also spotlighted how different inkers approached Pérez's breakdowns.

THE NEW TEEN TITANS No. 4

Left: *Interior, "Torment"; plot and script, Marv Wolfman; plot and pencils, George Pérez; inks, Romeo Tanghal. January 1985.*

Boasting an eight-year run on *The New Teen Titans*, embellisher Romeo Tanghal outlasted even George Pérez on the series. Recalling the thrill of receiving a pencilled Pérez page, Tanghal remarked, "I'd be looking at it, studying it, and then inking it, and I didn't want to stop unless I was really very tired."

THE NEW TEEN TITANS No. 1

Above: *Interior, "Shadows in the Dark"; plot and script, Marv Wolfman; plot, pencils, and inks, George Pérez. August 1984.*

The Titans were among the first DC titles sold exclusively in comics shops. The original series was renamed *Tales of the Teen Titans*, continuing the numbering of the 1980 series with No. 41, while *The New Teen Titans* "relaunched" with a Vol. 2, No. 1. The new series was published without the Code seal, permitting scenes like this one, confirming that Robin and Starfire's relationship was what had been hinted at previously.

THE NEW TEEN TITANS No. 33

Opposite: *Original cover art, George Pérez, July 1983.*

THE NEW TEEN TITANS No. 27

Above: *Interior, "Runaways, Part 2"; plot and script, Marv Wolfman; plot and pencils, George Pérez; inks, Romeo Tanghal. January 1983.*

JUST SAY NO

Left: *Cover art,* The Keebler Company presents DC Comics' The New Teen Titans in Cooperation with the President's Drug Awareness Campaign *No. 1; George Pérez and Romeo Tanghal. January 1983.*

Approached by the government about doing an anti-drug comic book starring Superman, Jenette Kahn and Paul Levitz suggested that the New Teen Titans were better candidates for such a project. Not only was their comic book more successful but the cast was closer in age to the target audience. Endorsed by First Lady Nancy Reagan, the custom comic was distributed to public schools while a variant edition was sold through comics retailers.

"What you try to do is to create the high points and low points for each character, where they are going to be at various stages so that one person's problems actually affect somebody else's. And you're trying to milk each person's emotions the best you can…. You want to build them as sort of stepping stones."

— MARV WOLFMAN

THE NEW TEEN TITANS No. 5

Above: *Cover art, George Pérez, February 1985.*

THE NEW TITANS No. 50

Right: *Interior, "Who Is Wonder Girl? Chapter One: Home Again"; plot and script, Marv Wolfman; plot and pencils, George Pérez; inks, Bob McLeod. December 1988.*

THE NEW TEEN TITANS No. 8

Opposite: *Interior, "A Day in the Lives"; plot and script, Marv Wolfman; plot and pencils, George Pérez; inks, Romeo Tanghal. June 1981.*

"We really were cooking by that point," Pérez said of this issue, meaning the creative team had established the tone and look it sought to achieve. The detailed art and clever layouts, coupled with Wolfman's character-driven narrative, created a unique reading experience fans looked forward to month after month.

SHE feels the *SENSATIONS* long before the obscene monstrosities are visually burned into her mind...

COLD caresses her with fearsome, frigid fingers, pulling at her, clutching at her, tugging her down, down, ever *DOWN*...

She *RESISTS*, fighting, clawing, but the sensations are everywhere and they press so *HEAVILY* upon her writhing flesh...

COLD so keen, so painful, it is like an arctic hoarfrost.

She dives low to *AVOID* the omnipresent icy hands...

But, the cold abruptly *ENDS*.

Heat from deep within ground that had not existed even a moment before suddenly rushes up to *BLANKET* her. Her skin hardens, tenses as boiling waters hold her in an inescapable grip.

Again she is brought down tumbling wildly toward the great frangible glass-like *MEMBRANE* which floats calmly in the dimensional seas so very far below...

She tries resisting, but any fight is *USELESS* now.

TALES OF THE TEEN TITANS No. 44

Above: *Cover art, George Pérez, July 1984.*

The penultimate chapter of Wolfman and Pérez's milestone "The Judas Contract" introduced Deathstroke's son Joseph — soon to be a new Titan called Jericho — as well as unveiling Dick Grayson's post-Robin persona of Nightwing.

THE NEW TEEN TITANS No. 39

Opposite: *Cover art, George Pérez, February 1984.*

By 1984, *Titans*' profits in the direct-sales market suggested that newsstand sales were becoming all but irrelevant. DC quickly launched a comic-shop-only version of the title, better printed and higher priced. That made the old imperatives to accommodate the general reader irrelevant as well. "In-jokey" homages to fan-favorite covers of years past — DC's or not — helped solicit orders: Here Pérez depicts the story's resignation of Kid Flash and Robin with a riff on the cover of *Spider-Man* No. 50.

THE NEW TEEN TITANS No. 12

Above: *Cover art, George Pérez, October 1981.*

More homage: The twin phalanxes of heroes rushing toward each other recall the cover of *Justice League* No. 56 (September 1967).

MARVEL AND DC PRESENT THE UNCANNY X-MEN AND THE NEW TEEN TITANS No. 1

Right: *Cover art, Walter Simonson and Terry Austin, 1982.*

When DC's Jenette Kahn and Marvel's Jim Shooter made arrangements to begin a new series of company crossovers, the latter envisioned one of them as a *Legion of Super-Heroes/X-Men* team-up. Having broken into the industry as a key Legion writer, Shooter still held the heroes in high regard but had to grudgingly admit that the red-hot *New Teen Titans* — who premiered after he and Kahn first spoke — was a better commercial choice to unite with Marvel's best-selling team.

NO!

CAMELOT 3000 No. 12

Opposite: *Interior, "Long Live the King"; script, Mike W. Barr; pencils, Brian Bolland; inks, Terry Austin. April 1985.*

Inspired by an Arthurian literature course, Mike W. Barr conceived *Camelot 3000* in the mid-1970s but had to wait several years before DC agreed to publish it. Intended to run for 12 issues rather than the typical miniseries three or four, the project was dubbed a "maxiseries."

CAMELOT 3000 No. 7

Top left and left: *Interior, "Betrayal"; script, Mike W. Barr; pencils, Brian Bolland; inks, Terry Austin. August 1983.*

The Knights of the Round Table were reincarnated in 3000 A.D. in a variety of forms. Sir Percival was a mute, genetically altered behemoth, while Sir Tristan was reborn as a woman and struggled with gender issues throughout the story.

CAMELOT 3000 No. 9

Above: *Original cover art, Brian Bolland, December 1983.*

Bolland's interior pencils for *Camelot 3000*, inked by others, could showcase only his draftsmanship and storytelling. His inking on the covers, however, displaying his exquisite use of fine line work, made him one of the industry's most sought-after cover artists.

NIGHT FORCE No. 1

Above: *Cover art, Gene Colan and Dick Giordano, August 1982.*

Marv Wolfman and Gene Colan's *Night Force* was envisioned as serialized novels and short stories that were connected by the common supernatural character Baron Winters. Recalling his unsold 1978 newspaper strip *The Unexplained*, Wolfman used the surname of its star Raven Winters for the Baron (having already repurposed her given name in *The New Teen Titans*).

ADVENTURE COMICS No. 502

Opposite: *Cover art, Ed Hannigan and Klaus Janson, August 1983.*

AMETHYST, PRINCESS OF GEMWORLD No. 1

Left: *Cover art, Ernie Colón, May 1983.*

A rare fantasy series with a female lead, *Amethyst* followed the adventures of young Earth girl Amy Winston through her discovery that she had been born a powerful alien princess in another dimension. Thanks to the time differential between the two realms, teenage Amy became adult Amethyst each time she visited her homeland.

ARION, LORD OF ATLANTIS No. 1

Above: *Cover art, Jan Duursema, November 1982.*

One of DC's most prolific writers, Paul Kupperberg made his most lasting contribution to the company mythos with his creation of Arion, a mage of Atlantis, with artist Jan Duursema.

V No. 1

Left: *Cover art, Eduardo Barreto, February 1985.*

The success of *V*, a 1983 TV miniseries about seemingly benevolent humanoid alien "Visitors" who turned out to be evil lizard-people, soon inspired TV follow-ups and a comic book tie-in. Of special note were the title's covers, all 18 of which incorporated the series' one-letter title into the design.

STAR TREK No. 3

Opposite: *Cover art, George Pérez, April 1984.*

When DC acquired the rights to *Star Trek*, editor Marv Wolfman encouraged writer Mike W. Barr to think beyond the primarily single issue stories that had appeared under previous publishers. Consequently, Barr—joined by artists Tom Sutton and Ricardo Villagran—launched the series with a four-part, 92-page adventure that he'd originally plotted as a stand-alone 22-page tale. Among the creative team's most celebrated works was an eight-part adventure involving *Trek*'s Mirror Universe.

JAWS

Right: *Poster art, Roger Kastel, Universal Pictures, 1975.*

Director Steven Spielberg's *Jaws* quickly became a cultural phenomenon in the summer of 1975, with references in TV, magazines, and pop music. At DC, Superman, Tarzan, and—unsurprisingly—Aquaman all crossed paths with great white sharks of their own in the months that followed.

ACTION COMICS No. 456

Far right: *Cover art, Mike Grell, February 1976.*

A Silver Age villain called the Shark was a natural for revival to take advantage of the mid-1970s fascination with *Jaws*, but his original nemesis Green Lantern was nowhere to be found.

HOUSE OF MYSTERY No. 269

Opposite: *Cover art, Jim Aparo, June 1979.*

HOUSE OF MYSTERY No. 247

Above: *Cover art, Jack Sparling and Vince Colletta, November 1976.*

Although *House of Mystery* began its late 1960s conversion to horror stories with reprints, it soon switched to new stories. The first, "House of Gargoyles," was illustrated by the prolific Jack Sparling, who was also on hand in the first issues of *The Witching Hour* and the revived *House of Secrets*. When the mystery titles ended in the 1980s, several unpublished Sparling stories remained in inventory, including one—"The Final Day of Nicholas Toombs"—that was writer Len Wein's first sale.

HOUSE OF MYSTERY No. 278

Left: *Cover art, Joe Orlando, March 1980.*

Although he'd left the editing of his horror titles by the mid-1970s, Joe Orlando could never truly stay away from them. He continued to draw occasional covers and short stories for the books into the early 1980s, concluding with the celebratory introduction page for 1981's *House of Mystery* No. 300.

HOUSE OF SECRETS No. 125

Above: *Interior, "Instant Re-Kill"; script, Steve Skeates; pencils and inks, Frank Robbins. November 1974.*

After several years as one of the principal Batman writers, Frank Robbins found himself preferring to strictly draw and shifted to Joe Orlando titles like *Plop!* and *House of Mystery*. Robbins' most ghastly image may have been a *House of Secrets* cover in which a human head melted in an ice cream cone.

363

FROM EVERY CORNER OF AN OPPRESSED GALAXY THEY CAME, A MISMATCHED COLLECTION OF REBELS-- DETERMINED TO OVERTHROW THE TYRANNY THAT HAS CRUSHED THEM LIKE ANTS UNDER A JACKBOOT'S HEEL...

BEGINNING -- THE SAGA OF THE...

STAR RAIDERS

PILOTS IN CHARGE
ELLIOT S! MAGGIN: WRITER
JOSE LUIS GARCIA-LOPEZ: ARTIST

STAR RAIDERS

Opposite: *Interior, "Star Raiders"; script, Elliot S! Maggin; pencils and inks, José Luis García-López; 1983.*

Atari brought video games out of the arcade and into the living room during the early 1980s, and the company's popularity made it a logical partner for DC's ongoing experiments in cross promotion. Star Raiders, a first-person space combat game in which the player blasted enemy Zylons, inspired the initial release in what would become DC's graphic novel series (which later included Jack Kirby's *Hunger Dogs*). Mini-comics starring Martin Champion of the Atari Force also found their way into Atari home video game releases, spawning the acclaimed ongoing series.

ATARI FORCE No. 1

Above: *Cover art, José Luis García-López.* Left: *Interiors, "Fresh Blood"; script, Gerry Conway; pencils, José Luis García-López; inks, Ricardo Villagran. January 1984.*

When developing the Atari Force concept for an ongoing series, writer Gerry Conway and artist García-López moved the action two decades ahead with a cast that included offspring of the original characters.

THE BEST OF DC No. 45

Top left: *Cover art, Stan Goldberg, February 1984.*

As part of its 1980s digest line, DC repackaged its early 1970s teen humor features for a new audience. Along with editorial revisions like changing a transistor radio to a Walkman, the digests also sported new covers that involved Binky with 1980s topics like video games and punk rock.

BATMAN AND THE OUTSIDERS No. 17

Above: *Cover art, Ed Hannigan, Jim Aparo, and Lynn Varley, January 1985.*

When he conceived an Egyptian-themed cover for *Batman and the Outsiders*, writer Mike W. Barr expected the usual line art piece by Jim Aparo (building on Ed Hannigan's rough layout). Design Director Neal Pozner was so taken with the image that he persuaded Executive Editor Dick Giordano to commission a painted version for the cover by Lynn Varley (working over a photo of Aparo's art).

BATMAN No. 377

Opposite: *Cover art, Ed Hannigan and Dick Giordano, November 1984.*

LITTLE NEMO IN SLUMBERLAND

Above: *Sunday comic strip, Winsor McCay. July 26, 1908.*

Widely regarded as one of comics' first masterpieces, Winsor McCay's "Little Nemo in Slumberland" used an entire weekly newspaper page as a canvas to experiment with color, architecture, perspective, and design. Among the feature's most famous sequences was one in which Nemo's bed sprouted elongated legs and walked through the city.

GRANT MORRISON

Opposite: *Photograph, Grant Morrison and Mina read* Batman, *Glasgow, Scotland, 1985.*

Reprint collections like 1971's *Batman from the 30s to the 70s* were a huge influence on fans like Grant Morrison. Committing arcane details from those stories to memory, Morrison and others of his generation would twist and reinterpret them in the years ahead.

BRUCE WAYNE CRUSADES AGAINST ALL CRIME, ALL INJUSTICE AS THE DREAD

BATMAN

CREATED BY BOB KANE

ARTISTS: MICHAEL GOLDEN & MIKE DeCARLO

BATMAN SPECIAL No. 1

Opposite: *Interior, "The Player on the Other Side"; script, Mike W. Barr; pencils, Michael Golden; inks, Mike DeCarlo. 1984.*

One of Mike W. Barr's most memorable Batman stories took its cue from a 1963 Ellery Queen novel in which its title character found himself stymied by a killer who, he eventually realized, was his virtual twin, albeit a villain rather a hero. In Barr's story, Batman faced his own "player on the other side," a killer whose criminal parents had been shot by a young Jim Gordon on the same night that Bruce Wayne's own father and mother were slain.

BATMAN: SON OF THE DEMON

Above: *Cover art, Jerry Bingham, 1987.*

DC's first hardcover graphic novel included subject matter that was beyond the scope of the traditional newsprint comic book. Forming an alliance with Rā's al Ghūl, the Dark Knight also consummated his relationship with the immortal's daughter Talia. Led to believe that his lover had miscarried, Batman was unaware that his offspring had survived and been put up for adoption.

BATMAN AND THE OUTSIDERS No. 1

Left: *Interior, "Wars Ended…Wars Begun!"; script, Mike W. Barr; pencils and inks, Jim Aparo. August 1983.*

The stand-alone story comic book was falling by the wayside in the early 1980s as fans increasingly gravitated toward books with ongoing continuity. A casualty of that shift was *The Brave and the Bold*, which was replaced with a new kind of Batman team-up. Developed by writer Mike W. Barr, the Outsiders were a less-cosmic team than the Justice League, a mix of dormant second-tier heroes and a handful of newcomers.

DETECTIVE COMICS No. 529

Above: *Interior, "The Thief of Night"; script, Doug Moench; pencils, Gene Colan; inks, Dick Giordano. August 1983.*

BATMAN No. 348

Above: *Interior, "Shadow Play"; script, Gerry Conway; pencils, Gene Colan; inks, Klaus Janson. June 1982.*

Playing on reader nostalgia, Batman and Robin were reunited in late 1981 as a regular team for the first time since 1969. Continuing the old-school trend, the Dynamic Duo relocated to the long-shuttered Wayne Manor in 1982 and put the original Batcave back into service.

BATMAN No. 303

Opposite: *Interior, "If Justice Be Served"; script, Denny O'Neil; pencils, Michael Golden; inks, Jack Abel. September 1978.*

Michael Golden seemed poised to be the next major Batman artist, balancing the Man-Bat series in *Batman Family* with various stories starring the Dark Knight himself. In the wake of unexpected cutbacks in mid-1978, Golden found himself lacking assignments, and made a move to DC's rival, returning in the early 1990s as both artist and editor.

BATMAN No. 344

Above: *Interior, "Monster, My Sweet"; script, Gerry Conway; pencils, Gene Colan; inks, Klaus Janson. February 1982.*

Bruce Wayne's 1969 move to a midtown Gotham penthouse was meant in part to disassociate *Batman* the comic with familiar details from the campy TV series. By 1977, though, a new Batcave was constructed deep below that skyscraper, complete with trophies like the giant penny and robot dinosaur, moved from the original cavern.

DETECTIVE COMICS No. 494

Right: *Interior, "The Crime Doctor Calls at Midnight"; script, Michael Fleisher; pencils, Don Newton; inks, Bob Smith. September 1980.*

Where did he get all those wonderful toys? In the case of the Batmobile, a 1980 issue of *Untold Legend of the Batman* revealed that stuntman Jack Edison had been building the succession of super-cars ever since the Dark Knight saved his life years earlier.

UNSOLVED CASES OF THE BATMAN
IF JUSTICE BE SERVED

"OKAY, ALFRED, THIS CASE GOES INTO THE *TIME CAPSULE* INSTEAD OF THE REGULAR FILES! IF ANYONE EVER GETS INTO THE *BATCAVE*, I WOULDN'T WANT THEM READING ABOUT IT!"

"THE WORLD SHOULD KNOW WHAT REALLY HAPPENED TO *BUZZY McKAME* AND *MARTY RAIL*... AND WHEN THE TRUTH GETS OUT AFTER MY DEATH, NO REAL HARM WILL BE DONE... I HOPE!"

"THE STORY BEGINS LAST SUMMER... THE *HOTTEST* IN THE HISTORY OF GOTHAM CITY..."

WRITER: DENNY O'NEIL
ARTIST: MICHAEL GOLDEN
INKER: JACK ABEL
LETTERER: MILT SNAPINN
COLORIST: ADRIENNE ROY
EDITOR: JULIUS SCHWARTZ

BATMAN No. 366

Opposite: *Cover art, Walt Simonson, December 1983.*

Until the mid-'80s proliferation of comic book shops made newsstand sales less relevant, the cover was still perceived to be a comic's most important element. If *Batman*'s interior art wasn't always exciting in this period, it could regularly boast spectacular covers like this one.

OF COURSE! I SHOULD HAVE KNOWN

Above: *Interior,* Batman Special *No. 1; script, Mike W. Barr; pencils, Michael Golden; inks, Mike DeCarlo. 1984.*

"I knew—or at least hoped—that Michael Golden would be the artist, and crafted many elements to cater to his many strengths. He disappointed me in none of them, and surpassed my expectations in many others."
—Mike W. Barr

BATMAN No. 340

Left: *Interior, "A Man Called Mole"; script, Gerry Conway and Roy Thomas; pencils, Gene Colan; inks, Adrian Gonzales. October 1981.*

Gerry Conway and Roy Thomas' revival of a minor 1955 villain called the Mole was really more of a tribute to a Harvey Kurtzman–Bill Elder story in 1952's *Mad* No. 2. The 1981 Batman episode even echoed the opening of the *Mad* tale with its scene of an uprooted dirt trail created by the Mole.

BATMAN No. 370

Above: *Cover art, Ed Hannigan and Dick Giordano, April 1984.*

Hannigan's original sketch for this issue involved Batman running a gantlet of villains with a ghostly Dr. Fang looking through them. His decision to draw the scene as a downshot proved incredibly time-consuming as he struggled to get the perspective right on each member of the mob.

"ONCE UPON A TIME, IN THE WILD WILD WEST..."

ROLL CALL:
SUPERMAN
GREEN LANTERN
ZATANNA
ELONGATED MAN
THE FLASH

And special **GUEST STARS:**
JONAH HEX
CINNAMON
SCALPHUNTER
BAT LASH

"EASE UP BOY!"

"YOU TRYIN'TA GET A MAN KILLED?"

"MOVE ONE INCH CLOSER, COWBOY... AND DEAD IS JUST WHAT YOU'LL BE!"

JONAH HEX CONSIDERS HIMSELF A GOOD MAN WITH A GUN -- BUT THIS GREEN-GARBED STRANGER WITH THE GLOWING EMERALD RING HAS A POWER THAT MAKES HEX ALMOST FEEL AFRAID.

HE DOESN'T LIKE THE FEELING...

...BUT HE DOESN'T MOVE, EITHER.

3

JUSTICE LEAGUE OF AMERICA No. 198

Opposite: *Interior, "Once Upon a Time, in the Wild Wild West…"; script, Gerry Conway; pencils, Don Heck; inks, Brett Breeding. January 1982.*

Despite existing in a "realistic" Old West, Jonah Hex met super heroes not once, but twice: First in a 1978 *JLA* two-parter, in which Hex and heroes from other eras were pulled to the future as pawns of the Lord of Time. In a sequel of sorts, four members of the Justice League traveled to Jonah's home turf circa 1878 and met Hex and other Western stars Bat Lash, Cinnamon, and Scalphunter.

JONAH HEX No. 71

Right: *Cover art, Ross Andru and Dick Giordano, April 1983.*

JONAH HEX No. 75

Below: *Cover art, Ross Andru and Dick Giordano, August 1983.*

Many mid-1980s *Jonah Hex* covers emerged from conferences between Ed Hannigan and Hex writer-editor Michael Fleisher. After several thumbnail sketches Hannigan detailed, Fleisher would "pick out this or that element that he likes or change the angles or whatever. It's usually a little harder…but usually I like the results a little better."

DC CHALLENGE No. 2

Right: *Interior, "Blinded by the Light"; plot and script, Len Wein; plot and pencils, Chuck Patton; inks, Mike DeCarlo. December 1985.*

The emergence of 19th-century bounty hunter Jonah Hex in the year 1985 took place just months after his own series underwent a radical reboot that thrust him even further into the future: the very bleak 21st century. As an alternative to cancellation, the Western hero became a road warrior in a post-apocalyptic America for 18 issues of the *Hex* series.

WONDER WOMAN No. 292

Above: *Cover art, Ross Andru and Dick Giordano, June 1982.*

Wonder Woman's team-up with "just about everybody" included a distinctive '40s-retro trade dress that included the appearance of a hardcover book's spine.

WONDER WOMAN No. 315

Opposite: *Cover art, Paris Cullins and Dick Giordano, May 1984.*

The final years of the original *Wonder Woman* comic book challenged the heroine's vision of herself and her history. Over the course of 1984, she discovered an offshoot race of Amazons in South America and learned that key memories of her past had been erased or altered by her mother Queen Hippolyta.

WONDER WOMAN No. 239

Above: *Interior, "A Duke Named Deception"; script, Gerry Conway; pencils, Jose Delbo; inks, Vince Colletta. January 1978.*

Subjected to illusions like a marauding Statue of Liberty, the WWII-era Wonder Woman aroused suspicions among military leaders already wary of a female who possessed so much power and influence.

WONDER WOMAN No. 300

Right: *Interior, "The Power That Corrupts"; script, Roy and Danette Thomas; pencils and inks, Keith Pollard. February 1983.*

The milestone 300th issue imagined several alternate paths the heroine's life might have taken, from wife and mother to reluctant queen of the Amazons to a power-mad public enemy who added her face to Mount Rushmore.

LA PRIMER GRAN AVENTURA

Opposite: *Film poster, artist unknown, Tri-Star Pictures, December 1984.*

The relative merits of the *Supergirl* movie and its ultimate box-office success or failure were irrelevant when it came to the fate of the film's comic counterpart. Jenette Kahn had signed off on the Girl of Steel's death months earlier in the spring of 1984, guaranteeing that Superman's cousin would perish in 1985's *Crisis on Infinite Earths*.

SUPERGIRL

Below: *Publicity still, Helen Slater as the Girl of Steel, 1984.*

Hollywood's inability to take the source material seriously seemed to erode the Superman franchise's box-office power. The situation reached critical mass with *Supergirl*: Warner Bros. was so unimpressed by the finished product that it declined to release the film, which was instead distributed by Tri-Star. Supergirl's comic book fortunes seemed utterly unaffected, as did Helen Slater's movie career: Following her brief turn as a super heroine, Slater found success in the 1985 cult classic *Legend of Billie Jean*, as well as comedies such as 1986's *Ruthless People* and 1991's *City Slickers*. She returned to the DC universe in the 21st century, however, with roles on *Smallville* and the *Supergirl* TV series.

BUCKLE UP!

Above: *Cover art, American Honda Presents DC Comics' Supergirl, Angelo Torres, 1984.*

Supergirl briefly became a spokeswoman for automotive safety in a pair of promotional comic books created for Honda. The second was published in 1986, a year after the Girl of Steel had been killed in *Crisis on Infinite Earths* No. 7.

MISTER MIRACLE No. 20

Left and opposite: *Interior, "Eclipse"; script, Steve Englehart; pencils, Marshall Rogers; inks, Vince Colletta. October 1977.*

Following a tentative stab at reviving Jack Kirby's Fourth World characters in late 1975, DC officially put *New Gods*—now produced by Gerry Conway and Don Newton—back on the schedule. Prevailed upon to script a new *Mister Miracle* title as a companion, Steve Englehart agreed to write a few issues with artist Marshall Rogers until someone more permanent could be found.

WELCOME, MY SON!

Below: *Interior,* Mister Miracle *No. 20; script, Steve Englehart; pencils, Marshall Rogers; inks, Rick Bryant and John Fuller. February 1978.*

Despite his intended short stay on the series, Englehart re-read the entirety of Jack Kirby's *Mister Miracle* before setting to work. The writer capped his brief run with a stunning face-to-face meeting between Miracle and his sadistic adoptive father Darkseid.

MISTER MIRACLE No. 22

Below: *Interior, "Midnight of the Gods"; script, Steve Englehart; pencils, Marshall Rogers; inks, Rick Bryant and John Fuller. February 1978.*

With the deadline looming on issue No. 1, Rogers enlisted Jack Abel, Terry Austin, Joe Brozowski, Dick Giordano, Al Milgrom, Mike Nasser, and Alan Weiss, the penciller assigned each artist a character in the story as well as asking Neal Adams to ink Mister Miracle's eyes on the splash page! "I wanted really deep, brooding eyes," Rogers insisted.

THOK

THE MINI-SERIES THAT SHAKES THE COSMOS!

SUPER POWERS

By Jack Kirby, Joey Cavalieri, Adrian Gonzales and Pablo Marcos!
THE NEW DC. THERE'S NO STOPPING US NOW!

*Indicates Trademark of DC Comics Inc. Copyright © 1984

SUPER POWERS

Opposite: *House ad art, Jack Kirby and Mike Royer, 1984.*

Although his Fourth World characters were created under an early 1970s agreement, Jack Kirby received royalties when his New Gods stories were reprinted in 1984. In a particularly inspired move, Kirby was also assigned to redesign several of his 1970s creations for Kenner's Super Powers action figures that generated a substantial amount of additional income for the legendary artist. As a tie-in to the toy line, Kirby also wrote a 1984 *Super Powers* miniseries, pencilling covers and the entire final issue.

POWER ACTION BAT PUNCH

Above: *Action figure package, Kenner, 1984.*

Although the Super Power line prominently featured Kirby villains, many of its figures were well-established heroes; as a bonus, the toys came packaged with mini-comics.

WHO'S WHO: THE DEFINITIVE DIRECTORY OF THE DC UNIVERSE No. 1

Left: *Cover art, George Pérez, March 1985.*

DC's encyclopedic *Who's Who* series offered a smorgasbord of artists new and old. In many cases, such as with Kirby's creations, the original illustrators were invited back to draw their profile pages.

HUNGER DOGS

Above: *Cover art, DC Graphic Novel No. 4, Jack Kirby and Greg Theakston, 1984.*

Asked to write and draw a conclusion to his New Gods saga, Kirby reluctantly complied. Virtually all involved in its creation agreed that the end result was compromised. Nonetheless, the goodwill that inspired the invitation to create it was a major step toward restoring fan sympathy and respect for the "King of Comics."

SAGA OF THE SWAMP THING ANNUAL No. 1

Above: *Cover art, Richard Hescox, 1982.*

The poster for 1982's *Swamp Thing* movie was repurposed as the cover for film's comic-book adaptation. In the big screen version's biggest departure, the comics' government agent Matt Cable underwent a sex change to become Alice Cable (played by Adrienne Barbeau).

SAGA OF THE SWAMP THING No. 24

Opposite: *Interior, "Roots"; script, Alan Moore; pencils, Stephen Bissette; inks, John Totleben. May 1984.*

After its cancellation in 1976, *Swamp Thing* returned in a tie-in to the 1982 Troma feature film, with art by Tom Yeates. Two of Yeates' uncredited assistants, Bissette and Totleben, took over the art in 1983—setting the stage for the phenomenon that was to come when writer Moore came aboard the following year.

SAGA OF THE SWAMP THING No. 2

Above: *Cover, photograph of Dick Durock as Swamp Thing, June 1982.*

Actor and stuntman Dick Durock ultimately spent 11 years portraying Swamp Thing. Following his role in the 1982 and 1989 films, Durock returned for a *Swamp Thing* TV series on the USA network (1990–1993).

SWAMP THING HOUSE AD

Right: *House ad art, Tom Yeates, 1982.*

Canceled in 1976 following an ill-advised detour into super-hero territory, the Swamp Thing solo series was scheduled for a revival in 1978—with original editor Joe Orlando mentioned as its possible artist—before the DC Implosion put it on hold. With the 1982 Swamp Thing movie acting as a prod, an ongoing book starring the muck-encrusted creature finally returned in 1982, scripted by Martin Pasko and illustrated by Tom Yeates.

...AND MEET THE SUN.

next: The Sleep of Reason...

IT THROBS. IT BREATHES. IN THE WORLD, IN ITS FIBERS...

THE PULSE QUICKENS, STRANDS TIGHTEN, DRAW TAUT, A CLENCHED GLOVE IN MY STOMACH...

UNDERGROUND, BURIED CLAWS WOUND THE SOIL...

SAVAGE FURROWS FILL WITH MOISTURE...

A FISH TWISTS...

THE BUBBLES RISE...

THE WORLD PULSES...

...AND SHUDDERS...

WITH LIFE...

...AND DEATH...

WITH TIDE...

...AND MAGMA...

WITH ME. WITH HIM.

....

Alan Moore

"We didn't realize at the time that Alan was transforming comics, but we definitely knew that something extraordinary was happening."

— KAREN BERGER

ALAN MOORE

Above: *Photograph, Alan Moore and Jack Kirby at the San Diego Comic-Con, 1985.*

Moore's only appearance at San Diego Comic-Con came in 1985 during his run on *Swamp Thing*, prior to the release of *Watchmen*.

"Characterization and all the rest of it are things I pay attention to," Moore remarked in 1985, "but it's messing around with structure, messing around with dialogue, seeing what effect can be achieved…. That's the thing that interests me most." — Alan Moore

SAGA OF THE SWAMP THING No. 34

Opposite: *Interior, "Rite of Spring"; script, Alan Moore; pencils, Stephen Bissette; inks, John Totleben. March 1985.*

Moore inherited the characters of Alec Holland and Abigail Arcane from previous writers, but quickly dropped Swamp Thing's Alec Holland persona and steered the two figures into an unusual and deeply spiritual romance. In "Rite of Spring," Abby and Swamp Thing consummate their love on both the physical and metaphysical planes. The lyrical issue explores the nature of life and desire, while contemplating how a mortal human might view reality through the omnipresent senses of an elemental being.

JOHN CONSTANTINE, HELLBLAZER

Above: *Interior, Saga of the Swamp Thing No. 37; script, Alan Moore; pencils, Rick Veitch; inks, John Totleben. June 1985.*

WRITING THE WATCHMEN

Right: *Alan Moore's notes to Dave Gibbons for the Charlton Action Heroes concept, 1984.*

Alan Moore's Watchmen concept hinged on the depiction of a world in which super heroes were real. Any serious exploration would look very little like the DC Universe, hence Moore's request to keep his proposed world free from inter-company crossovers. Ultimately Moore reworked the concept with original heroes, so that he could subsequently dismantle their world.

COMICS CAVALCADE WEEKLY No. 1

Far right: *Unpublished cover art, Dave Gibbons, 1985.*

This never-produced comic would have slotted Superman alongside the Charlton heroes.

SAGA OF THE SWAMP THING No. 35

Above: *Cover art, Stephen Bissette and John Totleben, March 1985.*

Alan Moore took over as writer on *Swamp Thing* with issue 20, quickly morphing the central figure from a man-turned-monster and into an elemental creature of "the Green."

SAGA OF THE SWAMP THING No. 29

Opposite: *Cover art, Stephen Bissette and John Totleben, October 1984.*

SAGA OF THE SWAMP THING No. 16

Above: *Original cover art, Tom Yeates, August 1983.*

Wary of committing to an ongoing series, Kubert School graduate Tom Yeates finally relented to editor Len Wein's pleas to draw the revived Swamp Thing series in 1982. Although he quit drawing the interiors after a year, Yeates continued to turn out covers for the title into 1984 when he passed the torch.

SAGA OF THE SWAMP THING No. 29

Opposite: *Interiors, "Love and Death"; script, Alan Moore; pencils, Stephen Bissette; inks, John Totleben. October 1984.*

This story's horrific elements—including a scene in which Abby tried to scrape away the stench of death from her skin with a wire brush—resulted in the issue being rejected by the Comics Code Authority. Despite some trepidation, DC stood by the book's creative team, publishing the issue without the Code symbol and submitting no subsequent issues of the series for Code approval.

VIGILANTE No. 1

Above: *Cover art, Keith Pollard, November 1983.*

The Vigilante began as a character driven to take the law into his own hands after his family was murdered. Writer Marv Wolfman's long-term plan had been to have the character slowly begin to recognize the negative consequences of his actions and react accordingly. Before he left the series, Wolfman had the original character retire, only to have a copycat rise in his place.

VIGILANTE No. 18

Opposite: *Cover art, Jim Baikie, June 1985.*

Two issues of the gun-toting Vigilante's self-titled series came from Moore's pen, featuring artwork by Jim Baikie. "Father's Day" tells a brutal tale of violence and revenge.

WHEN THE LAW IS NOT ENOUGH!

Left: *Interiors, DC Sampler No. 2; script, Marv Wolfman; pencils and inks, Ross Andru. September 1984.*

First seen in a 1980 *Batman* story, the Electrocutioner was reintroduced as a more savage alternative to the Vigilante, who killed criminals where his counterpart did not.

VIGILANTE No. 5

Above: *Cover art, Ed Hannigan and Dick Giordano, April 1984.*

Since their debut, a pair of assassins named Cannon and Saber were implied to be romantically involved. It was a few years later before editor Mike Gold confirmed that they were, in fact, gay. "Does it make a difference?" he continued, "No."

DR. MANDELL, THIS IS LOIS OLSEN SPEAKING FROM THE GALAXY NEWS CRUISER!

SHH! QUIET, YOU MOLLUSKS... SHE'S GOT A QUESTION!

AREN'T YOU AWARE OF RECENT FINDINGS...

...BY MY BROTHER, JAMES OLSEN IV, THAT SUPERMAN WAS PROBABLY *MORGAN EDGE*, THE BROADCAST PIONEER?

NONSENSE! IT WASN'T EDGE-- BUT TELL YOUR BROTHER THAT IT WAS A GOOD GUESS.

LOOK AT THIS! LOOK AT THIS!

IT'S AN OLD TWENTIETH-CENTURY MOVIE WE FOUND IN AN EXCAVATION HERE!

LOOK!... UP IN THE SKY--

IT'S A BIRD... IT'S A PLANE... IT'S *SUPERMAN!*

SUPERMAN--WHO CAN CHANGE THE COURSE OF MIGHTY RIVERS...

...BEND STEEL IN HIS BARE HANDS--

YAHOO! SUPERMAN!

YAYY!!

--AND WHO, DISGUISED AS *CLARK KENT*, MILD-MANNERED REPORTER FOR A GREAT METROPOLITAN NEWSPAPER...

...FIGHTS A NEVER-ENDING BATTLE FOR TRUTH, JUSTICE, AND THE AMERICAN WAY!

GREAT STUFF, HUH?

HE DISGUISES HIMSELF WITH THESE GLASSES, SEE?

HA! GLASSES? YOU CAN SEE RIGHT *THROUGH* GLASSES!

Frank Miller

"It's very comforting to know that there's a godlike figure going around making things right. That's a lot of what super heroes are about. Particularly with children, finding themselves in a world that frequently makes no sense whatsoever… To have moral concepts worked out on paper, and a world where people fight for them.… I think that's a lot of what draws our audience to comics."

— FRANK MILLER

FRANK MILLER

Above: *Photograph, for* Rolling Stone, *1986.*

RONIN No. 5

Below: *Original art, Frank Miller, May 1984.*

In a departure from most comic books of the era, *Ronin* was printed on neither newsprint nor white Baxter paper. The high quality 60 lb. paper stock used on the miniseries influenced Miller's approach to illustrating the story. No longer obligated to draw in a sharp, inky fashion meant to compensate for poor paper, Miller was able to achieve subtler effects.

RONIN No. 3

Following pages: *Interior, "Ronin: Book Three"; script and art, Frank Miller. November 1983.*

MILLER'S DARK KNIGHT

Above: *Cover,* Batman: The Dark Knight *No. 2, and 3-D display for comic-book retailers, 1985.*

Miller's monstrous Batman is battered but far from beaten on this unique, "embossed" 3-D display for the direct market. One of the first in a wave of items including posters, standees, and T-shirts from DC's marketing department, the image became almost as famous among Batman fans as the book it promoted.

SUPERMAN No. 400

Opposite: *Interior, "The Living Legends of Superman"; script, Elliot S! Maggin; pencils and inks, Frank Miller. October 1984.*

Frank Miller started at DC as an artist, but he returned for *Ronin*, over which he would have full creative control. In *Superman* No. 400, Miller illustrated Elliot S! Maggin's anniversary salute to the Man of Steel, offering a prelude to the gritty, noir sensibilities that would find a perfect expression in the 1986 miniseries *Batman: The Dark Knight*.

AAAAAAAAA!!!

Selected Index

Numbers in italics refer to page numbers with images.

Abel 86, 88, 93, *174*, *176*
Abel, Jack 201, 370, 380
Abigail Arcane 387, 388
Action Comics 20, 29, 30, *31*, *93*, 148, 149, 151, 193, 194, 207, 220, 221, 227, 234, 235, 242, 243, 257, 258, 266, 267, 272, 288, *341*, 360
Adams, Neal 7, 12, 15, 19, 20, 22, 25, 26, 30, 37, 49, 50, 62, 65, 67, 68, *71*, 72, 75, 76, 85, 86, 93, 95, 98, 105, 116, 120, 131, 145, 146, 185, 189, 217, 219, 230, 235, 236, 241, 250, 255, 272, 273, 380
Adkins, Dan 68, 167, 233
Adler, Jack 8, 11, 30, 65, 72, 98, 145, *155*, 160, 201, 217, 227, 229, 230, 235, 250, 262, 293, 311
Adventure Comics 16, 30, *108*, 109, *110–11*, *114*, 160, *161*, *194–95*, 219, 331, 332, *333*, *335*, *358*, 359
Albano, John 29, 89, 116
Alcala, Alfredo 68, 114, 320
Alcazar, Vincent 173
Alec Holland 387
Alfred Pennyworth 62, *69*, *118*, 370
Ali, Muhammad 37, *252–53*, 255
All New Collectors' Edition 232, *233*, *252–54*
All-New Super Friends Hour (TV show) 315
All-Star Comics *193*, 330, 331, 332
All-Star Squadron 40, *41*, 281, *329*, 331, *334*, 335
All-Star Western 29, 116, *117*
Amazing World of DC Comics, The 230, 262
Amazing World of Superman (theme park concept) *272–73*
Amazing World of Superman, Metropolis Edition 268, 269
Ambush Bug 342
Amendola, Sal 67, 220
Amendola, Vin 67
Amethyst 359
Anderson, Murphy 11, 22, 33, 95, 96, 98, 113, 145, 146, 149, 151, 158, 189, 217, 230, 235, 238, 269, 336
Andru, Ross 34, 40, 125, 167, 196, 235, *341*, 375, 376, 391
Anthro 16
Aparo, Jim 8, 9, 16, 37, 40, 89, 90, 110, 120, 123, 125, 194, 207, 219, 283, 363, 366, 369
Aquaman 7, 33, 37, 40, 47, 110, 123, 160, 182, 183, 189, *218–23*, 231, 265, 271, 299, 326, 382
Aragonés, Sergio *174*, 177, 178
Arak, Son of Thunder *320–21*
Arion, Lord of Atlantis 359
Armentano, Charlie 79
Arting, Fred J. 312
Aruns, Jane 225
Asimov, Isaac 95
Atari Force 365
Atlas 319
Atom, the *1*, *41*, *46*, *47*, *128*, *160*, *185*, *274*, *278*, *286*, *334*, *335*
Austin, Terry 34, 43, 67, 125, 128, 131, 132, *181*, 277, 278, 286, 354, 357, 380
Ayers, Dick 299, 300

Baikie, Jim 391
Barbara Gordon 135
Barbara, Joseph 182
Barney, Joe 286
Barr, Mike W. 43, 109, 322, 338, 357, 360, 366, 369, 373
Barreto, Eduardo 360
Bates, Cary 95, 145, 177, 207, 214, 217, 230, 238, 258, 286, 319
Batgirl 4, 68, 105, *134–35*, *192*, *231*, 271
Bat Lash 29, 375
Batman *1*, *4*, 6, 7, 19, 22, 33, 34, 37, 41, 43 *44*, 47, *60–68*, 70, 102, *103–7*, *118–21*, *123–33*, *136*, *137*, 139, *160*, *173*, *180*, *181*, *182–83*, *188–89*, 190, 211, 213, 222, 231, 251, 257, 261, *264–66*, 270, 271, 274–77, 278, 281, 282, 286, 287, 336, 347, *366–73*, *382*, *383*, 391 *393*; see also Bruce Wayne
Batman (movie) 132
Batman (TV show) 15, 68, 217, 370
Batman and the Outsiders 366, 369
Batman: Dark Detective 131
Batman Family 105, 120, *121*, 135, 196, 370
Batman: Joker's Last Laugh 125
Batman Special 368, 369, 373
Batman: The Dark Knight 319, *393*
Beck, C.C. 29, 30, 152, *155*
Bender, Howard 177, 241, 243
Berger, Karen 177, 347, 387
Berry, D. Bruce 57, 319
Berry, Jim 143
Bester, Alfred 9
Best of DC Blue Ribbon Digest 4, 146, 365
Bible, The *308–9*
Big Barda 53, *381*
Bingham, Jerry 369
Binky and His Buddies 365
Bissette, Stephen 300, 384, 387, 388
Bizarro 148, *182*
Black Canary 4, 37, 47, *128*, 160, 192, 193, 194, 195, 211, 265, 271, 274, 275, 282, 327
Blackhawk 336, 337
Black Lightning *4*, *36*, 37, 40, 75, *281*, 366
Black Manta 182, 299
Black Orchid 109, *194*
Black Pirate *1*, 114, *115*
Black Racer, the 54
Blaisdell, Tex 152
Blitzkrieg 296
Bodé, Vaughn 19
Bolland, Brian 43, 219, 326, 357
Boltinoff, Murray 85, 86, 132
Bomba the Jungle Boy 7
Bostwick, Jackson 30, *157*
Brainiac 148, 149, 182, *382*
Brando, Marlon 39, *244*
Brave and the Bold, The 119, 120, *123*, 369
Breeding, Brett 349, 375
Brennert, Alan 62
Bridwell, E. Nelson 34, 38, 40, 49, 157, *160*, 189, 190, 227
Brozowski, Joe 380
Bruce Wayne 62, *67–69*, 128, 132, 369, 370; see also Batman
Bryant, Rick 380
Buckler, Rich 37, 41, 143, 235, 262, 329, 335
Bulanadi, Danny 319
Burkett, Cary 68, 135
Burroughs, Edgar Rice 29, 113, 312
Busiek, Kurt 201, 238
Byrne, John 40, 125, 257

Cain 4, 16, 44, 86, 88, 89, 93, *173*, *174*, *177*, 201, 400
Calnan, John 109, 149, 201
Camelot 3000 42, 43, 44, *356–57*
Cancelled Comic Cavalcade *288–89*
Captain Carrot and His Amazing Zoo Crew 190, *191*, 251
Captain Comet 222
Captain Fear 109, *114*
Captain Marvel 8, 29, 30, *152–57*, 231, 251, 265
Carbonaro, Michael 265
Cardy, Nick 20, 85, 95, 152, 164, 199, 219, 222, 227, 266, 274, 288
Carter, Lynda 30, 33, *168–70*, 171
Catwoman *132–33*, 270, 332
Cavalieri, Joey 190
Celardo, John 303
Chabon, Michael 50
Challengers of the Unknown 336
Chan, Ernie 238, 283, 284, 286, 335
Changeling (Gar Logan) 41, *349*
Chaykin, Howard 7, 38, 105, 305, 316, 321, 336, 345
Chiaramonte, Frank 95, 135, 196, 236, 258, 278
Clark Kent 11, 149, *150*, 158, 241, 258, 278, 341; see also Superman
Cockrum, Dave 207, 338
Cohn, Gary 116
Colan, Gene 44, 68, 105, 109, 163, 171, 193, 278, 359, 369, 370, 373
Cole, Jack 225
Colletta, Vince 25, 40, 49, 50, 54, 58, 125, 135, 158, 164, 185, 196, 211, 220, 270, 278, 281, 286, 288, 325, 341, 363, 376, 380
Colón, Ernie 349, 359
Comic Reader, The 320, 321
Comics Cavalcade Weekly 387
Comics Journal 34, 292, 293
Conway, Gerry 34, 68, 105, 120, 132, 158, 167, 189, 193, 214, 233, 283, 319, 329, 336, 365, 370, 373, 375, 376
Cowan, Denys 303
Crandall, Reed 20
Creature Commandos 305
Creeper, the 16, 211, 288
Crimson Avenger, the 109, 335
Crisis on Infinite Earths 379
Crosby, Cathy Lee 33, *168*
Crumb, Robert 19
Cullins, Paris 376
Cyborg 40, 41, *348*, *349*, *351*

Dark Mansion of Forbidden Love 81, 82, 83
Darkseid 22, 25, 50, 201, *202–5*, 380
Davis, Jack 345
DC Challenge 375
DC Comics Presents 109, 114, *115*, *158*, *159*, 189, 342
DC Comics Presents Annual 196
DC Graphic Novel *364*, 365, *383*
DC 100-Page Super Spectacular *46–47*, 49
DC Sampler 173, 199, 208, 391
DC Special 18, 19, 86, 222, 288, 310, 311, 331
DC Special Series 67, 128, 129, 214, 300, 322, 340, 341, *343*
DC Super-Stars 177, 332
Deadman *4*, *122*, *126–27*, *219*, 262, 288
DeCarlo, Mike 44, 196, 329, 342, 369, 373, 375

DeFalco, Tom 190
De Gouw, Jessica 332
de la Rosa, Sam 34
Delbo, Jose 109, 135, 376
DeMatteis, J.M. 43, 219, 291, 303, 305
Demon, the *4*, *54*, *57*, 105, *229*
Destiny 88, 89
Detective Comics 57, 61, 62, 67, 69, 104, 105, 119, *124*, 125, *126–28*, 131, 132, *134*, 135, *138–40*, 180, 181, 212, *213*, 278, 336, 369, 370
DeZuniga, Tony 29, 79, 81, 90, 105, 110, 116, 132
Diana Prince 10, 19, 46, 82, 158, *162*, 163; see also Wonder Woman
Dick Grayson 68, 189, *351*, *354*; see also Nightwing; Robin
Dillin, Dick 189, 217, 274, 326, 329
Ditko, Steve 15, 16, 98, 291, 321
Doctor Fate 46, *322–23*, *329*
Doctor Mid-Nite *47*, *335*
Doctor Thirteen 98, 110
Dominguez, Luis 116
Donna Troy 192, *351*, *354*
Donner, Richard 38, *244*, 245
Doorway to Nightmare 43
Dorfman, Leo 85, 151, 227
Drake, Arnold 86, 173, 305
Drake, Stan 230
Draut, Bill 86
Drucker, Mort 247
Durock, Dick 384
Duursema, Jan 359

Edwing, Don 149, 177
Eisner, Will 12, 41, 211, 262
El Diablo 29, *116*
Elongated Man, the 4, *126–28*
Enemy Ace 296, 311
Englehart, Steve 43, 67, 125, 128, 131, 132, 380
Estrada, Ric 125, 143, 164, 177, 193, 286

Fafhrd and the Gray Mouser 316
Fagen, Tom 93
Falling in Love 79
Famous First Edition 341
Filmation Associates 157, 182
Firestorm 322
1st Issue Special 57, 284, 319, 325
Flash, the 4, 37, 40, 46, 47, 151, 160, 178, 182, 193, 212, *214–17*, 230, 231, 251, 274, 275, 286, 292, *322–23*, 330, 331, 332
Fleisher, Michael 110, 261, 291, 370, 375
Forbidden Tales of Dark Mansion 178, *179*
Forever People 22, 25, 49
Fourth World 22, 25, 29, 383
Fowler, Cate 270
Fox, Gardner 217, 326
Fox and the Crow, The 16
Fradon, Ramona 225
Frazetta, Frank 20, 82
Friedrich, Mike 20, 41, 90
From Beyond the Unknown 95, 96, 98
Fuller, John 380
Funky Flashman 53

Gafford, Carl 145
Gaiman, Neil 19, 194
Gaines, Max "M.C." 33, 308
Gaines, William 33, 34
Galloway, John, Jr. 258
García-López, José Luis 41, 43, 125, 163, 167, 230, *233*, 250, 257, 261, 276, 277, 319, 341, 365
Gattel, Gerda 149, 227
Gerber, Steve 322, 336
Ghosts 81, 85, 266
G.I. Combat 298, 299
Giacoia, Frank 57, 81

Gibbons, Dave 387
Giella, Joe 326
Giffen, Keith 44, 199, 201, 204, 207, 208, 211, 322, 342
Gigant 102, 283
Gill, Joe 81
Gilliam, Terry 119
Giordano, Dick 7, 11, 19, 20, 26, 30, 34, 40, 41, 43, 61, 62, 67, 68, *71*, 72, 75, 76, 90, 93, 119, 125, 128, 132, 146, 160, 163, 164, 167, 185, 189, 193, 196, 199, 208, 212, 214, 219, 220, 230, 233, 235, 241, 250, 251, 255, 257, 261, 262, 274, 276, 284, 332, 341, *347*, 359, 366, 369, 373, 375, 376, 380, 391
Girls' Love Stories 79
Girls' Romances 120
Glanzman, Sam 300, 303
Glaser, Milton 34, 37, 163
Gold, Mike 41, 391
Goldberg, Stan 185, 365
Golden, Michael 105, 369, 370, 373
Gonzales, Adrian 269, 329, 331, 373
Goodwin, Archie 20, 29, 57, *139*, 140, 181
Gordon, Al 190
Gorilla Grodd *182*, 286
Goscinny, Rene 119
Gospel According to Superman, The 258
Goulart, Ron 336
Grandenetti, Jerry 53, 186, 190, 284
Gravedigger 37, 299
Gray, Michael 157
Great Superman Book, The 261
Great Superman Comic Book Collection, The 43
Green Arrow 4, 7, 12, 13, 25, *26–27*, 37, 47, *71–73*, 77, 128, 160, 182, 194, 207, 211, 230, 231, 271, 274, 275, 282, 327, 332, 335, 338, 339
Green Lantern *1*, 4, 7, 8, 12, 13, 25, *26–27*, 37, 46, 47, 72, *71–74*, 75, 76, 77, 160, 182, 217, 230, 231, 251, 274, 329, 338, 374
Green Lantern/Green Arrow 12, 26, 76
Grell, Mike 143, 199, 207, 278, 325, 338, 360
Grell, Sharon 325
Griffin, Rick 19
Gus Gray 299

Hackman, Gene 39
Hal Jordan see Green Lantern
Hanerfeld, Mark 86, 93
Haney, Bob 20, 123, 149, 296, 306, 311
Hannigan, Ed 61, 132, 146, 208, 238, 359, 366, 373, 375, 391
Harris, Jack C. 123, 145, 177, 201, 211, 300
Harrison, Sol 34, 38, 41, 149, 227, 230, 250, 262, 265
Haunted Tank, the 299
Hawk and the Dove, The 16
Hawkgirl 47, *126–27*, 231, 274, 275, 329, *334*, 336
Hawkman *1*, 4, 41, 46, 47, *126–28*, 160, 182, 189, 231, 286, 292, 327, 330, 331, 335, 336, 382
Heath, Russ 85, 178, 299, 300, 303
Heck, Don 11, 49, 164, 171, 214, 329, 375
Helena Wayne 332
Hembeck, Fred 173
Hercules Unbound 318, 319
Herriman, George 12
Hescox, Richard 384
Hess, Roger 270

House of Mystery 16, 19, 44, 85, 86, 89, 93, 101, 201, *362–63*, 400
House of Secrets 29, 84, 85, 86, 93, 100, 101, 283, 363
Howard, Robert E. 316
Hudson, W.H. 315
Human Target, the 29, 30, *31*, *93*, 119
Hunger Dogs 365, 383
Huntress 105, *192*, *193*, 332
Infantino, Carmine 16, 19, 22, 25, 26, 29, 30, 33, 34, 72, 79, 102, 119, 125, *155*, 182, 193, 211, 212, 214, 227, 230, 238, 284, 325, 336
Infinity, Inc. 109, 151, 281
In the Days of the Mob 58, 59
Ironwolf 320, 321
Isabella, Tony 37, 75
Isis 157
Jacobson, John 177
Jaissle, Paul R. 212
Janson, Klaus 68, 359, 370
Jason's Quest 284
Jefferson Pierce 75
Jemm, Son of Saturn 46
Jensen, Dennis 109, 214
Jimmy Olsen 23, 50, 146, 148
John Carter of Mars 113
John Constantine 387
Johnny Quick 329, 334, 335
Johnny Thunder 46, 116
John Stewart see Green Lantern
Joker 41, 64, 65, 68, 120, *125*, 128, 130, 131, *190*, 265, 270, *372*, 382
Jonah Hex 4, 29, 116, *117*, 282, *374–75*
Jones, Arvell 214
Jones, Bruce 132
Jones, Jeff 7, 81, 82
Joyce, Barbara 332
Just'a Lotta Animals 190, *191*
Justice Inc. 109
Justice League of America 8, 30, 40, 75, 160, 182, 189, 190, 235, 278, *326–29*, 335, 336, *341*, 374, 375
Justice Society of America 190, 330, 331, 333, 335
Kahn, Jenette 34, 37, 38, 41, 44, 222, 233, 250, 251, 255, 274, *351*, 354, 379
Kaluta, Michael 11, 16, 29, 43, 44, 61, 95, 106, 109, 113, 212, 291, 345
Kamandi, the Last Boy on Earth 29, 56
Kamuda, Alan 262
Kane, Bob 67
Kane, Gil 20, 212, 257, 338
Kanigher, Robert 19, 79, 95, 96, 101, 164, 171, 173, 283, 284, 292, 293, 294, 296, 299, 300, 303, 315
Karate Kid 143, 201
Kashdan, George 20, 173, 303
Kastel, Roger 360
Kelley, Bill 303
Kidder, Margot 39, *178*
Kid Flash 354
King, Don 255
King Arthur 42, *356–57*
Kirby, Jack 15, 16, 22, 25, 29, 30, 41, 49, 50, 53, 54, 57, 58, 105, 217, 229, 284, 319, 345, 365, 383, 385, 387
Klein, George 185
Kong, the Untamed 315
Korak, Son of Tarzan 112, 113
Kristin Wells 196
Krypto the Superdog 148, 149, *185*
Kubert, Adam 95, 255
Kubert, Andy 294
Kubert, Joe 15, 19, 29, 96, 109, 125, 173, 185, 265, 274, 283,

293, 294, 296, 305, 308, *311*, 312, 315, 335, 336
Kukalis, Romas 336
Kupperberg, Alan 227
Kupperberg, Paul 38, 177, 278, 286, 359
Kurtzman, Harvey 119
Lady Cop 284
Lay, Carol 190
Layton, Bob 119, 332
Leave It to Binky 16
Lee, Stan 11, 15, 19, 25, 250
Legends of the Superheroes (TV special) 332
Legion of Super-Heroes 20, 198–207, 208–10, 211, 332, 338
Leiber, Fritz 316
Leslie Thompkins 119
Letterese, Joe 227
Levitz, Paul 7, 89, 177, 193, 199, 201, 204, 250, 251, 286, 305, 321, 322, 331, 332, 336, 342, 351
Lewandowski, Arthur 208
Lex Luthor 152, 182, 238, *269*, *382*
Liberty Belle 329, *334*, 335
Licensing Corporation of America 265
Limited Collectors' Edition 65, *145*, *157*, 308–9
Little Nemo in Slumberland 366
Lobo 44
Lois Lane *148*, 152, *158*, *159*, 192, 193, 196, 230, 241, *341*
Lynch, Jane 336
Machlan, Mike 281
Madame Xanadu 43, *192*, 193
MAD magazine 16, 33, 34, *149*, *174*, *246*, *247*, *373*
Maggin, Elliot S! 76, 89, 135, 151, 181, 196, 225, 230, 258, 286, 319, 336, 345, 365, 393
Maguire, Kevin 277
Mahlstedt, Larry 132, 199, 201, 204, 207, 208, 322
Manak, Dave 173, 177
Man-Bat *104*, *105*, 370
Mandel, Lillian 227
Manhunter 29, 57, *139–41*, 288, 291
Marcos, Pablo 149
Mark Shaw 57
Marston, William Moulton 164
Martha Wayne 62
Martian Manhunter, the 47
Martin, Don 149
Martin, Gary 98
Marvin 33, *183*
Masters of the Universe 211
Mayer, Sheldon 194, 308
McCartney, Paul 120
McCay, Winsor 366
McGregor, Don 44
McKenzie, Roger 299
McLaughlin, Frank 109, 193, 214, 217, 220, 278, 329
McLeod, Bob 286, 352
Mego 135, 265
Men of War 37, 299
Mera *192*, 220, 221, 271
Metal Men 120, *336*
Metamorpho 366
Metron *24*, *48*, *50*
Michelinie, David 296, 299, 325
Milgrom, Al 222, 288, 316, 326, 380
Miller, Frank 7, 44, 269, 303, 319, 345, *393*
Mister Miracle 22, 25, 50, *51*, *53*, *54*, *57*, 228, 229, 380–81
Mr. Mxyzptlk *149*, 196
Mœbius 345
Moeckel, Ken 261
Moench, Doug 68, 86, 369
Moore, Alan 384, *387*, 388, 391

Moreira, Ruben 98
Morrison, Grant 236, *366*
Morrow, Gray 90, 116, 194
Ms. magazine 32, 33
Mushynsky, Andy 177
Mystery in Space 43
Nathaniel Dusk 44
Netzer, Michael (né Michael Nasser) 322, 380
Neville, W. M. 34
New Gods 22, 24, 25, *48*, *50*, *54*, 380
Newsboy Legion 50
New Teen Titans 41, 329, 346–47, 349–55, 359
Newton, Don 68, 125, 157, 370
New York Herald, The 366
New York Times Magazine, The 15
Night Force 359
Nightmaster 316
Nightwing 236, *349*, *354*; see also Dick Grayson
Niño, Alex 95, 96, 114, 178, 305
Nocturna 367
Novick, Irv 128, 196, 214, 217
Oda, Ben 347
Oksner, Bob 30, 72, 145, 151, 152, 160, 171, 194, 235, 241, 243, 288
Oleck, Jack 95, 303
OMAC 57
Omega Men 44
100-Page Super-Spectacular 30
O'Neil, Dennis ("Denny") 7, 8, 9, 11, 9, 12, 22, 25, 26, 37, 62, 65, 67, 68, 71, 72, 76, 82, 106, 113, 119, 128, 131, 143, 152, 155, 189, 194, 227, 316, 326, 336, 338, 370
Ordway, Jerry 281, 329, 331, 335
Orlando, Joe 16, 29, 37, 75, 79, 81, 86, 89, 90, 93, 102, 109, 110, 114, 174, 193, 250, 251, 269, 295, 325, 326, 332, 363, 384
Our Army at War 15, 19, 293, 294, 295, 300, 301, 303, 306–7
Outsiders 284
Overstreet, Robert 262
Pasko, Martin 40, 196, 281, 322, 336, 384
Patchwork Man 283
Patton, Chuck 375
Paul Kirk 139
Penguin, the 41, 120, 125, 190, 270, *382*
Pérez, George 40, 326, 329, *347*, 349, 351, 352, 354, 360, *383*
Perisic, Zoran 244
Perry White *148*, 149
Pettee, Clinton 312
Phantom Stranger 86, *87*, *90*, 92, 93, 98, *99*, 122, *123*, 292
Plastic Man 219, 224–25, 231, 335
Plastic Man (cartoon) 38, 225
Plop! 101, *173–75*, *177*, *178*, 363, 399
Podwil, Jerome 81
Pollard, Keith 196, 376, 391
Post, Howard 16
Potts, Carl 286
Power Girl *192*, *193*, 330
Pozner, Neal 250, 366
Prez 186–87, 288
Purcell, Howard 16
Puzo, Mario 38, *244*
Queen Hippolyta 376
Ragman 283
Randall, Ron 300
Rā's al Ghūl 6, 7, 65, 70, 125, 369
Raven 40, *41*, *192*, 193, *349*, *351*
Raymond, Alex 230
Redondo, Frank 294

Redondo, Nestor 89, 102, 283, 308, 315
Reeve, Christopher 37, 38–39, 244, 245, 247, 248
Ricard, Jack 247
Richard Dragon *142*, *143*
Riddler, the 41, *125*, *182*, 265, 270
Rima, the Jungle Girl 94, 95, 96, *97*, *314–15*
Robbins, Frank 61, 86, 105, 106, 363
Robbins, Trina 167
Robin 4, 6, 20, 21, 33, 40, 41, 46, 62, 63, 68, 104, 105, 118, 120, 121, 125, 126–27, 135, 136, *137*, 182, *183*, 190, 196, 231, 251, 270, 271, 275, 276, 281, 286, 332, 351, 354, *354*, 367, 370, *373*, *382*; see also Dick Grayson
Robinson, Jerry 61, 128, 345
Robotman 329, *334*, 335
Rogers, Marshall 43, 67, 105, 125, 128, *131*, 132, 345, 380
Romita, John 79
Ronin 44, 45, 319, 393–95
Roosevelt, Franklin D. 331
Rosenberger, John 284
Rotsler, William 336
Roussos, George 151
Roy, Adrienne 347
Royer, Mike 22, 25, 30, 53, 57, 225, 229, 383
Roy Harper 27, 72, 73
Rozakis, Bob 75, 105, 128, 135, 145, 196, 220, 243, 248, 265, 278, 281, 305
Rubinstein, Joe 105, 217
Saga of the Swamp Thing 384–89
Saga of the Swamp Thing Annual 384
Saladino, Gaspar 22, 227
Salkind, Alexander 37, 38
Sandman 29, 30, *46*, *57*, 89, 109
Sandy the Golden Boy 109
Sarnoff, Bill 250
Saturday Night Live 178
Saviuk, Alex 109, 220, 278
Scalphunter 116, 375
Scarpelli, Henry 72, 185
Schaffenberger, Kurt 30, 125, 152, 157, 158, 173, 185, 230, 281, 342
Schwartz, Julius ("Julie") 8, 11, 12, 22, 25, 30, 34, 37, 72, 76, 93, 98, 146, 152, 164, 214, 217, 227, 235, 255, 269
Sciacca, Tom 177
Scooby-Doo (cartoon) 190
Scott, Ashley 332
Sea World 270
Secret Society of Super-Villains 53, 214, 286
Secrets of Haunted House 88, 89, *176*, 177, 290, 291
Sekowsky, Mike 19, 160, 163, 284, 326
Sgt. Fury 300
Sgt. Rock 15, 19, 282, *283*, 292, 293, 294–95, 299, 300, 302, 303
Seuling, Phil 30
Seven Soldiers of Victory 335
Severin, Marie 262
Shade, the Changing Man 288, 291
Shadow, the 11, 34, 86 *101*, 106, *107*, 194, 265
Shaw, Scott 190
Shazam 29, 30, 152–56, *157*, 189, 230; see also Captain Marvel
Shazam! (TV show) 30
Shelton, Gilbert 19
Sherman, James 286
Shiner, Mike 262

Shining Knight 330, *334*, 335
Shooter, Jim 20, 199, 201, 354
Showcase 16, 38, 49, *193*, 284, 288, *316*, 336
Shuster, Joe 261, 341
Siegel, Jerome "Jerry" 113, 261
Sienkiewicz, Bill 345
Silly Putty Man Meets the Eggomeany 185
Silver St. Cloud 132
Simon, Joe 16, 25, 29, 30, 53, 57, 186, 284
Simonson, Louise 29, 101
Simonson, Walter 29, 57, 125, 139, 140, 201, 316, 319, 336, 345, 354, 373
Sinister House of Secret Love 80, 81
Skeates, Steve 7, 9, 11, 89, 90, 101, 110, 114, 173, 177, 178, 219, 220, 225, 286, 363
Skrenes, Mary 225
Slater, Helen *378*, 379
Slifer, Roger 44
Smith, Bob 125, 225, 370
Smolinksi, Aaron 248
Snyder, Ivan 265, 266
Soul Love 284, 285
Sparling, Jack 7, 363
Spectre, the 16, *47*, 109, 110–11, *123*
Speedy 20, *21*, 26, *27*, 335
Spengler, Pierre 244
Spiegle, Dan 235
Spirit, the 41, *211*
Spirit World 16, *58*
Springer, Frank 37, 75
Squeglia, Vince 190
Stalker 321
Star Boy *206*, 207
Starfire 40, 41, *192*, 193, *251*, *325*, *349*, *351*
Starlin, Jim 316
Starman 46, *219*, 288
Starr, Leonard 345
Star Raiders *364*, 365
Star-Spangled Kid 330, *335*
Star Spangled War Stories 293, *296*, *297*, *311*
Star Trek 360, *361*
Staton, Joe 119, 193, 322, 331, 332, 336
Steacy, Ken 181
Steinem, Gloria 33, 119, 164
Steranko, Jim 25, 345
Stevens, Dave 181
Steve Trevor 171
Stewart, Bhob 19
Strange Adventures *95*, *96*
Streaky the Supercat 149
Super A 185
Super B 185
Superboy *197*–99, *201*, 207, *210*, 241
Superboy and the Legion of Super-Heroes 201, 286, *287*
Superboy Spectacular 40, 43
Super DC Giant 78, *79*, 220
Super Dictionary 274, 275
Super Friends (TV show) 30, 33, 38, *181–83*
Supergirl 4, 109, *148*, 160, 161, *192*, 196, 231, 236, *237*, 251, 271, 275, 378–79
Supergirl (movie) 247, *378*, 379
Supergirl (TV show) 379
Super Healthy Cookbook 274
Super-Heroes Battle Super-Gorillas 286
Super Juniors 190
Superman 2, *4*, 7, 8, *11*, 14, 15, 22, 23, 33, 35, 37–40, 43, 46, 47, 49, 50, 71, 75, 89, 95, 113, 144–52, 158–60, 167, 178, 181–83, 185, 189, 193, 196, 197, 211, 217, 226, 227, 230–32, 233, 234–43, 244, 245–49, 251–53,

255–61, 262, 265–71, 274–77, 278, 280–82, 286, 330, 331, 336, 340–45, 347, 351, 360, *360*, 369, 382, 387, 392, *393*; see also Clark Kent
Superman: The Movie 37, 38–39, 149, 243, 244, 247–48, 261, 281
Superman II (movie) 38, 244, *245*, *247*, 341
Superman III (movie) 248, 249
Superman Album 269
Superman Annual 181, *259*
Superman Family 236
Superman's Girl Friend, Lois Lane 158
Superman's Pal, Jimmy Olsen 22, 23, 49, 50, 54, *55*, 146
Superman Taschenbuch 269
Superman vs. Muhammad Ali 37, 252–55
Superman vs. The Amazing Spider-Man 34, 35, 41
Super Powers *382*, *383*
Super Team Family 214, *215*, 286
Superwoman *196*, *197*
Sutton, Tom 360
Swamp Thing 29, 93, 98, 100, 101, *102–3*, 283, 303, 384–86, 387 388–89
Swan, Curt 11, 22, 95, 135, 145, 146, 149, 151, 158, 185, 189, 193, 196, 220, 227, 230, 236, 258, 259, 262, 269, 278
Swierzy, Waldemar 248
Sword of Sorcery 316, 317
Talaoc, Gerry 86, 305
Tales of the New Teen Titans 348, 349
Tales of the Teen Titans 349, 351, 354
Tales of the Unexpected 98
Talia al Ghūl 68, 369
Tanghal, Romeo 163, 171, 214, 299, 300, 329, 341, 347, 349, 351, 352
Tarzan 28, 29, 312, 315, 360
Tarzan of the Apes 312
Tawky Tawny 230
Taylor, Mark C. 225
Ted Knight 46
Teen Titans 20, 21, 40, *41*, 43, 120, 326, *354*
Theakston, Greg 383
Thomas, Danette 109, 376
Thomas, Roy 9, 40, 41, 109, 114, 158, 163, 171, 190, 193, 278, 281, 316, 320, 329, 331, 335, 341, 373, 376
Thomas Wayne 62
Time Warp 95, *291*
Tor 312, *313*
Torres, Angelo 379
Torres, Enrique 336
Toth, Alex 79, 81, 90, 178, 181, 182, 194, 274, 293, 306
Totleben, John 384, 387, 388
Tremayne, Les 157
True Divorce Cases 284
Truman, Timothy 300
Tuska, George 40, 211, 281, 341
Two-Face 65, 125, 196
Unexpected, The 43, 86, 98, *172*, 173
Unknown Soldier 296–97, *311*, 319
Untold Legend of the Batman 40, 41, 125, 370
Uslan, Michael 265
U.S.S. Stevens 300, *303*
V 360
Varley, Lynn 366
Veidt, Conrad 128
Veitch, Rick 300, 303, 387
Via, Ed 291
Vigilante *47*, 335, 390–91
Viking Prince 310
Villagran, Ricardo 360, 365

Vixen 288
von Eeden, Trevor 37, 75, 132, 338
Vosburg, Mike 262, 325
Waggoner, Lyle 171
Waid, Mark 241, 306
Waldinger, Morris 227
Warlord 4, 324–25
Watchmen 387
Wein, Glynis 227
Wein, Len 20, 29, 30, 40, 61, 90, 93, 98, 109, 113, 119, 125, 177, 189, 194, 236, 238, 305, 347, 363, 375, 388
Weird Adventure Comics 16
Weird Mystery Tales 16, 17, 52, 53, 89
Weird War Tales 19, 29, 96, 174, 303, 304–5
Weird Western Tales 16, 29, 116, 174
Weird Worlds 19, *113*
Weisinger, Mort 11, 22, 40, 95, 151, 158
Weiss, Alan 189, 380
Weiss, Larry 266
Weist, Jerry 101
Wendy 33, *183*
Whiting, Steve 225
Who's Who: The Definitive Directory of the DC Universe 383
Wiacek, Bob 199, 207, 286
Wildcat 46, *193*, 217
Wildey, Doug 81
Williams, Robert 19
Williamson, Al 20, 238, 345
Winged Victory 330, *335*
Winger, Debra 168
Witching Hour, The 86, 90, *91*, 363
witzend 20
Wolfman, Marv 20, 40, 89, 90, 278, *347*, 349, 351, 352, 354, 359, 360, 391
Wolverton, Basil 174
Wonder Dog 49, *183*
Wonder Girl 20, 21, 41, *168*, 349
Wonder Twins 4, *182*
Wonder Warrior *196*, *197*
Wonder Woman 4, 7, 10, 11, 19, 32, 33, 37, 40, 46, 82, 109, 158, *159*, 162–71, 182, *183*, 192, 193, 211, 231, 232, 235, *251*, 257, 261, 265, 266, 270, 271, 274–77, 278, 279, 281, 292, 326, 331, 336, 369, 376–77, 382; see also Diana Prince
Wonder Woman (TV movie) 33, *168*
Wonder Woman (TV show) 30, 33, 168–70, 171
Wood, Wally 20, 143, 193, 286, 321, 331
World of Krypton 38, 40
World's Finest Comics 22, 149, 158, 211, 257, 283, 336, 338
World's Greatest Superheroes 38, 40, 281, 341
Wrightson, Bernie 16, 29, 93, 101, 102, 106, 189, 315, 316, 345
Yeates, Tom 125, 384, 388
York, Susannah 244
Young Love 79
Young Romance 79
Zachary Nail 98
Zap Comix 19, 20
Zatanna *192*, *194*
Zatara 194
Ziel, George 82

397

Bibliography

Daniels, Les. *Batman: The Complete History.* San Francisco: Chronicle Books, 1999.
Daniels, Les. *Comix.* New York: Outerbridge & Dienstfrey, 1971.
Daniels, Les. *DC Comics: Sixty Years of the World's Favorite Comic Book Heroes.* Boston: Bulfinch Press, 1995.
Daniels, Les. *Superman: The Complete History.* San Francisco: Chronicle Books, 1998.
Daniels, Les. *Wonder Woman: The Complete History.* San Francisco: Chronicle Books, 2000.
Feiffer, Jules. *The Great Comic Book Heroes.* New York: Dial Press, 1965.
Gabilliet, Jean-Paul. *Of Comics and Men: A Cultural History of American Comic Books.* Jackson, MS: University Press of Mississippi, 2010.
Grand Comics Database. http://www.comics.org.
Hadju, David. *The Ten-Cent Plague: The Great Comic-Book Scare and How It Changed America.* New York: Farrar, Straus and Giroux, 2008.
Jones, Gerard. *Men of Tomorrow: Geeks, Gangsters, and the Birth of the Comic Book.* New York: Basic Books, 2004.
Mike's Amazing World of DC Comics. http://www.dcindexes.com.
Overstreet, Robert. 1970–2010. *The Comic Book Price Guide.* 40 vols. Cleveland, TN: Overstreet Publications.
Pasko, Martin. *The DC Vault: A Museum-in-a-Book Featuring Rare Collectibles from the DC Universe.* Philadelphia: Running Press, 2008.
Spiegelman, Art, and Chip Kidd. *Jack Cole and Plastic Man.* San Francisco: Chronicle Books, 2001.
Steranko, Jim. 1970–1972. *History of Comics.* 2 vols. Reading, PA: Supergraphics.

Quotations are from 2010 interviews and:

Adams, Neal. *Comic Book Superheroes Unmasked.* History Channel, August 5, 2010.
Adler, Jack. "Scenemakers Behind the Scenes." By Carl Gafford. *Amazing World of DC Comics,* No. 10 (January 1976): 3–13.
Aleksander, Irina. "Diane von Furstenberg Channels Her Inner Wonder Woman, But Do Superheroes 'Work' in Fashion?" *New York Observer,* October 7, 2008.
Alter Ego, No. 1. Summer 1999.
Alter Ego, No. 25. June 2003.
Chabon, Michael. "The Amazing True Adventures of Michael Chabon." By Peter Quinones. *The Comics Journal,* No. 231 (March 2001): 89–97.
Arnold, Andrew D. "How Much for Those Comix?" *Time.* June 29, 2001.
Benton, Mike. *Superhero Comics of the Golden Age: The Illustrated History.* Dallas: Taylor Publishing, 1992.
Benton, Mike. *Superhero Comics of the Silver Age: The Illustrated History.* Dallas: Taylor Publishing, 1991.
Benton, Mike. *The Comic Book in America: An Illustrated History.* Dallas: Taylor Publishing, 1989.
Braun, Saul. "Shazam! Here Comes Captain Relevant." *The New York Times Magazine.* May 2, 1971.
Bridwell, E. Nelson. Introduction. In *Superman from the 30's to the 70's.* New York: Crown Publishers, 1972.
Bridwell, E. Nelson. Introduction. In *Shazam! from the 40's to the 70's.* New York: Crown Publishers, 1977.
Brown, Slayter. "The Coming of Superman." *The New Republic.* September 2, 1940.
Carter, Lynda. Interview by Les Daniels. Transcript. 1995.
Christensen, William and Mark Seifert. "Dark Legend." *Wizard,* No. 40. December 1994.
Coogan, Peter. *Superhero: The Secret Origin of a Genre.* Austin, TX: MonkeyBrain Books, 2006.
Eisner, Joel. *The Official Batman Book.* Chicago: Contemporary Books, 1986.
Eisner, Will. *Will Eisner's Spirit Casebook.* Princeton, WI: Kitchen Sink Press, 1990–1998.
Feiffer, Jules. "The Minsk Theory of Krypton." *The New York Times Magazine.* December 29, 1996.
Fifty Who Made DC Great: Suddenly, 50 Years Later. New York: DC Comics, 1985.
Finger, Fred. Interview by Dwight Jon Zimmerman. *Comics Interview,* No. 31 (1983): 3–11.
Flessel, Creig. "The Creig Flessel Interview." By Gary Groth. *The Comics Journal,* No. 245 (August 2002): 54–74.
Friedrich, Otto, Beth Austin, and Janice C. Simpson. "Up, Up and Awaaay!!!" *Time.* March 14, 1988.
Gaiman, Neil. Interview by Les Daniels. Transcript. 1995.
Gaiman, Neil. Official website. "Biography."
Gilmore, Mikal. "Comic Genius." *Rolling Stone,* No. 17 (March 1986): 56–58.
Haney, Bob. Interview by Les Daniels. Transcript. 1995.
Heller, Steven. "The Art of Rebellion." *The New York Times.* August 9, 2009, sec. BR12.
Jennings, Dana. "The Magic of Comics! While Batman Turns 64, a Fan Goes Back to 9." *The New York Times,* August 27, 2003.
Jensen, Jeff. "Heroic Effort: The Man of Steel first defended truth, justice, and the American way 63 years ago." *Entertainment Weekly,* June 6, 2001.
Johns, Geoff. "Geoff Johns brings the Legion to Smallville." By Jevon Phillips. *Los Angeles Times,* Hero Complex weblog, January 15, 2009.
Kane, Bob with Tom Adrae. *Batman and Me.* Forestville, CA: Eclipse Books, 1989.
Kobler, John. "Up, Up and Awa-a-y!" *The Saturday Evening Post.* June 21, 1941.
Kurtzman, Harvey. *From Aargh! to Zap!: Harvey Kurtzman's Visual History of the Comics.* New York: Prentice Hall, 1991.
Lansdale Jr., Lt. Col. John and the editors. "Superman and the Atom Bomb." *Harper's Magazine* (April 1948): 355.
Life 60, No. 10. "The Whole Country Goes Supermad." March 11, 1966.
Loeb, Jeph. Discussion at ICv2 Comics and Media Conference, San Diego, CA, July 22, 2009.
Los Angeles Times. "This Time, It Isn't Mr. Ali Who Gets in the Last Word." May 25, 1980, sec. C2.
Marston, William Moulton. Letter to Coulton Waugh, March 5, 1945. DC Comics Archive.
McKean, Dave. "A Decade in Comics: An Interview with Dave McKean." By Christopher Brayshaw. *The Comics Journal,* No. 196 (June 1997): 58–89.
Moore, Alan. Introduction. In *Bill Sienkiewicz Sketchbook.* Seattle, WA: Fantagraphics Books, 1990.
Morrison, Grant. "Grant Morrison: The Comic Foundry Interview." By Laura Hudson. Comic Foundry, March 16, 2009.
Morrison, Grant. "Quotes." DC Comics Database.
Moldoff, Sheldon. "I Never Went a Day without Work." By Steve Ringgenberg. *The Comics Journal,* No. 214 (July 1999): 90–107.
Musgrove, Michael. "Graphic Novels." *The Washington Post.* January 11, 1998.
National Periodical Publications Inc. President's Report, 1963.
Newsweek. "The Story of Pop." April 25, 1966.
Robinson, Jerry. *The Comics.* Newspaper Comics Council, 1974.
Ross, Alex. "The Alex Ross Interview." By Christopher Brayshaw. *The Comics Journal,* No. 223 (May 2000): 38–74.
Sacks, Ethan. "Distinguished Company." *Wizard,* No. 223 (April 2010).
Schelly, Bill. *Man of Rock: A Biography of Joe Kubert.* Seattle, WA: Fantagraphics Books, 2008.
Schwartz, Julius, with Brian M. Thomsen. *Man of Two Worlds: My Life in Science Fiction and Comics.* New York: HarperEntertainment, 2000.
Schwartz, Julius. "Strange Schwartz Stories." By Guy H. Lillian III. *Amazing World of DC Comics,* No. 3 (November 1974): 2–11.
Siegel, Jerry and Joe Shuster. "Of Supermen and Kids with Dreams." By Rick Marshall. *Nemo* No. 2 (August 1983): 6–19.
Publisher's Weekly. "DC's Vertigo Marks 10 Years." December 23, 2002.
Spiegelman, Art, and Françoise Mouly, eds. *The TOON Treasury of Classic Children's Comics.* New York: Abrams ComicArts, 2009.
Spurlock, J. David. *The Amazing World of Carmine Infantino.* Somerset, NJ: Vanguard Productions, 2001.
Starger, Steve and J. David Spurlock. *Wally's World: The Brilliant Life and Tragic Death of the World's 2nd Best Comic Book Artist.* Somerset, NJ: Vanguard Publications, 2006.
"Superman's Pal, Curt Swan." *Comics Values Monthly Special,* No. 2 (1992).
Swan, Curt. "Drawing Superman." In *The Krypton Companion,* by Michael Eury. Raleigh, NC: TwoMorrows Publishing, 2006.
Time. The Press. "Superman's Dilemma." April 13, 1942.
Time. Show Business. "Onward and Upward with the New Superman." August 1, 1977.
Tollin, Anthony. "Origins of the Golden Age: Sheldon Mayer." *Amazing World of DC Comics,* No. 5 (March–April 1975): 2–11.
Variety. "Action Comics Chief Liebowitz Spawned Superman in 1937." July 8, 1987.
Variety. "Superman Gets New 'Look,' Roots Return Under Byrne's Pen." July 8, 1987.
Wagner, Geoffrey. "Superman and His Sister." *The New Republic.* 1955.
Weisinger, Mort. "Here Comes Superman!" *Coronet.* July 1946.
Weist, Jerry. *100 Greatest Comic Books.* Atlanta: Whitman Publishing LLC, 2004.
yronwode, catherine, with Denis Kitchen. *The Art of Will Eisner.* Princeton, WI: Kitchen Sink Press, 1982.

Credits

EDITORIAL NOTE

Early comics carried few credits or often credited creators of features rather than the actual talent producing the stories. We've endeavored to research credits for accuracy, and regret any errors.

In order to provide the most accurate reproductions of the comics reading experience, we have dispatched photographers to work from the comics themselves... which, being artifacts that were often published on inexpensive paper and were read and collected, sometimes show their wear and tear. Collectors have graciously shared their treasures with us, and we have done our best to reverse the effect of time without altering the art. And treasures they are—despite the author's poor judgment in being unwilling to spend $130 for an *Action Comics* No. 1 when the first Comic Book Price Guide came out in 1970, today that issue has sold for more than a million dollars and many other old DC issues have skyrocketed as well.

The distances we went to in this quest are only hinted at by details like the odd UK tax stamps on a cover or two reproduced here. Other rare photos and original artwork have been treated with similar respect, but are subject to the same caveats that we have not always been able to identify the photographer or all the subjects.

It is our hope that you'll have been able to enjoy all these artifacts from the Golden Age (and earlier) as if you were actually holding them, or even more, since they're better reproduced and not crumbling.... This is our best approximation of inviting you into our personal library to sit down and share our delights.

The majority of the comics included in this series were photographed from the Ian Levine Collection. Also featured are the collections of Art Baltazar, Ivan M. Briggs, Saul Ferris, Grant Geissman, Tom Gordon, Jim Hambrick, P.C. Hamerlinck, Philip Hecht, Bob Joy, Chip Kidd, Peter Maresca, Jim Nolt, Jerry Robinson, David Saunders, Anthony Tollin, Ellen Vartanoff, Jerome Wenker, Mark Zaid, and, notably, Bob Bretall, Mark Waid, Heritage Auctions, and Metropolis Comics.

Any omissions for copy or credit are unintentional and appropriate credit will be given in future editions if such copyright holders contact the publisher.

Courtesy 1821 media / Paris Kasidokostas Latsis and Terry Dougas: 49 (top). © American Broadcasting Companies, Inc.: 33 (right). Used with permission of Apple Corps Ltd.: 120 (top). © Bettmann/CORBIS: 264. Bill Bridges: 25 (center). Courtesy Bob Kanigher Estate: 292. © Burt Glinn / Magnum Photos: 245.a Courtesy Cate Fowler: 270 (bottom). Courtesy Constantine Nasr: 244 (bottom), 248 (top left). Courtesy Daniel Herman: 54 (top left). © 2015 Fantagraphics Books, Inc. Used by permission: 292. Courtesy Hake's Collection: 294 (top right). Courtesy Heritage Auctions: 16 (top left), 17, 55, 76 (bottom), 76 (top), 81 (bottom left), 88, 151 (top right), 160 (bottom), 167 (top), 212 (bottom), 212 (top), 222 (top right), 225 (bottom right), 228, 235 (bottom), 235 (right), 290, 312 (top), 350, 357 (top right), 360 (bottom left), 383 (top left), 388 (top left). Image courtesy of Hershenson / Allen Archive: 247 (top), 249, 378. From the Irene and Ellen Vartanoff Archive of Comic Arts and Popular Culture: 227 (bottom). Courtesy the Ivan M. Briggs Collection: 135 (bottom), 136 (bottom), 263. Courtesy Jack Adler Estate: 8 (top), 11 (bottom right), 30 (bottom), 65 (top), 155 (bottom), 160 (top right), 201, 229 (top), 230 (bottom), 233 (top), 262 (bottom), 293 (top), 311 (top). © Jackie Estrada: 131 (top). Courtesy Joe Kubert: 292. Courtesy Josh Baker Collection: 266 (top right). Courtesy Ken Steacy: 181 (top). The Kobal Collection / Warner Bros.: 169, 170. © Larry Williams: 393 (top right). Photo by Leigh Morrison: 368 (bottom). Courtesy Lynda Carter: 33 (right). Courtesy Marv Wolfman: 347 (top). Courtesy Paul Levitz: 122, 126–127, 200. Courtesy of Peter Hamilton: 136 (top left). Photo by Popperfoto / Getty Images: 34 (top). Courtesy Sam de la Rosa and Bill Neville: 34 (left). Courtesy Shirley Duke: 271. Star Trek / Courtesy of CBS Television Studios: 338 (bottom), 361. © Steve Schapiro: 261 (top left). Courtesy Susan Bay Nimoy: 338 (bottom). © Trina Robbins: 167 (top). © 1975 Universal Pictures: 360 (bottom left and right). © William M. Gaines, Agent, Inc. / Courtesy Grant Geissman: 89 (top).

MACY'S THANKSGIVING DAY PARADE

Page 2: *Photograph, Superman balloon, New York City, Thanksgiving ca. 1982.*

The largest Macy's balloon ever—measuring 107 feet—was the Superman first used in 1980. To get the face correct, Sol Harrison and Dick Giordano went to the hangar where it was built, and painted with the construction crew. It differed from the two previous versions in that the hands were separate chambers, one of which deflated in 1980. The next year, a hand fell off and had to be carried to parade's end. There were no mishaps in the third year, but a balloon this size was apparently considered too unwieldy as it never made a fourth appearance.

THE NUMBERS ALL ADD UP

Page 4: *House ad art, Ross Andru and Dick Giordano, May 1980.*

'COMIC BOOK' McFIEND

Right: *Interior,* Plop! *No. 24; script, Don Edwing; pencils and inks, Dave Manak. November–December 1976.*

THE END

Following page: *Interior,* House of Mystery *No. 186; script, Robert Kanigher; pencils, Neal Adams; inks, Dick Giordano. May–June 1970.*

Editors: Josh Baker, Oakland; Nina Wiener and Steve Korté, New York

Art direction and design: Josh Baker, Oakland

Editorial consultants: Paul Levitz, Mark Waid, Martin Pasko, John Wells, and Daniel Wallace

Production: Stefan Klatte, Cologne

Layout: Evan Weinerman and Jessica Trujillo, Los Angeles

Editorial assistant: Joseph Heller, Los Angeles

Photography: Jennifer Patrick and Ed Fox, Los Angeles; Keith Krick, New York City

To stay informed about upcoming TASCHEN titles, please request our magazine at www.taschen.com/magazine or write to TASCHEN America, 6671 Sunset Boulevard, Los Angeles, CA 90028, USA; contact-us@taschen.com. We will be happy to send you a free copy of our magazine, which is filled with information about all of our books.

EACH AND EVERY TASCHEN BOOK PLANTS A SEED!

TASCHEN is a carbon neutral publisher. Each year, we offset our annual carbon emissions with carbon credits at the Instituto Terra, a reforestation program in Minas Gerais, Brazil, founded by Lélia and Sebastião Salgado. To find out more about this ecological partnership, please check: *www.taschen.com/zerocarbon*

INSPIRATION: UNLIMITED.
CARBON FOOTPRINT: ZERO.

COPYRIGHT © 2015 DC COMICS

All related characters and elements are trademarks of and © DC Comics. (s15)

TASCHEN GmbH
Hohenzollernring 53, D-50672 Köln
www.taschen.com

Printed in China
ISBN 978-3-8365-3579-3

Thanks to Martin Pasko, Mark Waid, Daniel Wallace, and especially John Wells for research and writing assistance on captions and biographies; and to Denny O'Neil for sharing his stories for this volume.

Special thanks to Ian Levine for allowing access to his amazing collection. Thanks as well to Bob Bretall, who holds the 2014 Guinness World Record for Largest Collection of Comic Books and freely allowed us to dive into his trove.

At DC Comics, thanks are due to Michael Acampora, Allan Asherman, Karen Berger, Roger Bonas, Georg Brewer, Richard Bruning, Mike Carlin, Christopher Cerasi, Mark Chiarello, Eddy Choi, Ivan Cohen, Dan DiDio, John Ficarra, Larry Ganem, Bob Harras, Geoff Johns, Bob Joy, Hank Kanalz, Kevin Kiniry, Jay Kogan, Jim Lee, Evan Metcalf, Connor Michel, Lisa Mills, John Morgan, Diane Nelson, Scott Nybakken, Anthony Palumbo, Frank Pittarese, Barbara Rich, Cheryl Rubin, Andrea Shochet, Joe Siegel, Bob Wayne, Scott Bryan Wilson, Michael Wooten, and Dora Yoshimoto. At Warner Bros., my thanks to Josh Anderson, Leith Adams, Ben Harper, Stephanie Mente, and Nikolas Primack.

Many thanks to the numerous individuals who helped in the production of this book, including Jack Adler; Doug Adrianson; Teena Apeles; Dawn Arrington; Chris Bailey; Jerry Bails; Art Baltazar; John Barton; Jerry Beck; John Benson; Steve Bingen; Arnold Blumberg; Brian Bolland; Jim Bowers; Cindy Brenner; Ivan Briggs; Jonathan Browne; Scott Byers; Steve Carey; Pete Carlsson; Mildred Champlin; Dale Cendali; Ruth Clampett; Alice Cloos; Dick Cole; Wesley Coller; Gerry Conway; Margaret Croft; Les Daniels; Dave Davis; Jack Davis; Ken DellaPenta; Joe Desris; Lee Dillon; Michael Doret; Spencer Douglas; Paul Duncan; Mallory Farrugia; Saul Ferris; Stephen Fishler; Chaz Fitzhugh; Steve Fogelson; Danny Fuchs; Neil Gaiman; Craig B. Gaines; Grant Geissman; Dave Gibbons; Frank Goerhardt; Tom Gordon; Steven P. Gorman; Jared Green; Steven Grossfeld; James Halperin; Jim Hambrick; P. C. Hamerlinck; Yadira Harrison; Chuck Harter; Philip Hecht; Jim Heimann; Joseph Heller; Andy Hershberger; Jessica Hoffman; Martin Holz; Julia Howe; Adam Hyman; Lisa Janney; Klaus Janson; Jenette Kahn; Elizabeth Kane; Chip Kidd; Kirk Kimball; Denis and Stacy Kitchen; Stefan Klatte; Todd Klein; Florian Kobler; Charles Kochman; Christopher Kosek; Keith Krick; Joe Kubert; Danny Kuchuck; Amy Kule; Paul Kupperberg; Olive Lamotte; Caroline Lee; Hannah and Alfred Levitz; Jeanette, Nicole, Philip, and Garret Levitz; Steven Lomazow; Alice and Leonard Maltin; Tony Manzella; Peter Maresca; Byrne Marston; Pete Marston; Rachel Maximo; David Mazzucchelli; Thea Miklowski; John Morrow; Mark McKenna; Ryann McQuilton; Eric Nash; Constantine Nasr; Meike Niessen; Scott Neitlich; Adam Newell; Maggie Nimkin; Robert Noble; Mark Nobleman; Jim Nolt; Erica Pak; Jennifer Patrick; Kirstin Plate; Joe Orlando; Joe Rainone; Debbie Rexing; Dennis Robert; Jerry Robinson; Alex Ross; Barry Sandoval; Mike Sangiacomo; David Saunders; Zina Saunders; Randy Scott; Susannah Scott; Jürgen Seidel; David Siegel; John Smedley; Ben Smith; Wayne Smith; Geoff Spear; Art Spiegelman; Bob Stein; Roy Thomas; Shane Thompson; Anthony Tollin; Jessica Trujillo; Ellen Vartanoff; Mark Voglesong; Mike Voiles; Phillip Wages; Chris Ware; William Wasson; Evan Weinerman; Jerry Weist; Sean Welch; Jerome Wenker; Josh White; Douglas Wheeler-Nicholson; Nicky Wheeler-Nicholson; Alex Winter; DebbySue Wolfcale; Marv Wolfman; Steve Younis; Mark Zaid; Thomas Zellers; Barry Ziehl; Marco Zivny; and Vincent Zurzolo.

And a special acknowledgment to Steve Korté, Josh Baker, and Nina Wiener, and the eagle eye of Benedikt Taschen, without whom this series of books would have been impossible.

— PAUL LEVITZ